THE POWER
OF THE CENTER

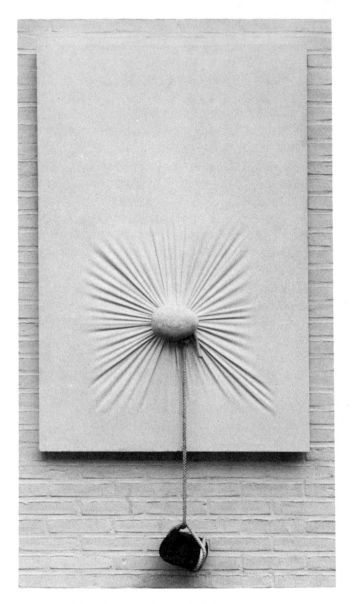

Nobuo Sekine, Phases of Nothingness. 1971.
Louisiana Museum, Humlebæk, Denmark.

THE POWER
OF THE CENTER

A STUDY OF COMPOSITION
IN THE VISUAL ARTS

THE NEW VERSION

RUDOLF ARNHEIM

UNIVERSITY OF CALIFORNIA PRESS

BERKELEY · LOS ANGELES · LONDON

University of California Press
Berkeley and Los Angeles, California
University of California Press, Ltd.
London, England
© 1988 by
The Regents of the University of California

Library of Congress Cataloging-in-Publication Data

Arnheim, Rudolf.
The power of the center.

Bibliography: p.
Includes index.
1. Composition (Art) I. Title.
N7430.A69 1988 701'8 87-25529
ISBN 0-520-06242-6 (pbk. : alk. paper)

Printed in the United States of America
5 6 7 8 9

CONTENTS

INTRODUCTION

This book has been entirely rewritten. There are paragraphs here and there and even an occasional page that have remained untouched, but more likely than not they will now be found in different places. A few illustrations have been added, others have been dropped, and a comparison between the table of contents of the earlier edition and that of the present one will show substantial rearrangements.

How can such thorough revamping be justified? How is it even possible? I shall try to explain. The first writing of the book was influenced by the happy realization that I had made a discovery. Composition, a prime requirement of any organized visual statement, has been discussed for centuries by artists, art theorists, and critics. Practical rules for proportion and spatial arrangement have been proposed; intuitive judgments of good and faulty balance have been presented; triangles and circles and all sorts of arrows have been drawn on reproductions of works of art. Some of these devices looked more convincing than others, but most of them applied to particular works of art or to particular styles. Principles of composition that might apply universally to buildings, sculpture, and painting, to the applied arts as well as the fine ones, regardless of their place and time of origin, were not sought out. They were considered unattainable and perhaps undesirable.

My own training and inclination have always led me to what things have in common rather than what distinguishes them. Looking at the offerings of the arts of the ages as the collective attempt of mankind to explore the endlessly variable ways of giving shape to one thing—art—I became increasingly convinced that composition, in whatever style or medium, derived from the interaction of two visual principles, which I now call the centric and the eccentric systems. I began to see reasons for the necessary universality of these principles, and as the search for them opened my eyes to the

organization and meaning of more and more works in the various forms of art, I felt ready to give an account of what I had found.

The mounting evidence telling me that what I was seeing could be seen everywhere and the euphoria accompanying this discovery and confirmation led me to write the first version of the book in the order dictated by inspiration. What occurred to me first was said first, and as the topics arising in the course of the study made for unexpected observations, I reported on them whether or not they strictly belonged to the theme of the book. This semi-improvisational quality of the first version endeared it to some readers; but I began to realize that to have the practical usefulness that has made my *Art and Visual Perception* a standard tool for over thirty years, the book required a systematic presentation; it had to be clearly focused on every page upon its one basic subject.

In the introduction to the edition of 1982 I apologized for not writing *more geometrico*, as Spinoza called it, "that is, to present my subject in the systematic order to which treatises and textbooks so rightly adhere." The apology has become less pertinent. The book begins now with a more thorough analysis of composition viewed as the dynamic interaction of visual forces. I describe vectors and their primary groupings as centers of energy. From the role of the principal centers—the force of gravity and the influence of the viewer—I proceed to the more general interplay of compositional centers. Observations on frames are now consolidated with those on the tondo and the square, and the balancing center as the spine of a composition is now clearly distinguished from its function as a divider in bimodal groupings. Extensions into time and some theoretical underpinnings of my basic approach have been collected in a final chapter.

The search for the most suitable terminology cannot be said to have ended. The term *centricity* is clearly appropriate for the more basic of the two compositional systems. The other system was called the Cartesian grid in the first version of the book; but although grids figure in composition, especially in the design of buildings and cities, they refer only to the special case of vectors arranged in the most regular fashion. Since the directed forces of vectors make up the second system, the name "vectorial system" might suggest itself, were it not that centric patterns, too, consist of vectors, arranged to form a higher configuration. I decided to adopt the term *eccentricity* to differentiate between compositional forces related to an internal center and others acting in response to an external center. Only time will tell which term emerges as the most suitable.

As I endeavored to articulate the conceptual skeleton of this study, its relation to the earlier *Art and Visual Perception*, at first only dimly sensed,

became more explicit. Some of the fundamental phenomena of perception that I had related to the elements of art in the earlier book manifested their presence at the level of composition. By now the connection has become so direct that after exploring the foundations of visual form in *Art and Visual Perception*, readers can comfortably proceed to composition as the next level. The gestalt principle of simplicity, described in the earlier book as the organizer of shape and space, applies to visual patterns in general. It also underlies composition—for instance, by making the vectors of a sunburst distribute as symmetrically as possible or by placing the balancing center in the middle of the perceptual field. Beyond that, however, composition deals with the more particular problem of what happens when foci of visual energy organize the field and when vectors connect such centers.

From the beginning, it had been evident to me that there was little point in analyzing the organization of perceptual shapes in the arts unless the resulting patterns could be shown to symbolize vital aspects of the human experience. As I discussed matters of visual shape with students and other audiences, I began to see that the interaction of centricity and eccentricity directly reflected the twofold task of human beings, namely, the spread of action from the generating core of the self and the interaction with other such centers in the social field. The task in life of trying to find the proper ratio between the demands of the self and the power and needs of outer entities was also the task of composition. This psychological relevance justified the concern with the formalities of composition. Far from being limited to playing with pleasant shapes, artistic form turned out to be as indispensable to human self-awareness as the subject matter of art and indeed as the intellectual investigations of philosophy and science.

The relevance and symbolism of centricity and eccentricity go beyond what is suggested by the visual evidence of works of art. When, for example, in a famous denunciation of modern civilization the art historian Hans Sedlmayr spoke of "the loss of the center," he did not have composition in mind. Our terms have profound philosophical, mystical, and social connotations, undoubtedly pertinent to the full interpretation of works of art.[1] Even so, I resisted the temptation to carry the quest of significance beyond the direct evidence accessible to the eyes. I deal with symbols only to the extent that the visual shapes reveal them through their dynamic behavior, in the con-

1. For a recent detailed survey on the symbolism of circular shapes see Perrot (1980). As another example, see L. A. Cummings (1986) attempting to describe the crossing of radial axes in a dominating center as an expression of focused political and religious power in the Renaissance. (Here and throughout the present book, numbers in parentheses following authors' names refer to the year of publication of titles in the Bibliography.)

viction that these direct perceptual manifestations are among the most powerful conveyors of meaning available to the human spirit.

I should mention one difference between my early approach, going back to the 1940s and 1950s, and the present one. In *Art and Visual Perception* I applied principles of visual perception to examples taken from the arts. In *The Power of the Center* I am trying to account for artistic form by whatever facts are available in perceptual research and by whatever principles can be derived from that research. The basic enterprise remains the same, but the starting point has shifted. Rather than look from psychology to art, I look from art to the resources offered by psychology. This makes for more emphasis on the interpretation of particular works and hence for more photographs than diagrams. Even so, I have complemented photographic reproductions with tracings wherever this seemed appropriate.

This shift in emphasis is related to the hospitality offered me by the Department of Art History at the University of Michigan in Ann Arbor. For ten years after my retirement from Harvard, my friends at Tappan Hall permitted a mere psychologist to teach in their midst; and even after my more definitive leave from teaching, the friendship and expertise of my colleagues and the freshness of new generations of students have helped to keep me alert and confident. Once again, too, I want to express my thanks to my wife, Mary, for taking upon herself the arduous task of transcribing my handwritten pages into type. I am grateful also to Mary Caraway for her sensitive and intelligent editing.

TWO SPATIAL SYSTEMS

B Y VISUAL COMPOSITION we mean the way in which works of art are put together of shapes, colors, or movements. The present book deals almost exclusively with shapes, although the principles I am using can be applied to the composition of colors or movements as well.

A MASTER KEY TO COMPOSITION

Composition reveals itself when, as we inevitably do, we see a painting or sculpture or building as an arrangement of definable shapes organized in a comprehensive structure. Why do the shapes of such a work need to be composed rather than simply added up in any odd way? The reason usually given is that artists like to put things together in an orderly and balanced fashion because the harmony thus obtained pleases their own eyes and those of the people who look at their work. This explanation, although pertinent, is barely a beginning of what we need to know about composition.

The common practice for showing composition in a treatise on the subject is to reduce the actual image of a work to the simple shapes and directions we see as constituting its skeleton. Circles or squares or triangles underlie pieces of visible matter; arrows indicate directions. Usually the diagrams resulting from this useful procedure illustrate the schema of one particular work or, at most, that of a kind of work created by a single artist or the practitioners of a particular style. Each diagram differs from the next.

My own objective is more ambitious and perhaps foolhardy. It seems to be possible to describe a compositional scheme common to works of visual art of whatever time or place—a condition that needs to be met by all art if it is to fulfill its function. How would such universality come about? Obviously, there is no convention prescribing one particular form of composition to all cultures. Rather, its principle would have to be deeply rooted in

human nature and ultimately in the very makeup of the nervous system we all have in common. Whatever knowledge is available by now on this score will be mentioned in Chapter XI.

Universality also can be expected to come about only if our compositional scheme symbolizes a condition of human experience so fundamental that without it any artistic statement would look irrelevant. I propose that this fundamental theme can be found in the interaction of two tendencies of human motivation, which I will call the centric and the eccentric tendencies, and that this interaction is symbolized in art by the corresponding interaction of a centric and an eccentric compositional system.

CENTRICITY AND ECCENTRICITY

Psychologically, the centric tendency stands for the self-centered attitude that characterizes the human outlook and motivation at the beginning of life and remains a powerful impulse throughout. The infant sees himself as the center of the world surrounding him.[1] Things are understood as being directed toward him or away from him, and his actions are controlled by his own needs and wishes, his pleasures and fears. A social group, be it a family, an association of persons, a nation, or even humanity as a whole in its relation to nature, retains centricity as a strong component of its outlook and motivation.

Soon enough, however, the self-centered individual or group is compelled to recognize that its own center is only one center among others and that the powers and needs of other centers cannot be ignored without peril. This more realistic worldview complements the centric tendency with an eccentric one. The eccentric tendency stands for any action of the primary center directed toward an outer goal or several such goals or targets. The primary center attracts or repels these outer centers, and the outer centers, in turn, affect the primary one.

It will be seen that the interaction of the two tendencies represents a fundamental task of life. The proper ratio between the two must be found for existence in general as well as for every particular encounter between the inner and the outer centers. Taken by itself, the activity of either tendency would be one-sided in an unnatural way. It would represent a state of easy freedom desirable to the naive mind but intolerable in the long run and de-

1. I apologize for not adopting the practice of supplementing masculine pronouns with feminine ones. I am all in favor of eradicating the verbal residues of sexism as soon as our language succeeds in offering an acceptable solution. But the law of parsimony, omnipotent in science and art, forbids me to introduce differentiations not required by a proposition. No writer can afford to say, "He bites the left or right hand that feeds him."

prived of the basic challenge of life. The tension between the two antago-
nistic tendencies trying to achieve equilibrium is the very spice of human
experience, and any artistic statement failing to meet the challenge will strike
us as insufficient. Neither total self-centeredness nor total surrender to outer
powers can make for an acceptable image of human motivation.

How are the arts to make this theme visible? Fortunately, centricity and
eccentricity are spatial relations, as their very names indicate. They are as
basic to the physical as to the mental world, and they are easily represented
through visual shapes. Furthermore and perhaps even more important, since
the psychological relations that art is called upon to depict are motivational
strivings, their images, too, must display the action of directed forces. Here
we meet a basic problem.

[handwritten margin note: I doubt this is all that art does.]

Shapes drawn on paper or painted on canvas as well as those made of
various materials in sculpture and buildings are in and by themselves not
only physically immobile but also undynamic, in the sense of not being in-
habited by animating forces. A ball of clay neither expands nor contracts,
and even the drawing of an arrow does not go anywhere. One can see such
shapes in what one might call an impoverished or deprived way—a view
limited to their purely spatial dimensions. This undynamic view is sufficient
and indeed useful for some purposes. Geometry, for example, is concerned
only with spatial relations, and therefore a circle is nothing but a figure of
certain measurements, and so is a straight line. Even in the arts, as we shall
see, such pure shapes serve useful purposes, especially that of supporting
visual order.

[handwritten margin note: static geometry that is, but...]

[handwritten note: but now we can animate geometry.]

Artistic expression, however, requires shapes that are thoroughly dy-
namic. If they are to depict human experience, they must look animated.
Here again we are lucky. Although the optical images projected upon the
retinas of our eyes share the static hardness of the objects whose surfaces
they reflect, their electrochemically generated counterparts in the nervous
system do not. These are much more in the nature of processes, and so are
their equivalents in consciousness, that is, in visual perception. To the full-
fledged vision that is needed for artistic expression, all shapes are configu-
rations of forces.[2] In practice, this way of looking at the world is familiar to
anybody open to the experience of art. In fact, it is natural to all people, for
example, young children, whose vision has not been degraded by being used
for information and identification only. As a matter of theory, however, the
traditional notion that the visual world is nothing but an agglomeration of
static things is not easily relinquished. It may help to be reminded here of

2. For a more explicit discussion of visual forces see Arnheim (1974, pp. 16ff. and chap. 9).

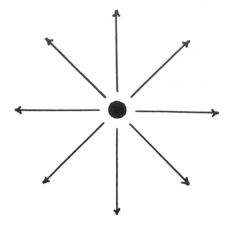

FIGURE I

the changed picture of the physical world offered to us by the physicists of our century. The old distinction between mass and energy has been superseded by a more unified conception, according to which the universe consists of patterns of energy only. What looks to us like mass, what we call a thing or object, is nothing but a field of energy.

Similarly, things fully perceived appear to us as configurations of forces, and this dynamics of our vision enables us to do justice to the mental and physical strivings portrayed in works of art. Therefore, if we wish to describe compositional structure, the elements to start out from are not things or shapes but vectors. *One basic postulate.*

VECTORS AND THEIR TARGETS

For our purpose, a vector is a force sent out like an arrow from a center of energy in a particular direction.[3] When a system is free to spread its energy in space, it sends out its vectors evenly all around, like the rays emanating from a source of light. The resulting symmetrical sunburst pattern is the prototype of *centric composition* (Fig. 1). In nature it is most perfectly embodied in the spherical shapes of planets and stars, but it is also evinced in snowflakes or microscopic radiolarians. Goethe observes in his aphorisms on geology: "Anything that embodies itself with some freedom seeks round shape." *What about rivers?*

3. Vectors refer to physical as well as to mental situations. In the present book, I am applying the term to either. The first psychologist to speak of vectors was Kurt Lewin (1935, p. 81).

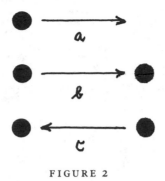

FIGURE 2

The sunburst pattern can be analyzed into a multitude of vectors, each of them issuing from the center and sending its energy into space (Fig. 2a). Depending on its strength, its activity will evaporate at a shorter or farther distance from the center.

So far, we are dealing with purely centrifugal behavior. A different situation comes about when a second object is introduced into the neighborhood of the first. We might say that as the original center responds to the presence of another one, a centric orientation changes into an eccentric one (Fig. 2b). *hmmm?* The primary centric system is no longer alone in the world; it acknowledges the existence of other centers by acting upon them and being acted upon by them. Here we have the prototype of our second system, that of *eccentric composition.* *But in his world all these centers are tacitly assumed to be*

As the primary center focuses upon a second one, the nature of the vector, *positive.* represented by our arrow, changes. It is no longer a mere passive emanation of energy released into empty space but rather an active goal-directed aiming at a target, a striving to approach that may be friendly, like a longing, or hostile, like an attack. The power of the primary center may also manifest itself as a magnetic attraction, in which case the direction of the vector is reversed (Fig. 2c). *You can't really tell if magnetic attraction is a push.*

Even if the primary center acknowledges that it is not alone in the world, it may still view the situation in an entirely self-centered fashion: the primary center is conceived as generating all activity and undergoing affliction passively, whereas the secondary center is only a target or afflicted victim. With one step further toward a more realistic appraisal of the situation the secondary center is recognized as a focus of energy in its own right. The primary center comes to realize that it receives an outer power's action when it is attracted or approached. *This all sounds very psychological. You know, drives & all that.*

If we, as the external spectators, choose to switch allegiance and to identify

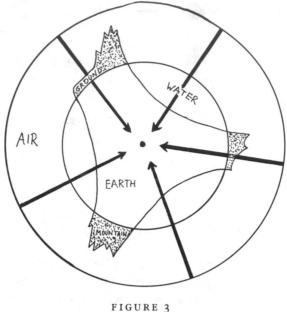

FIGURE 3
(after Klee)

with the secondary center by making it the primary one, the entire dynamics
of the situation is reversed. What was active becomes passive and receptive,
and the target becomes the initiator.

We arrived at the notion of the vector by deriving it as a detail or element
from the primary sunburst pattern of a focus spreading energy in all direc-
tions. Centricity is always first. This is true physically, genetically, and psy-
chologically. Let me mention here the biological fact that in the embryonic
development of the nervous system the nerve cells grow first as independent
entities and only secondarily send out linear axons to establish communi-
cation with their neighbors. Another, very different, example of this priority
of the central system may be illustrated with a drawing derived from Paul
Klee (Fig. 3). The section through the earth shows a centric system orga-
nized around its middle by the focus of the force of gravity. Gravity attracts
everything throughout the body of the sphere, including all the living and
inorganic things on its surface and in the air. This view of the whole planet,
however, is not the one that is natural to us humans as we inhabit the earth.
Our attitude is somewhat ambiguous. The attraction to which we are sub-
jected can be perceived as weight, that is, as a property inherent in the mass
of our own bodies. This mass presses downward as a vector issuing from the

FIGURE 4.
Paul Klee, drawing from *Unendliche Naturgeschichte*, p. 33.

body as the primary center—a centric conception that ignores the existence of the outer attractive power.

Less narrowly and more modestly, however, we acknowledge the eccentric power of gravity that pulls us down. In response, we struggle to liberate ourselves from the coercion of our earthbound condition and to rise—with height as an eccentric objective, the explicit target of our striving. As we shall see, this tension-laden struggle is a vital component of artistic expression because it dramatizes the pervasive human conflict between powers trying to pull us down and our own striving to overcome them.

The world of our immediate experience, then, is a partial and parochial one. Rather than see ourselves as the outer particles of the terrestrial centric system, each of us has shifted the primary center to his own body—a center tied to an ever-present ground force. The parochial confinement of our environment also modifies the nature of our space fundamentally. Instead of a system of radial vectors oriented toward the center of the earth we perceive a system of parallel verticals, as indicated in another drawing by Paul Klee (Fig. 4). A plumb line establishing the vertical shows us that if we measure their orientation with microscopic precision, the left and the right side walls of a building converge toward the center of the earth; but they run parallel for all practical purposes. It follows that the dominion of the eccentric system is often expressed in whole rows or groups of verticals. This parallelism is found in the choruses of columns or trees or crowds of people.

We should be most grateful for this narrower conception of space because by transforming convergence into parallelism it simplifies our world in a vitally helpful way. It allows us to impose a framework of vertical parallels supplemented by horizontal parallels upon our life space and thereby supplies us with the simplest and most perfect instrument for spatial orientation the mind could seek. Imagine the complications in mathematics and in the pursuit of our daily business if Descartes had had to build his basic analytical geometry on a framework of converging radii; and recall that it took

an Einstein to cope with a universe that does not conform to a Cartesian grid. *What happened to diagonals?*

Grids of this kind may be constituted of vectors that perform their dynamic action in the vertical or horizontal directions, but they also may be simply the coordinates of a framework of order, in the sense just indicated above. I can refer here to the usefulness of purely geometric shapes, of which I spoke earlier. The grid of analytical geometry is not dynamic, nor is the grid that allows us to define places and spatial relations on geographical maps. Similarly, implicit grids in works of painting and architecture help to create visual order and thereby serve an important compositional purpose.

If such grids are to come alive as elements of artistic expression, however, they must be perceived as vectors. Think of the difference between the streets of Manhattan laid out for the sake of order as a network of empty channels and these same channels populated with streams of people and vehicles moving toward their goals in all four directions. A similar difference holds between mere scaffolds of order in an artistic composition and arteries pervaded by directed visual energy.

Grids & circles

INTERACTION OF THE SYSTEMS

Is this what he means by eccentric?

Consequently, when we go back to our two spatial systems, the centric and the eccentric, we can represent them in two ways. Figure 5 shows them as mere scaffolds of order, both singly and in combination. The concentric circles offer a pattern for the arrangement of things around a common center. The network of parallels meeting at right angles serves to localize items in a homogeneous space, in which no one place is distinguished. The combination of the two in a single pattern presents the facilities of both but also suffers from complications appreciated by anybody who has tried to cope with the street map of Washington, D.C.

Figure 5 can be considered the trellis on which the actual composition performs its vectorial play. Similarly structured, Figure 6 shows the dynamic version of our combined systems. The centric system is now an arrangement of vectors radiating from their common center into empty space. In practice, this system need not be complete. There may be no more than one vector relating to its center in this manner, or there may be a few. The second system is represented by a grid of parallel vectors moving toward or away from outer centers of attraction or repulsion. Here again we have a schematization of what happens in practice. Actually such grids are rare, in nature as well as in art, although they are pervasive in architecture. More gen-

centric

eccentric?

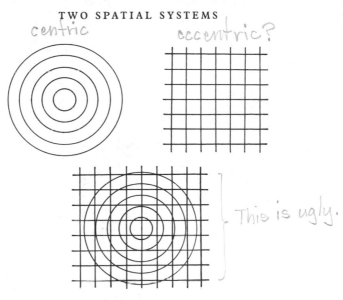

This is ugly.

FIGURE 5

erally, eccentric vectors occur in any number and can be oriented toward outer targets in whatever direction. Figure 6 also shows the combination of the two patterns of forces in a single structure.

Thus in Figure 5 we see the spatial order to which the compositional forces conform, whereas Figure 6 schematizes the behavior of these compositional forces themselves within the given framework. In both cases the combination of two rather disparate patterns makes the relationship quite intricate. In the framework of spatial order it allows for the simultaneous presence of focused and homogeneous space but complicates the order by creating a tricky relation between curves and straight lines. In the framework of vectorial dynamics it produces the tension and discord needed by the artist when he represents self-centered behavior as trying for a modus vivendi with outward-directed behavior. This is a bit of a stretch.

We shall see that in almost every practical case both the centric and the eccentric systems are at work. The ratio in which they combine varies greatly. It will be useful to give here two examples in which either the one or the other system clearly predominates. The tracing in Figure 7 is taken from a Japanese mandala of about A.D. 1000. Eight Buddhas and Bodhisattvas surround the supreme deity, Vairocana, from whom creative energy radiates in all directions. The religious hierarchy is expressed by the dominance of the centric system of composition. The only concession to the eccentric system is that all the figures, in deviation from the radial pattern, sit

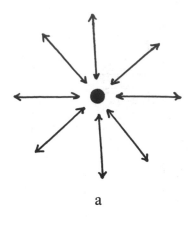

a

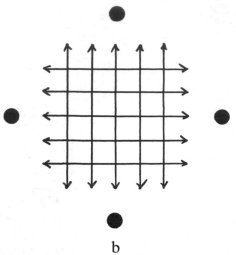

b

centered
vs.
centerless

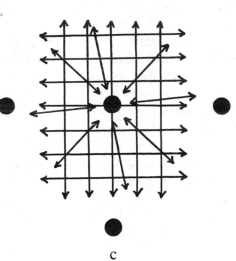

c

FIGURE 6

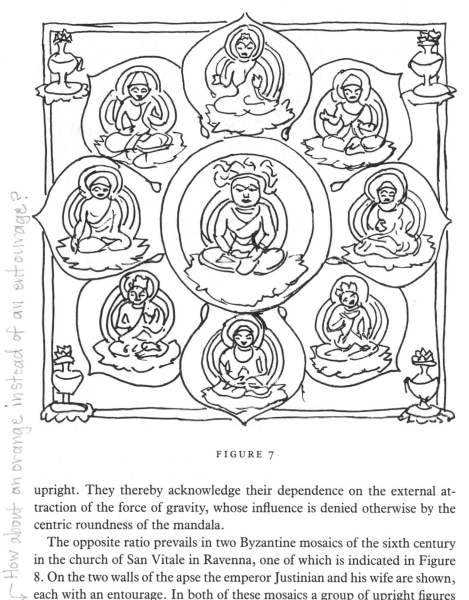

FIGURE 7

How about an orange instead of an entourage?

upright. They thereby acknowledge their dependence on the external at-
traction of the force of gravity, whose influence is denied otherwise by the
centric roundness of the mandala.

The opposite ratio prevails in two Byzantine mosaics of the sixth century
in the church of San Vitale in Ravenna, one of which is indicated in Figure
8. On the two walls of the apse the emperor Justinian and his wife are shown,
each with an entourage. In both of these mosaics a group of upright figures
supports the vault of the chapel like a row of columns. This uprightness
indicates the dominance of the eccentric system, which ties the figures to the
ground and has them respond by proudly rising in the opposite direction.
This alignment of columnar figures, however, would look like a mere fence
if it were not held together by a center, which is located in each case in the
imperial figure. Empress Theodora, the first among equals, is distinguished

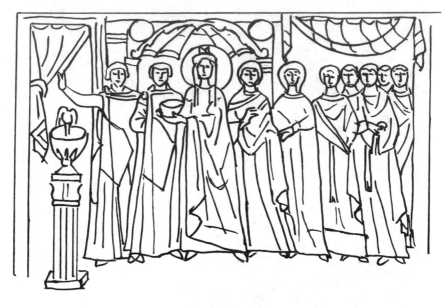

FIGURE 8

by her crown, jewelry, and halo and roofed by a special cupola. The figure of the emperor on the opposite wall is similarly distinguished.

A comparison of these examples reveals the striking difference between the two compositional systems. The Japanese mandala celebrates the power of the central figure by grouping the entire picture around it. The Byzantine mosaics, limited to a carrying function in the larger architectural context of the apse, refer to the outer powers that hold the human figures down but allow the figures also to rise to the task of holding up the sacred building.

Between these two extremes there ranges the whole wealth of artistic interpretation made possible by the various combinations of the two compositional systems.

CENTERS AND THEIR RIVALS

Never mind = pay no attention

Never mind.
It doesn't matter.

THE WORD *CENTER* refers to more than one thing. Two clearly different meanings of the term derive from what was shown in the first chapter. In the dynamic sense, a center is a focus of energy from which vectors radiate into the environment; it is also a place upon which vectors act concentrically. As long as by center we mean merely a center of energy, its location may not matter. As soon as we deal with relations between items, however, an entirely different meaning comes into play: now the word *center* may refer to what has its place in the middle.

That is, it's location may not precipitate matter.

GEOMETRIC AND DYNAMIC

For a simple example from architecture, take four buildings arranged symmetrically as shown in Figure 9. The square created by the four buildings has a center that can be determined geometrically. As such, it serves only spatial order. If workmen were asked to place a statue in the middle of the square, they would determine the center by measuring its distance from each of the buildings. Similarly, the group of concentric circles in Figure 5 has a purely geometric center.

Any such situation, however, can also be viewed dynamically. For artistic purposes indeed it *has* to be seen dynamically. When the situation of Figure 9 is viewed as a field of visual forces, the four buildings become centers of energy emitting their vectors in a wide range of directions. Together, the four groups of vectors constitute a field that is subject to a striving for equilibrium. Any state of equilibrium in which the vectors of a field compensate one another implies the establishment of a center—as, for example, when the weights in the pans of a scale balance around the instrument's center. Thus, a dynamic center reveals itself on the architectural square through the presence of the four buildings. Such a center may or may not coincide with the geometric center of the field, but the two tend to be closely related.

They wouldn't have to measure. Two intersecting lines would do as well, in fact better.

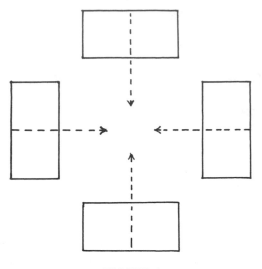

FIGURE 9

A dynamic center is invariably present in any visual field. It may be explicitly marked or created only indirectly by perceptual induction. The sense of vision establishes it intuitively—a process that can be understood by analogy to a corresponding physical process. Suppose one wishes to determine the center of a piece of plywood. If the piece is of simple geometric shape, one can determine the center by measurement. When the shape is irregular, its dynamic center can be found in the manner illustrated in Figure 10. The piece of plywood is suspended first by one and then by another point near its contour. The place where verticals dropped from the points of suspension cross is the object's center of gravity, its dynamic center.

One can obtain the same result by balancing a flat object on the tip of one's finger. In doing so, one searches intuitively for the place where the forces that pull the object down hold one another in equilibrium. This process of testing physical forces by kinesthetic sensation is similar to testing the behavior of visual forces through perceptual exploration and discovering thereby the dynamic center of a shape or configuration.

Throughout this book the various meanings of the term *center* may invite confusion. I shall try to clarify in each case whether I am talking about a focus of energy or a place in the middle. There is also, as I have mentioned, the difference between a place actually marked, for example, by a black dot in the middle of a circle—in which case we would say that the center has "retinal presence"—and a center merely brought about by perceptual induction. An empty circle we look at is organized around a center as a part

Its barycenter? {

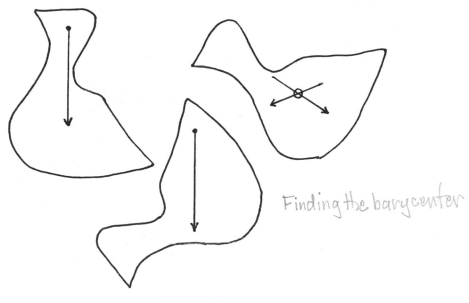

Finding the barycenter

FIGURE 10

of what we "see" even though that center does not actually figure in the circle's optical projection on the retinas of our eyes. In fact, we cannot even grasp the structure of such a shape without seeing it as organized around its center. Imagine someone drawing, say, a pentagon mechanically by connecting five equally long lines, one after the other, with angles of 108°. He will be in for a sudden structural surprise when the ends meet. The pentagon emerges as a centric figure symmetrically organized around its middle. We shall see that even the most complex patterns, as long as they are spatially limited, are organized around an implicit center and that without reference to that center a pattern's visual structure cannot be understood.

Add to this complex state of affairs yet another variation: a center as marked by a draftsman or artist may be a simple dot; but it may also assume any other shape, or it may be a cluster of shapes. As a source or target of dynamic action, any visual object whatever is a center. It will be evident that when I undertake to tell the story of the center, I am not dealing with a simple matter.

THE PULL OF GRAVITY

The planet on which we live is dominated by the force of gravity. Therefore the geometric center of the earth is its dynamic center as well. Physi-

cally, for all practical purposes this gravitational center rules unopposed. Strictly speaking, any object at all represents such a center, but actually, of course, a person is not significantly attracted by the building next to which he is standing. Nor does his body cast a measurable spell on the apples in a nearby fruit bowl.

We look at the situation from our human perspective, that is, from the viewpoint of small creatures that crawl on the surface of the earth. Unless you are a geologist, you are likely to consider yourself the primary center, for which the focus of gravity in the middle of the earth is an eccentric power even though it is the much stronger one in the play of forces. Our relation to the downward pull is somewhat ambiguous. We may experience it not as an attraction from the outside but as weight, that is, as a property of our own body. Weight is perceived as an active force that presses us downward. Even so, this heaviness is not felt as being under our control; it is a burden we have to cope with. Any initiative toward movement must overcome the inertia inherent in weight.

Overcoming the resistance of weight is a fundamental experience of human freedom. Birds and insects flying through the air display their triumph over the impediment of weight. To naive spontaneous perception, motion is the privilege of living things, whereas dead things are immobilized by their heaviness.

Walking downhill, dropping, or falling is experienced kinesthetically as acceding to one's own weight. One is being pushed downward by a force situated in the center of one's own body. But such downward motion is also very likely to give us a different conception of the dynamic situation, namely, that of being attracted by an outer power located in the ground beneath our feet. Physically, weight and gravitational pull are the same thing. Perceptually, they are related but distinguishable. By a special mental effort, I can make myself aware of this more sophisticated conception. Standing upright, I can let myself be pulled down by the floor beneath my feet. This involves emptying my body of its weight. I feel like a mere husk. All my muscles relax; limbs and torso respond to nothing but the pull from below. This surrender of the self's prerogative as a center of activity puts the person— and, by extension, any other thing on earth—at the mercy of eccentric outer powers.

The dominant pull of gravity makes the space we live in asymmetrical. Geometrically, there is no difference between up and down; dynamically, the difference is fundamental. In the field of forces pervading our living space, any upward movement requires the investment of special energy, whereas

FIGURE 11

downward movement can be accomplished by mere dropping or by merely removing any supports that keep objects from falling.

Human beings experience the dynamic asymmetry, or anisotropy, of space by means of two senses, kinesthesis and vision. The physical effect of gravity is perceived as tension in the muscles, tendons, and joints of the body. Visually, the world is pervaded by a similar downward pull, whose influence on the dynamic character of the things we see may be illustrated by the difference between what goes on visually in horizontal and vertical surfaces. Compare what happens to the simple figure of a cross in each situation (Fig. 11). Geometrically, they are identical; it makes no difference which way they are oriented to the controlling center of gravitational attraction. Visually, however, their different dynamics makes them two quite different figures.

The horizontal cross acknowledges its geometric symmetry. The two bars have the same function, and the point at which they cross is clearly the balancing center of the figure. In the horizontal plane all spatial directions are interchangeable unless they are given some particular role. Since all points of the horizontal figure have the same relation to the ground, the two bars balance each other and thereby establish the center around which the figural forces are evenly distributed. The centric system rules unopposed. If one wished to strengthen this symmetry, one could pierce the center with a vertical axis. This would enhance rather than contravene the structure.

How different is the perceptual effect of the same figure in the upright position! Here a vertical symmetry axis, namely, the vertical bar of the cross, gives the figure a spine. From the vertical axis the horizontal bar spreads sideways in both directions, like the branches of a tree or the arms of a person's body. The center breaks up the unity of the horizontal bar and transforms it into a pair of symmetrical wings. The vertical, by contrast, barely acknowledges the crossing. Strengthened by the gravitational vector

that pervades the visual field, it persists as an unbroken unit, for which the particular location of the crossing point is not compelling. The centric geometric symmetry is reduced to a mere bilateral one by the perceived asymmetry of the vertical field. The two parts of the vertical spine, the upper and the lower, serve different visual functions. They are not perceived as symmetrical, since reaching up is different from reaching down. Therefore, visual logic demands that they not be of equal length. When they are, there is a visual contradiction between equality of length and inequality of function. The axial symmetry of the Latin cross serves the upright position better than the centrical symmetry of the Greek cross. When the upper part of the vertical bar is made shorter than the lower, the difference gives visual expression to the functional difference. It also does justice to a fact that will concern us soon: an element in the upper part of a pattern carries more visual weight than one in the lower part and therefore should be smaller if it is to counterbalance a corresponding element below.

Whereas the horizontal cross is purely centric, the vertical one shows centricity subjected to the influence of the eccentric system, here represented by the gravitational pull. In consequence, the center of the figure, which was limited to the crossing point in the horizontal plane, annexes the vertical bar and converts it into an extended center. All such dynamic properties, so evident in the simple pattern of the cross, will now be shown as active determinants in the composition of artworks.

THE VISUAL CENTER UNDERNEATH

Nobuo Sekine's relief *Phases of Nothingness* looks almost like a diagram meant to illustrate the interaction of our two compositional systems (frontispiece). The round object tied into the fabric and surrounded by a sunburst of folds recommends itself as the primary center, if only because of its placement close to the eye level of the viewer. The centricity of the sunburst is somewhat interfered with. It acquires a bilateral symmetry in response to the stone that hangs from the primary center and acts as a representative of the gravitational force by pulling the primary object downward. The dynamic relation between the centricity of the principal object and the eccentric attraction exerted by the secondary center constitutes the theme of the work. We are invited to sense the particular kind of equilibrium into which the partners of the action have settled.

Sekine's relief is mounted on the wall at some distance from the ground and is thereby somewhat detached from the visual locus of gravity. The suspended stone is a representative rather than an executive of gravity. If the

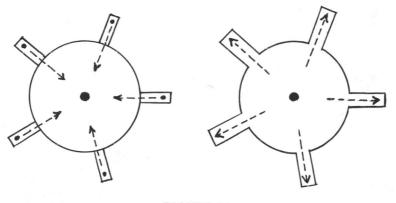

FIGURE 12

work were framed, as some reliefs and most paintings are, this detachment would be even more pronounced. Sculpture also displays its dependence on gravity more directly when it is based on the ground; in a work suspended in the air, such as a mobile, its dependence is much less direct. Of all the arts, architecture is most firmly rooted in the ground. Therefore in the vertical dimension architectural composition is always firmly tied to gravity.

The foregoing references to the force of gravity as the dominant example of a dynamic center in our environment have made me concentrate on its attractive power. We are concerned here, however, with perceptual centers rather than physical ones; and perceptual centers, as will be remembered from Chapter I, are made up of outgoing vectors as much as of inner-directed ones. It is necessary, therefore, to make a distinction, which is illustrated in Figure 12. Five small towers are seen standing on the ground. When we perceive each of these objects as possessed by a center of its own, the object is seen as attracted by the ground. But the objects can be seen alternatively also as excrescences or outgrowths of the power in the ground, like the outgoing rays of the basic sunburst in Figure 1. As we look at objects standing on the ground, be they trees or buildings, statues or even upright human beings, we see them as both pressing downward by their own weight and being pulled down by the ground's attraction, but also as sprouting up from the ground. The dominant direction depends on how much of a center of its own is perceived in the object.

Look at the remnants of the so-called Temple of Vesta, which stands near the Tiber in Rome (Fig. 13). The original crown of the ancient building, its entablature and roof, is no longer there, and its flimsy replacement upsets the original equilibrium of the architecture. We can assume that when the building was intact, its crown was strong enough to make it look like a

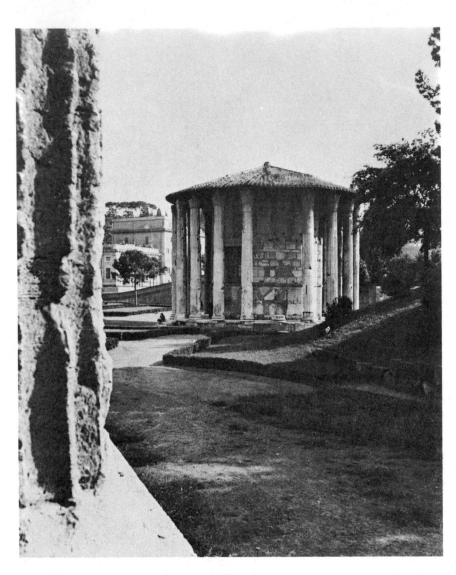

FIGURE 13.
Temple of Vesta. c. 100 B.C. Rome. Photo, Ernest Nash.

FIGURE 14

weighty primary center, pressing downward through the circular row of the twenty Corinthian columns. Now, however, the columns move skyward, all but flipping off the makeshift cover of the roof.[1]

VARIETIES OF WEIGHT

We must be prepared for even greater complexity in the dynamic relation between centers. Accordingly, I will develop here a few further general remarks on the conditions of visual weight. Two factors especially merit discussion:

A. Weight increases attraction.
B. Distance (1) increases visual weight when perception is focused upon the center of attraction and (2) decreases attraction when perception is anchored in the attracted object.

A. *Weight increases attraction.* Other factors being equal, the greater the visual weight of objects, the stronger their attraction to one another. There is an analogy here to the physical law that tells us that the force of attraction between objects varies directly with the product of their masses. Figure 14 is meant to show that when two objects are placed at the same distance from a powerful center of attraction, the larger one will be the more strongly attracted. In the vertical direction this effect accounts for top-heaviness. When an object has too much visual weight, it presses downward so strongly that it throws the composition off balance.

B(1). *Distance increases visual weight.* This statement contradicts what we know from physics. The gravitational law of the inverse square states that physical attraction diminishes with the square of the distance. Since gravitational attraction determines physical weight, it follows that objects become lighter with increasing distance from the center of the earth. To be sure, for terrestrial purposes the effect is minimal, but it predicts the opposite of what

1. For the two-way dynamics of columns, see my book on architecture (1977a, p. 48).

we find visually. When perception is anchored to the center of attraction, visual weight *increases* with distance.

This phenomenon corresponds more closely to the physical behavior of potential energy. The potential energy inherent in an object grows as that object moves away from the center of attraction. Similarly, visual experience informs us that in a painting the higher an object is in pictorial space, the heavier it looks. This occurs only when the object is perceived as being anchored to a center of attraction, especially the gravitational base. Under such conditions, the object has to be made smaller or otherwise diminished in weight if it is to equal the weight of a similar object in the lower portion of the picture. One can understand this phenomenon by thinking of the object as attached to the center of attraction by a rubber band. The farther removed it is from the center, the more resistance it has to overcome, and this capacity to resist is credited to it as additional weight.

B(2). *Distance decreases attraction.* In the visual world, weight is not just an effect of attraction from the outside. Visual weight also accrues from an object's size, shape, texture, and other qualities. Therefore even if the rubber band of our example snaps and the dynamics is no longer anchored to the base of attraction but switches to the object itself, the object remains endowed with weight. The object becomes an independent center, and its dynamics changes accordingly. With increasing distance from the base, the object looks freer. Take, as an example, the head of a standing statue. When the head is seen as attracted by the base, its power to maintain itself at so great a distance adds to its weight. But as we switch the dynamics and see the head as its own anchoring center, the head strains upward, intent on freeing itself from its tie to the ground. The head will actually give a lift to the entire figure, pulling it upward within the limits of its power.

The two ways of perceiving the situation, B(1) and B(2), are contradictory and mutually exclusive. They cannot both be held by a viewer at the same time, although he can switch back and forth between them. For this reason there does not seem to be a direct interaction that would make the two ways of seeing fuse in a compromise image. Rather, oscillation produces a balancing of the two opposite versions.

A tower rising above a building will be seen essentially as a centrifugal vector emanating from the massive center of the building. It will attenuate into space, perhaps through the decrescendo of a tapering spire. Although such a spire makes the building reach great height, the dwelling place of the building will be judged visually by its principal center of weight, which may be fairly low down. To make an explicit point of its height, the tower must reinforce its upper section by establishing a definite secondary center of its

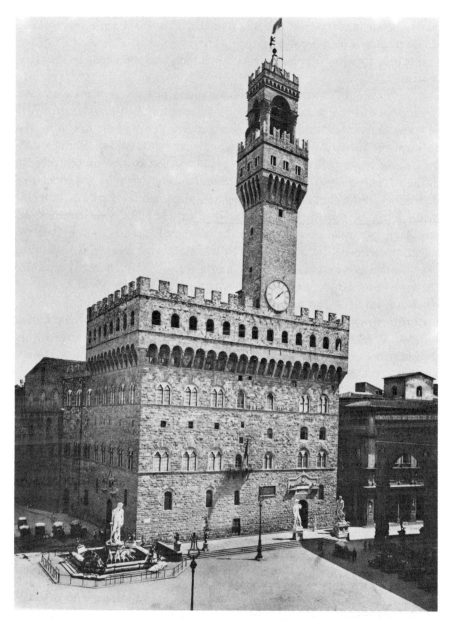

FIGURE 15.
Palazzo Vecchio. c. 1300. Florence. Photo, Anderson.

own. The slender tower of the heavily cubic Palazzo Vecchio in Florence would display little more weight than a factory smokestack were its top not strengthened by its corbeled gallery, which provides the needed secondary center (Fig. 15).

If we look at the palazzo as a whole, we notice the expected ambiguity. As a primary center, it presses downward on the ground, or is attracted by it, or both. At the same time, as a vectorial outgrowth of the ground, it moves outward and upward—a tendency strengthened by the tower. The size and bulk of the tower gallery seem just right for perfect balance in the context of the entire building. When we perceive the gallery as a secondary center dependent on the primary mass of the building, it gains visual weight by its distance from the main center below. The "rubber band effect" creates the tension, or potential energy, that results in the gain of weight. But when we switch the moorings of our perception from the cubic mass of the building to the tower gallery as a center in its own right, the relation between the centers is reversed. Now the gallery's weight exerts its own power, and since it remains connected to the mass of the building, it gives the building a lift, pulling it upward within the limits of its strength. It adds the height of a secondary center to an otherwise earthbound mass. If one tried to establish the balancing center of the palazzo as a whole, one would find that the tower raises that center higher than it would be for the main building alone.

If a tower provided with such an effective secondary center of its own did not have the support of a sufficiently massive building, it would look unbalanced in two ways. In relation to a weak base, the secondary center would look top-heavy. And viewed by itself, it would display so much visual weight as to float away, dragging the rest of the tower with it like a kite's tail. One possible example of such flightiness is the clock tower of the houses of Parliament in London when it is looked at in isolation from the buildings it surmounts.

SCULPTURE AND THE GROUND

How do our observations apply to sculpture? I mentioned before that the dynamic relation of sculpture to the base provided by the ground is somewhere between that of architecture and that of painting. Many sculptures stand on the ground and thus have a direct visual connection to it. But rarely is a sculpture so firmly rooted in the ground that it would seem to sprout from it as buildings commonly do. More often and more clearly than architecture, a piece of sculpture appears as an independent object, attracted by the ground and reaching toward it but organized predominantly around a

center of its own. On the other hand, sculpture is rarely as independent of the ground as paintings are. To be sure, a Calder mobile may be suspended in space like a planetary system, but floating sculpture is an exception.

The relation of sculpture to the ground varies with its shape. In general, vertical works, variations of the basic column shape, are most explicitly connected to the ground. When the main dimension is horizontal, the body of the sculpture moves in a direction parallel to the ground and seems barely attracted by it. Similarly, a strongly compacted mass, such as one of Brancusi's egg shapes, looks detached from the ground, not only because it barely touches it but because the work is compellingly organized around a center of its own. It is held by gravity but can take off to float in space without much effort.

In the human figure as the favorite subject matter of sculpture one can explore the relations between the compositional centers within the body itself and the forces inherent in the ground. Actually, this relationship is most visibly expressed in the dance, where the human figure, centered around its middle, is shown in mobile interaction with the forces attracting it from the floor. The classical ballet conveyed the illusion of a human victory over material weight. Modern dance tends to emphasize the struggle between the eccentric powers that pull us down and our attempts at spiritual liberation, symbolized by the vectors of rise and leap. In sculpture these same dynamic tendencies are perceived in the shapes and relations of immobile objects.

The upright body of the Roman Artemis (Fig. 16) is organized around its center in the middle, indicated in this case by the slightly curved belly below the belted waist. This centricity is overlaid by the linear extension of the columnar figure, which coincides with the vertical direction. Within this eccentric dimension of the figure,[2] the center effects a subdivision between the lower part of the body, which strives downward, and the upper part, which rises. The legs taper downward to the narrow platform of the feet, pressing the ground and being attracted by it. Chest and head are proudly elevated, in liberation from the ground. This upward-directed vector wins out when the figure as a whole is perceived as an outgrowth of the gravitational center in the ground. The head, a powerful center of its own, helps to lift the body, as the tower gallery lifts the Palazzo Vecchio (Fig. 15). At the same time, the head, held to the ground by the "rubber band effect," acts also as a kind of lid, which keeps the figure from evaporating into outer space.[3]

2. Readers will kindly remember that when I speak of eccentricity, here and throughout, the term refers to the eccentric compositional system, not to anything erratic or bizarre.

3. Notice here how the hanging folds of garments help to strengthen the connection of the

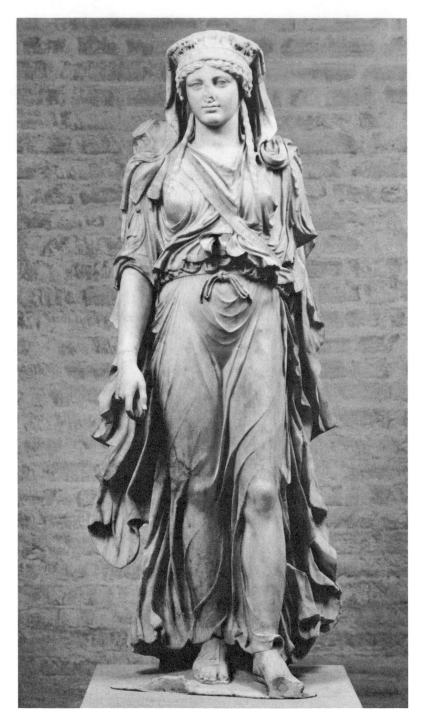

FIGURE 16.
Artemis. Roman, 1st century A.D. Glyptothek, Munich.

Other secondary centers may support the lifting action of the head. In some figures by Gaston Lachaise, large female breasts produce this buoyancy. Michelangelo's *Saint Petronius* in Bologna holds a small fortified town, which adds a strong visual weight to the upper part of the body. Similarly, the head of the Medusa, cantilevered by the arm of Canova's *Perseus* (Fig. 17), helps to lift the figure while at the same time weighing it down with additional gravitational attraction.

These examples show how much more complex is the function of visual weight than what takes place physically. With respect to Canova's marble, the addition of the severed head to the upper part of the body makes the figure physically heavier and increases the downward pressure. Visually, this downward pressure is counteracted by the tendency of the Medusa's head to act as an independent center, rising like a balloon. Therefore in judging the distribution of weight in certain Baroque works—for example, some of Bernini's figures—it is essential not simply to apply the criteria of physical equilibrium and to assume that bulk in the upper part of a work makes it top-heavy.[4] A prancing horse or gesturing figure that would topple if made of flesh and blood may be held aloft in the sculpture by the very components that would weigh it down physically.

A dominant head can be strong enough to lift an entire group of figures. In Michelangelo's *Pietà* in Florence, the spire-like hooded head of Nicodemus rises in counterpoint to the sagging body of the dead Christ (Fig. 18). This theme of opposite forces has, of course, no equivalent in the physical situation; all parts of the block of marble press downward.

On the Artemis, the clothing emphasizes the power of the center in the middle of the body. Any modification of shape or stance, however, may displace the compositional centers or create new ones. In Reg Butler's figure of a girl pulling a shirt off her chest (Fig. 19), the raised arms, amplifying the head area, lift the entire body so convincingly that the sculptor can have his soaring figure perch quite credibly on a slight metal bar rather than a solid base.

The power of eccentric downward attraction is also diminished when the principal mass of the sculpture is clearly detached from the ground, as in the case of a sculpted standing horse. In Marino Marini's horseback rider (Fig. 20), a sunburst of legs, neck, and tail stresses the centric organization around the mass of the body, and the figure of the rider supports this com-

figure with the ground by making the gravitational attraction directly visible. Compared with such loosely closed figures, nudes can look curiously detached, as though they were suspended in empty space.

4. Chamberlain (1977) discusses Bernini's sculpture in relation to physical statics.

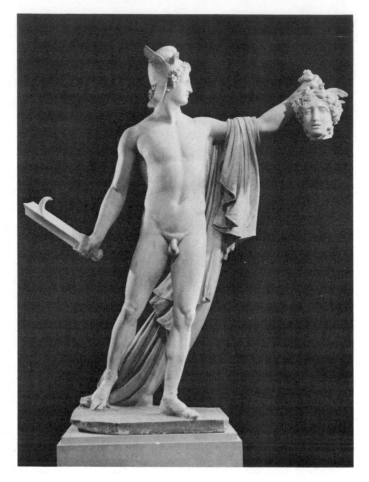

FIGURE 17.
Antonio Canova, Perseus Holding the Head of the Medusa.
1804–1808. Metropolitan Museum of Art, New York.

positional theme by taking off from its seat on the horse, with the torso rising and the legs extending. Freely suspended in midair, the animal's body is a challenge to the tyranny of the ground.

A geometric abstraction can display with particular clarity some of the dynamic forces constituting a sculptural composition. At first approach, the eccentric aspects of Barnett Newman's *Broken Obelisk* (Fig. 21) prevail in the upward direction. From a broad pyramidal basis, which seems to suck energy from the ground and concentrate it in a point, a columnar piece shoots upward into the sky. But this first impression is reversed as soon as

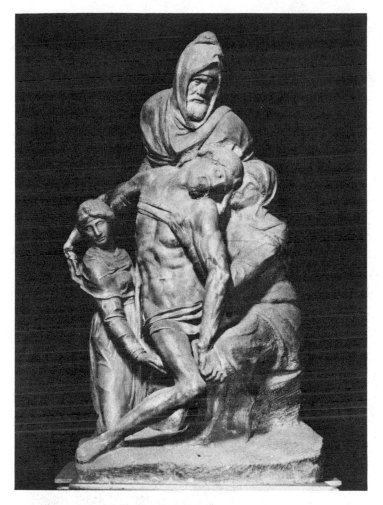

FIGURE 18.
Michelangelo, Pietà. 1550–1553.
Santa Maria del Fiore, Florence. Photo, Alinari.

one notices that the obelisk stands on its head, with its peak pointing downward and its broken end materializing the object from thin air—an acrobatic balancing act that could look precarious if the central vertical, like a sturdy steel spine, did not stabilize the axis. The downward push can also invert the dynamics of the pyramidal base, making it grow from a point above into the broad expanse at the bottom.

The two-way action along the eccentric dimension of the vertical has the upward and downward dynamics compensate each other in a kind of sym-

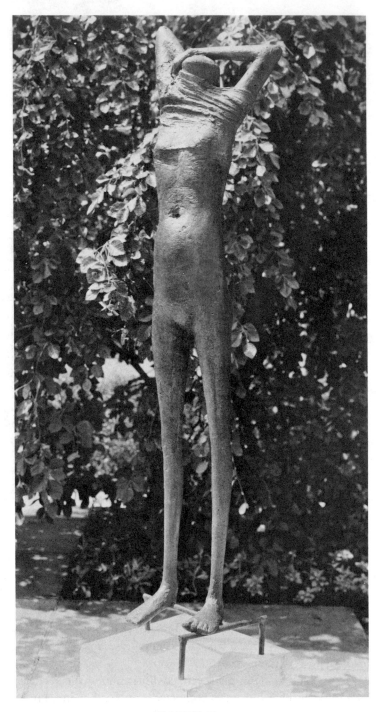

FIGURE 19.
Reg Butler, Girl. 1953–1954.
Museum of Modern Art, New York.

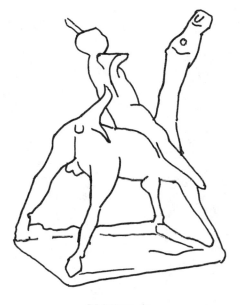

FIGURE 20
(after Marini)

metry—a contribution to the centricity of the composition. The center, so
clearly marked by the point of constriction, is located below the geometric
middle of the twenty-six-foot-high monument and probably also below its
visual balancing center. This displacement causes much of the weight to be
displaced toward the bottom, thereby stressing the downward push of the
inverted obelisk. Nevertheless, the midpoint exerts its centralizing power by
tying the sculpture together at its waist and creating a focus of energy. As
happens so often, the vectors related to this center are pointing in opposite
directions. On the one hand, the peaks of the two volumes, the obelisk and
the pyramid, clash head-on. On the other hand, both volumes end with the
same angle of 53°, so that their edges fuse in a symmetrical sheaf of crossings.
A crossing is not a clash, and the combination of clash and crossing produces
a counterpoint between collision and harmonious continuation.

The energy concentrated in the point-shaped center may remind us of an
arc lamp, whose incandescent electrodes generate a light of glaring intensity.
We may also think of Michelangelo's *Creation of Man* (see Fig. 117), where
the creative spark leaps along the eccentric horizontal and across the center
from the Creator to the creature. In that painting, as well as in Newman's
monument, eccentric action from mass to mass is held together by the pri-
mary center in the middle.

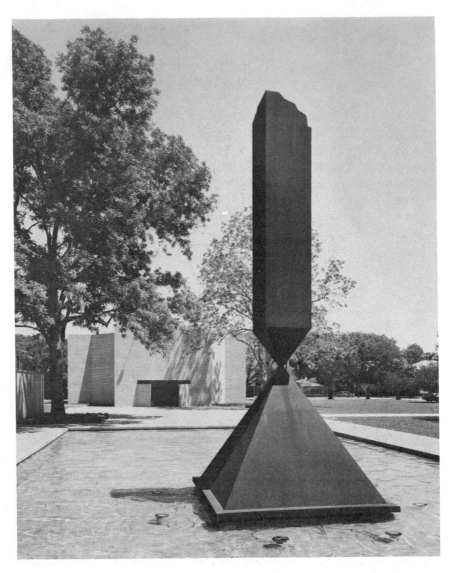

FIGURE 21.
Barnett Newman, The Broken Obelisk. 1968.
Rothko Chapel, Houston.

MATISSE UNDER PRESSURE

Much of the present chapter has been devoted to the relation between works of art and the push and pull toward and from the ground—the principal eccentric power in our terrestrial existence. We noted that physically as well as perceptually the space of our experience is anisotropic, that is, the upward direction differs fundamentally from the downward direction. We also observed that the media of the visual arts are not equally dependent on the outer center in the ground.

A framed picture on the wall enjoys a high degree of independence—for two reasons. First, more often than not, pictures present a perceptual space of their own, separated by the frame from the space that surrounds them. This separation enables the painter to handle the dynamics of pictorial space as he pleases. He can distribute weight in such a way that it presents a visual analogue to the downward pull of gravity. Or he can distribute it so evenly that his composition looks weightlessly suspended. Second, the separation obtained by the frame is enhanced when a painting hangs at some distance above the floor and is correspondingly less affected by the floor's attraction. To be sure, the canvas is in direct contact with the wall, which also acts as a dynamic center. It attracts the canvas from behind, but because this visual magnetism is perpendicular to what goes on within the pictorial surface, it imposes no directional bias. Being a strongly two-dimensional surface, however, the wall does influence pictorial space in the sense of flattening it. It strengthens the frontal plane.

In Henri Matisse's still life *Gourds* (Fig. 22), all five objects stand upright, as distinguished from what their spatial orientation might be if they floated in weightless space. But they conform to the vertical eccentric vector to different degrees. Only the white pitcher on the upper left spells out the vertical direction explicitly. This stability gives it a dominance that is hard for the other objects to match. Next in stability is the covered pan, whose horizontal expansion creates a balanced relation to the vertical vector. The small funnel is at least upright and symmetrical; but on the plate an independent centricity prevails, and the blue gourd at left tilts ostentatiously away from the vertical.

As far as the arrangement as a whole is concerned, the lower part of the canvas is occupied by two large compact objects that acknowledge the anisotropy of space in the vertical dimension. They give the whole composition a solid mooring. If one turns the picture upside down, one realizes that the weight of the two objects would be excessive if they occupied the upper region. It's like a pendulum bob.

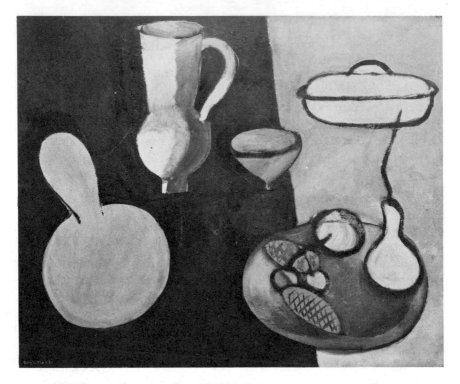

FIGURE 22.
Henri Matisse, Gourds. 1916.
Museum of Modern Art, New York.

Each of the five objects is endowed with properties that make it strive against the gravitational pull: the large blue gourd reaches upward with its neck; the pitcher is dominated by the crescendo of the opening cone and a handle whose center lies high up; the little red funnel has its maximum expansion at the upper rim; the handle of the pan cover makes it seem ready to lift off; and a yellow gourd on the plate points upward like a chimney. Together the five shapes form a chorus of uplift, which strongly influences the mood of the entire performance.

So much for the effect of the most powerful outer center upon Matisse's painting. It is equally true, however, that the painting's distance from the floor and its protective frame isolate it sufficiently to let the five elements of the composition float in space rather freely. Only the fruits and vegetables on the plate rest on a base. The black and blue background of the picture offers no such support. Each of the five objects, of course, is a dynamic center of its own, and together they are organized around the balancing cen-

ter in the middle of the rectangular canvas. The balancing center is not explicitly indicated by the painter—it has no "retinal presence"—but it is perceptually indispensable for establishing the equilibrium of the composition as a whole.

The effects of the five objects upon one another depend on their relative visual weights, and these weights are determined by various factors, such as their size, their flatness or volume, their conformity to the framework of verticality and horizontality, their color and brightness, and so on. These various weight factors also determine the distances between the objects. They are established by the painter with delicate intuition. We understand, for example, that the two lower shapes, because of their heaviness, must keep a greater distance between them than the smaller shapes, whose mutual attraction is weaker and therefore requires less restraint.

Before we consider further the centric and eccentric relations of the dynamic centers within a composition, another outer power must attract our attention.

THE VIEWER AS A CENTER

B Y NOW IT HAS BECOME evident that the visual forces determining the composition of a work of art do not all originate within the work itself. The pull and push from below, we came to realize, derive from an eccentric power whose influence upon composition should always be considered. This eccentric power is experienced in visual perception, but it has a close analogy in the physical force of gravity, which dominates life on earth. The next step of our investigation takes us to a second, equally universal eccentric power— one that cannot claim, however, to have a counterpart in the physical world.

It takes eyes and nervous systems to make the world visible; but in a purely physical sense, we, the carriers of these instruments of perception, are simply one kind of object among others. The physical existence of a work of sculpture does not require that a person be present in its neighborhood, nor do person and work influence each other by their mere coexistence. The sculpture remains the same thing when the person leaves the room, and the person is not modified by standing next to a piece of carved wood. Nor is the layout of an architectural space influenced by the visitors passing through it. But that is a description of the world without the mind.

SELF-CENTERED VISION

Perceptually a person is a viewer, who sees himself at the center of the world surrounding him. As he moves, the center of the world stays with him. Considering himself the primary center, he sees the world populated with secondary objects, eccentric to him. Looking at a sculpture means sending out a vector toward that object: seeing is a manipulation of the object on the part of the viewer. But here again the dynamics of any center operates reciprocally, in both outer-directed and inner-directed ways. The work of art sends out its own vectors, attracting and affecting the viewer. In fact, the

eccentric to him merely means outside of him.

36

power of the work can become so strong that it is no longer simply an ec-
centric target. It takes over as the primary center, seemingly governing its
own structure, independent of the viewer, who has become immersed in the
object, oblivious of his own outer existence.

Before examining this relationship further, however, let me say a bit more
about the two-way dynamics in the primary experience of central vision. The
personal center of the perceptual world is normally experienced as being
between the eyes or the ears. When I look at the open landscape before me,
my self reaches out to the horizon, which separates the lake from the sky.
Turning around, I see at shorter distance the woods and the house and, even
more close by, the ground beneath my feet. All these sights are experienced
as being seen from the locus of my self, and they group themselves around
it in all directions. Looking around more sensitively in such an environment,
I notice that my spatial relationship to the various objects is not adequately
described by distances and locations. Rather, the relation is dynamic. As I
sit in my study, for example, my glance runs into the bookshelf and is
blocked from further progress in that direction. The bookshelf responds to
my approach by a counteraction: it advances toward me. But as my eyes rest
on it, I can also make it display the opposite tendency, namely that of yield-
ing to my approach by moving, somewhat heavily because of its great visual
weight, away from me, thus joining the direction of my glance. Every visible
object exhibits this twofold dynamic tendency in relation to the viewer's self:
it approaches and recedes. The ratio between the two tendencies varies.
Some objects more readily approach, others more readily recede. Although
physically objects may stand still at a distance that can be measured with a
yardstick, perceptually that standstill corresponds to a delicate balance be-
tween approach and withdrawal.

VARIOUS POSITIONS IN SPACE

What comes first in the interaction between viewer and work of art is their
very relation in space and its effect on both of them. An artwork can make
its appearance anywhere in the spherical space surrounding the viewer. It
can face him at his own level in an either upright or recumbent position; it
can be on the ceiling or on the floor. Spatial orientation influences the way
the object is perceived, as we noted already in the simple comparison of the
cross shape in two positions (see Fig. 11), and it also influences the com-
position itself as conceived by the artist.

Elsewhere I have suggested that the vertical dimension serves as the pre-
eminent domain for visual contemplation, whereas the horizontal is the

realm of activity.[1] Upright things, be they paintings on the wall or people standing before us, are seen head-on, which means they are seen well. They present themselves without distortion and from a comfortable distance. This permits us to scan the object as a whole, and since the visual vector issuing from the viewer can hit the viewed object at a right angle, it does not have to get entangled with the vectorial configuration within the plane of the composition itself. Although we can step forward and reach the object, we experience it as possessing its own space and occupying a vertical region of its own. The relation is one of pure exploration across a gap of space.

Upright works, we noted, tend to reserve a significant role for the eccentric vertical. This distinguishes them from typical ceiling or floor decorations, whose surfaces are perpendicular to the gravitational force and therefore tend to be organized in a centric manner.

Two exceptions to this rule should be mentioned here. As the viewer raises his head toward the flat or vaulted ceiling, he is aware of the room's spatial framework. Looking upward, he expects to see in the picture what one might see in the physical world, perhaps a cupola or the open sky populated with clouds and angels. In the more limited sense, however, of the visual field received by the eyes, the horizontal ceiling also possesses a subjective up and down. It makes no difference, after all, what our spatial orientation is while we look at a picture as long as our line of sight meets that picture perpendicularly. Profiting from this perceptual ambiguity, the so-called *quadro riportato* is a picture painted on the surface of a ceiling exactly the way it would be on a vertical wall. The scene portrayed in such a painting presupposes a viewer looking at it along a horizontal line of sight, however aware he might be that he is looking upward. Michelangelo's paintings on the ceiling of the Sistine Chapel are such *quadri riportati* (see Fig. 117).

Wolfgang Schöne has pointed out that viewers feel a strong urge to remedy this awkward contradiction by looking at ceiling paintings obliquely rather than from directly underneath.[2] In fact, Schöne maintains that the most effective ceiling decorations have been designed for oblique inspection. This is particularly true of paintings that purport to continue the architectural structure by depicting a heavenly scene as it might appear through the open roof. In such representations Schöne notes a contradiction between the pictorial treatment of the architecture and the human figures populating it. Andrea Pozzo's famous vault in San Ignazio in Rome, for example, presents the architecture as it would appear from a viewing station directly beneath

1. Arnheim (1977a, p. 54).
2. In addition to the paper by Schöne (1961) see Sjöström on quadratura (1978).

the center of the painting, whereas the figures are depicted as they would look at some distance from that center.

There are several advantages to such a solution. Viewed from directly underneath, a human figure looks absurdly foreshortened, whereas a less acute viewing angle lessens the distortion and the figure approaches its normal appearance. Moreover, the plumbline view from directly beneath the center has two perceptual consequences that are not necessarily welcome. First, any undistorted projection of the depicted scene's overall symmetry would underplay spatial depth. It would shorten the perceptual distance between viewer and ceiling and interfere with the illusion of a heavenly vista. At the same time, it would anchor the viewer to the space underneath, which is desirable only under special circumstances—namely, when movement is intended to come to a stop, for example, in a rotunda vaulted by a cupola. When, however, the decorated ceiling is applied to a space designed as a link in the visitor's progression through the building, the ceilings of a Pozzo or Cortona let the viewer look forward to what he is approaching, reach a climactic stasis, and move beyond it on the horizontal plane of activity. vs.

This brings to mind the second exception to the rule that horizontally oriented paintings tend to be centrically composed. Many buildings are extended in length, for example, the basilica type of church, which leads the visitor from the entrance all the way to the altar. Correspondingly the decorations of ceiling and floor often incorporate an additional eccentric vector, pointing in a horizontal direction. On the floor, in particular, this horizontal vector is reinforced by the walking visitors. Directed activity complements and sometimes overrules the inherent centricity of the composition.

Let me add here a remark on the difference between looking at the ceiling and looking at the floor. A ceiling decoration is seen from a distance and therefore in its entirety and without impediment. At a relatively narrow angle of vision a viewer can survey the fresco of a Baroque ceiling, together with its accompanying circle of related scenes. The floor, in contrast, is the base of much human action, so that, when used for visual decoration, it has to serve two conflicting functions. Our feet get in the way of our eyes. Would it not be awkward to traverse the floor of a Pompeian villa across a large mosaic representing the battle between Alexander and Darius? There is a disturbing contradiction between the verticality of the viewer and that of the figures represented in the floor. In addition, the close physical relation discourages detached contemplation. The situation is uncomfortable in a purely optical sense. The eyes of us bipeds are meant to look forward, to scan the environment in search of whatever shows up vertically as friend or foe. For

the vertical plane of contemplation?

the eyes to look down, the head or body has to bend, and even then the object underfoot cannot be viewed perpendicularly. It will be seen at an angle and therefore distorted, and that angle changes continuously as the person, engaged in his business, moves across the floor. The viewer's eyes are too close to encompass and analyze any extended horizontal pattern as a whole. Different portions present themselves in the visual field as the viewer changes position. Only in an aerial photograph can one truly comprehend, for example, the artful geometric pattern that radiates from the statue of Marcus Aurelius across the pavement of Capitol Square in Rome.

A SLAB IN SUSPENSE

The following example will illustrate in some detail the particular interaction between our two compositional systems in a work intended to be seen horizontally. When the city of Cologne rehabilitated its old town hall, badly damaged in the Second World War, the painter Hann Trier was commissioned to create a painted slab to be suspended in the atrium of the building, roughly halfway between floor and ceiling (Fig. 23). Daylight enters the court from above through a gridwork of beams. The shape and color scheme of Trier's work are derived from the escutcheon of the city of Cologne, which shows in its upper band three golden crowns on a red ground and in its lower part eleven stylized black flames on white. The traditional coat of arms was designed, of course, for vertical display and is therefore symmetrical around a vertical axis. To adapt this shape to a horizontal position, the painter eliminated the dominance of the gravitational axis together with the symmetry of the heraldic imagery. Instead he fashioned an abstract design of black flames surrounded by golden crowns and distributed it across the surface of a roughly six-pointed star. Central symmetry replaced axial symmetry for another reason as well: the top surface of the slab, viewed from an elevated gallery, received a different design, namely a stylized aerial map of Cologne, looking somewhat like a spiderweb.

A slab of about nine meters in diameter suspended at a height of six to seven meters above the floor makes for a wide visual angle of about 80°. Instead of inviting reposeful contemplation from a fixed station on the floor, it calls for viewers to walk back and forth, constantly shifting their focus of attention. Consequently, the composition is diffuse rather than rigidly centered, a crisscross of eccentric vectors. In paralleling the floor, which is the realm of active locomotion, the pictorial surface of the slab can be said to mirror the comings and goings of the town hall's visitors, who traverse the court in all directions.

FIGURE 23.
Hann Trier, The Cloud (painted baldachin). 1980.
Town Hall, Cologne.

Since the slab is suspended in midair above the visitors' heads, it has to display at once both the solidity of a protective roof and the fluffy translucency of a celestial medium. As the viewer raises his head to look at the floating picture, he feels safely shielded yet released to roam freely through uncharted space. Abstract painting offers surface qualities that can meet such dual requirements.

As viewers look down from the gallery, the visual substance of the slab's upper surface must have a similarly dual character. The familiar map of the hometown must have the solidity of the earth but, suspended above the ground, must also possess an airy intangibility that distinguishes it from the reliable firmness of the atrium floor underneath.

Obviously, special conditions call for special effects. Trier's suspended slab, with a shape of its own, is much more independent of the architectural setting than it would be if it were firmly anchored to ceiling or floor and conformed to the shape of the building. A ceiling painting must either share the physical solidity of the ceiling or override it, as the heavenly visions of some Baroque vaults do. A floor decoration, in turn, should assure the visitor that he can walk across safely.

SEEING THE WORLD SIDEWAYS

There is still another aspect of the spatial relation between viewer and viewed composition that should be explicitly mentioned, because its considerable influence is hardly ever discussed. I said that vision is served best when the line of sight meets its object perpendicularly. Sculpture tends to put its best side forward, and painting spreads its wares on a flat surface and is displayed as closely to eye level as is compatible with its purpose. But what about the compositional structure of the scene depicted in a painting? The Japanese mandala of Figure 7 meets the optimal condition for perception. The centric structure of the scene faces the eye fully and without distortion. The main center is in the middle, the secondary items arranged symmetrically around it. There is a perfect coincidence between the structure represented and the structure seen.

But suppose the same scene were to be shown on a theater stage. Now the plane of display is essentially horizontal, and the viewer is located at a parallel level. The slope of the auditorium and that of the stage remedy the situation somewhat but do not resolve the dilemma. How are we to see a circle of performers if that circle is perspectively squashed? The arrangement promotes the frontal figures at the expense of those behind them, and

in the distortion even the central figure is obstructed from view. The audience sees the stage action sideways. It is almost as though one tried, with eyes at tabletop level, to read a book. The cause of the trouble is, of course, that when the performance takes place in the physical world, it shares physical space with the viewers. Up and down for them is up and down for it.

Since the horizontal plane is the realm of activity, it suits the theater as a place of ongoing action but interferes with it as an object of contemplation. The situation predisposes the viewer to active participation in what he sees rather than to detached observation. As we know, the stage developed from precisely such a social situation, with performers and participants integrated in a common event. The later separation of the stage from the audience created a spatial dilemma that cannot be truly resolved. The viewer—the dynamic center for whom the show is intended—sees it either from one side and therefore as compressed and encumbered or from above and therefore unnaturally. In practice, the director of a show must rush back and forth between stage and audience, trying to solve the twofold task of organizing the stage action according to its own logic and creating at the same time a readable perspective for the audience. But the conflict created by the imposition of an eccentric projection is basically unresolvable.

The problem does not arise in painting as long as it limits its display sufficiently to the frontal plane. The Byzantine mosaic of Figure 8 is realistic enough to portray space with its gravitational up and down; but there is hardly any depth, that is, the horizontal floor of the stage is absent. Nothing is distorted; nothing essential is hidden.

The situation changes, however, as soon as painting invades the depth dimension, as took place in Western painting during the Renaissance. I shall show in Chapter IX that this extension splits pictorial space into two interacting compositional structures: the frontal projection, which is the visually more direct and natural one but which tends to compress the represented scene into flatness, and the structure expanding in the depth dimension, which presents the scene objectively but can be perceived only indirectly through a kind of angular transposition.

The difficulty is caused by the disconcerting fact that we look at our world sideways. Instead of facing it as detached viewers, we are in it and of it, and we therefore see it partially and from a private perspective. Our view interprets but also misinterprets our position in the world, a dilemma resulting from the ambiguous function of the human mind. In a typically and perhaps exclusively human way we participate actively in our world while at the same time trying to view it with the noninvolvement of an observer.

THE VIEWER AS AN INFLUENCE

So far I have discussed the interaction between viewer and viewed work of art purely in terms of their relative positions in space. The two affect each other, however, more tangibly; and once again the dynamic action works both ways: the vectors operate centrifugally away from their center and centripetally toward their center. Of course, any work of art is a perceptual object and, as such, exists only in the consciousness of the viewer. Its properties are aspects of the viewer's percepts. Even so, it is useful among these properties to distinguish those that are contributed by the work's inherent pattern from those effected by the viewer's own behavior.

A work of art is an image whose center is charged with visual energy emanating out to the viewer. This is most evident in certain aspects of the subject matter, which attract the attention of the viewer and reward him by paying attention to him. Eye contact, especially, makes the viewer feel that he is being looked at by a person or animal fashioned by the artist. In a painting, an open door or window or a road leading into a landscape invite the viewer to enter. In the more formal sense of composition, the visual organization imposes itself upon the viewer. The various centers of the work claim to be seen in their hierarchical order. To neglect these compositional claims is to miss the message of the work.

The vectors moving in the opposite direction, from the viewer toward the work, are equally evident. Some of them are in the nature of purely optical requests. Certain conditions have to be met by the work to make it visually reachable. Because light moves only in straight lines, an object such as a picture cannot be seen in its entirety unless the light issuing from all its parts reaches the eye at the same time—the flat plane of the pictorial canvas is the most notable acknowledgment of this fact. Toward the end of the last century this requirement to serve the comfort of our eyesight was felt so strongly that some theorists and artists demanded that even sculpture conform to a plane frontal surface. In his influential book *The Problem of Form in Visual Art* (1893), Adolf von Hildebrand suggested that the sculptor should conceive of a figure as arranged between two parallel glass panels in such a way that its outer points touch them; and he proclaimed, "As long as a sculptural figure presents itself primarily as a volume [*ein Kubisches*], it is still in an early phase of its formal creation; only when it gives the effect of a surface, although it has volume, does it acquire artistic form, that is, it becomes relevant to visual conception."

When the rule is worded in such extreme terms, it denies the very nature of sculptural roundness. It is true, however, that much sculpture throughout

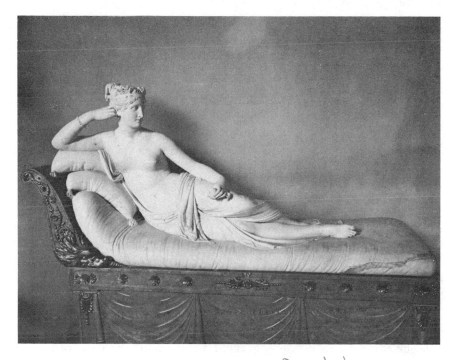

FIGURE 24. Sexy lady
Antonio Canova, Paolina Borghese. 1805.
Galleria Borghese, Rome.

the ages has acknowledged its dependence upon the viewer. The frontal ex-
posure of Canova's *Paolina Borghese* (Fig. 24) can be explained only partially
in terms of what the representation of the human figure requires within it-
self: the hierarchy of views culminates in the bent symmetry of the frontal
surface. Even so, the somewhat coerced attitude of the figure is fully justified
solely by reference to the viewer, for whom the figure is displayed in a single,
synoptic image.

In examples such as these, the composition of a work cannot be fully
understood unless the presence of the viewer is acknowledged. In the next
chapter, however, I shall argue that this dependence on the viewer does not
make him a part of the composition. The person assumed to be looking at
Paolina is not a part of her portrait but merely affects the portrait with an
element of passivity. Even so, examples should be mentioned here in which
space and function are reserved for external participants within a work itself.
In such cases the composition cannot be understood unless that reserved
space is filled potentially or actually with the human actors.

Practical objects such as chairs or scissors are the most obvious illustrations. A chair is indeed incomplete without the body of the person intended to sit in it. In addition to the "retinal presence" of the chair, there is the induced presence of the sitter, who adds an important visual countercenter to the composition. Similarly, the metal loops of the scissors call for the fingers of the user as an integral part of the situation. The designer has the difficult task of inventing a form that makes the object look balanced and complete by itself and at the same time capable of being integrated in the larger whole, which includes the user, his body, and his limbs. No such specific role exists for the viewer of a painting, although there is the medium's general need to be looked at.

Architecture offers examples similar to the chair and the scissors. Neither a portal nor a bridge nor a public square is complete without its users. It is true, however, that architectural shapes are less directly determined by contact with human bodies than chairs and scissors. Accordingly, they function more independently as artistic statements in their own right. Frank Lloyd Wright's Guggenheim Museum may be said to need the stream of visitors moving down its spiral, but even as an empty shell it has a complete beauty of its own.

Sculpture alone seems neither to admit nor require the active presence of the visitor. Granted that a congenial setting such as a sanctuary or the Lincoln Memorial in Washington, D.C., can define a statue as poised to receive the worshippers, but without that help the sculpture seems to repose in its own being. Even the great Buddha of Kamakura is immersed in his meditation, incapable of admitting any interlocutor. This is all the more true for works that have been deprived of their public function, or never possessed one. Michelangelo's *David*, removed to the rotunda of a museum, no longer calls the citizens of Florence to resist tyranny, and he is unaware of their calling on him.

Let me return to the influence of the viewer on the perceived composition of works of art. The example of Sekine's relief (frontispiece) demonstrated that when the principal center of a work is placed at the eye level of the viewer, its role is more likely to be appropriately acknowledged. At the same time, the given optical conditions do not simply coerce the viewer to do the bidding of the work. He can resist the demands of its formal structure and decide perversely, for example, in the case of Sekine's relief, to focus his glance on the stone hanging down from the middle. A midget standing before the relief might be induced to do so. Since the viewer as a dynamic center confers additional visual weight and importance upon any place on which he concentrates his attention, he can try to make the stone the primary center and see it as pulling from an eccentric position at the more powerful

center in the middle, to dislodge its privileged place. In this way, a secondary feature of the composition can be misinterpreted as being the principal one.

We also observed, for example, that as long as a visual object is seen as dependent on the attraction of a primary center, its weight will increase with its increasing distance from that center. If, instead, the viewer focuses his attention on that visual object, it will look increasingly independent of attraction from the outer center and possessed only by its own inherent weight as it moves away.

Although the eyes of the viewer are fairly free to scan a work of art in a way that confirms or disturbs the composition's intrinsic structure, the mechanism of vision itself does not operate entirely without constraints. Scanning in the horizontal direction occurs somewhat more readily than *Yes* scanning up and down. Also there is a tendency, largely unrelated to actual eye movements, for viewers to perceive pictures as organized from left to right, so that the lower-left corner appears to be the composition's point of departure. *If they habitually read from left to right.*

This latter approach, imposed by the viewer upon the picture, is obviously related to what is perceived as the asymmetry of the visual field, by which the left and the right sides appear to be of different weight. The left side is *visual* endowed with special weight; it assumes the function of a strong center with *weight* which the viewer tends to identify. It provides a station point from which he surveys the rest of the composition, even though he is facing the middle of the canvas. The left side is also a hub, where more weight can be tolerated— just as physical weight placed on a pair of scales registers less the closer it is to the center. This perceptual asymmetry is likely to have a physiological *You think* cause related to the different functions of the cerebral hemispheres of the *so? Or* brain. The right hemisphere normally favors perceptual organization, and *maybe it* since by the optical action of the eye lenses the information from the left side *has to do* is projected onto the right brain, the left side of the visual field is likely to *with left* be favored, to be perceived as more weighty, more important, more "cen- *and right handedness.* tral" in some respects.[3]

Very Barycentric. Weight is determined in relationship to a frame,... even if the frame

LOOKING INTO DEPTH *is only the boundary of*

When artwork occupies the third spatial dimension either physically or *the object.* only perceptually, the viewer exerts influences that need to be mentioned here. To suggest the depth dimension of, say, a landscape, a painting has to

3. One cannot help feeling alarmed by the presence of still another compositional center, this one imposed asymmetrically upon the image area. It does not coincide with the balancing center of the area nor need it determine any of the centers introduced by the artist's composition. Even so, the interaction of the various centers should be welcomed as a complexity worthy of that of the human brain, by which and for which art is produced.

21 Oct 2002

overcome the material flatness of the canvas. If nevertheless the depth effect of pictures can be quite compelling, this results in part from the dynamism of the observer's glance. As the vector of the glance strikes the picture plane perpendicularly, it strives to continue in the same direction and in doing so pierces the depth dimension. The glance provides the pictorial composition with an additional axis, which reinforces any depth-directed vector offered by the composition itself, for example, by central perspective. This means that merely by looking at a picture, the viewer gives it more depth than the structure of the work itself contributes. *This is perfectly wild.*

boink!

His viewer is definitely sending out rays from the eyes.

Although this visual penetration supports the depth effect of the painting in a general way, the particular orthogonal direction of the viewer's glance need not be in accord with the spatial layout of the artwork. To be sure, when the main axis of a picture coincides with the viewer's line of sight, as is the case, for example, in Dieric Bouts's *Last Supper* (see Fig. 134) there is a smooth two-way traffic between viewer and picture. The viewer's glance slides unhampered into the pictorial space, and conversely the depicted space reaches out from inside the frame and involves the viewer in its continuity. In other instances, however, the axis of pictorial space runs obliquely. In traditional Japanese painting, for example (see Fig. 128), the encounter occurs at an oblique angle not only along the ground plane but also from above.

The lover's cock slides unhampered into the vaginal space. Uh huh.

Oblique vistas represent a higher level of complexity than orthogonal ones. They create a structural disagreement between the two dynamic centers, the world of the viewer and the world depicted. Such an encounter can be perceived in two ways. If the spatial framework of the image prevails, the viewer perceives himself as being at odds with the situation he faces. This is typically the case in architecture when a viewer standing, say, in a rectangular room faces in the direction indicated by a solid arrow in Figure 25a. The discord creates a tension, which is alleviated if the visitor changes his position to conform with one of the two structural axes of the room. But in principle it is also possible that someone in an extremely self-centered frame of mind would insist that his own orientation is the central axis of the situation, so that the room would look out of step, as indicated in Figure 25b.

When such a situation arises during an encounter with a picture, the viewer can try to look at the picture obliquely, but by doing so he distorts his image of the composition. Instead, the conflict should be accepted as a valuable aspect of the artistic statement. What do we see when we look at one of Degas's ballet studios extending obliquely through the picture? Most commonly such a view is interpreted as a manifestation of subjectivism: the artist shows what the world looks like from the particular point of view of a

And conversely the vagina reaches out to engulf the cock. Strong image.

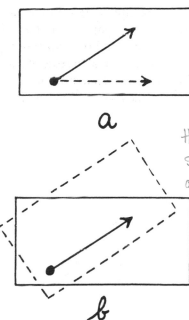

a

b

FIGURE 25

Vector mechanics, anyone? 20 Oct 2002

So we have a two frame theory, the viewer's frame superimposed on the frame of the object/space and vice versa. But why must the frame be rectangular? And why must it have definite edges?

Cubism breaks up the one big frame into many →

particular individual. The center of the frame of reference is in the viewer. But it is also possible to defend the opposite position. Wolfgang Kemp, in an essay on perspective in photography, has asserted that "the apparently subjective segment of reality can also be interpreted as the triumph of nature over man's formative intention. The omnipotence of the authoritative artist seems to have gone. The restriction of the visual angle, which suggests the continuance of reality outside the picture, replaces the artful limitation and construction of the objects for the purpose of the image. Such pictures presuppose the existence of a reality that does not need to be built and organized but simply exists and therefore can be depicted." Viewed in this fashion, the oblique vista points to the autonomy of the outer world, to whose framework the approaching visitor must adapt. Either way, in comparison with the easy access to orthogonal space, an estrangement is diagnosed by the artist. Entering the world poses a problem. *autonomy again*

In a general way, these examples will have made it clear that the interaction of dynamic centers constituting visual composition is not limited to the vectors generated by the work itself. The viewer participates in this interaction as a powerful center among centers by his way of apprehending things.

Needless to say, when it comes to the full human experience of a particular

interpenetrating small frames of various angles.

person perceiving a work of art, the range of what is offered by the work goes much beyond mere formal composition. This full message of the work is met by the equally rich individuality of attitudes, memories, and desires that amplify the responses of any real person. A more complete discussion of the interrelation between the viewer and the artwork would have to deal with this broader aspect of the matter—but this is beyond the scope of the present study.

LIMITS AND FRAMES

There's a theorem here

landmarks and enclosures

T HERE ARE TWO main ways of orienting oneself in limitless space. To
name them, we can use the terms introduced by the architect Kevin
Lynch. The most elementary way is what Lynch calls the establishment of
a landmark, a center to which other places in the environment can be related.
Somewhat more sophisticated is the definition of a place by an enclosure;
Lynch calls this a district. Thus, a world can be made up essentially either
of centers and the network of the relations between them or of confined areas
subdividing the available space. For our compositional purpose we shall have
to refer to both.

I see no good reason why an enclosure is "more sophisticated" than a "land mark". Quite the opposite in fact

ENCLOSURES SPREAD ENERGY

The two devices are, first of all, instruments of order or orientation. They
serve to indicate what places exist, where they are, and how they relate to
one another. More importantly, we need to consider them as bases for dy-
namic action. Dynamically, a tower standing in an empty field or a ceramic
vase on a table are centers of visual energy sending out vectors in all direc-
tions and thereby surrounding themselves with a tension-loaded field that
spreads and gradually peters out in empty space. Such a centric setup is what
the physicist would call an open system.

An enclosure, taken as a whole, behaves just like such a centric system.
Like the tower or the vase, it spreads energy through its environment. But
the borders of an enclosure—the walls of a tower or vase, after all, are also
enclosures—are centers of energy in their own right. To be sure, the edge
of a frame is linear; but centers of energy can assume any shape. Every one
of the edges that make up an enclosure is, in our terms, a combination of
centricity and eccentric extension. It generates tension-loaded fields that
reach into the outer and the inner neighborhood, and these fields diminish

very malleable centers, these!

His theory is a theory of tensional fields & simple.

51

How can a center if it is a point have any shape?

← o →

This is perfectly wild! *electro magnetic ?.?*

in strength with increasing distance. Together, the edges create by induction a center in the middle of the enclosure. This center becomes a focus of energy of its own and organizes the space within the enclosure. The enclosure is a closed system, which, taken as a whole, behaves as one center of energy.

Since every visual object, be it a patch of paint or a building, is a centric system from which a vectorial field spreads into the surroundings, sufficient space is needed to give this energy as much free play as seems desirable. When a building is hemmed in by other architecture, the building's design is compromised by a lack of breathing space.[1] The same is true for any spacing of objects, for example, for the arrangement of paintings on a wall. Sculpture also can be badly obstructed when its field of action is encumbered.

TAMPERING WITH THE RANGE

Similarly, as we shall see, a composition will be enlarged, modified, or distorted by other objects seen in relation to it. This creates a curious problem when such external objects are not physically present but only inferred from a work's subject matter. A telling example is Michelangelo's marble figure *Moses* (Fig. 26), a powerful center of energy. The deflection of the head from the frontal symmetry of the figure and the fierce concentration of his glance introduce an oblique vector that moves outward like the beam of a lighthouse. If a viewer wishes to account for the target of the lawgiver's

Argh! wrath, he might refer to the crowd of Israelites worshipping the golden calf. But even if Michelangelo had this biblical episode in mind, it would be a mistake for the viewer to try to "complete" the composition by supplying the "missing" distant crowd in his imagination. Such an attempt at completion would fatally distort the sculptural meaning by making the figure of Moses one of two competing centers of composition balancing around a third center located somewhere on the floor of the church of San Pietro in Vincoli. The figure would now have an inner and an outer side—one facing the scene on Moses' left, the other facing away from it. Such a view would interfere with the frontal, essentially symmetrical character of the figure, which is intended to dominate the work. This frontality is merely modified by the turn of the head. If instead Moses' line of sight is made the dominant eccentric axis of the figure, the composition becomes unreadable. *readability?*

The sculpture is a center of outward-directed vectors and perhaps also of some inward-directed ones, and the viewer may have appropriate reasons to

1. For architectural spaces, see Arnheim (1977a, p. 28).

FIGURE 26.
Michelangelo, Moses. 1514–1516. San Pietro in Vincoli, Rome.
Photo, Alinari.

FIGURE 27
(after Velásquez)

relate these vectors to external targets or sources. But in no way can the external centers be incorporated as parts of the work itself without a fatal overthrow of the composition, that is, of the meaning of the work. No outside goal is included in the work. The beam of the glance is a vector that evaporates with increasing distance from the center, and the compositional arrow it creates has to be balanced within the dynamics of the figure itself.

Another such misguided reference to the viewer's imagination is found in the numerous attempts to determine the "real" location of the royal couple in Velázquez's painting *Las Meninas* (Fig. 27). Here the misinterpretation derives from the inexcusable assumption that what we are looking at is a

Ah, c'mon! Are you kidding?

room of the royal palace in the Alcázar rather than a painting by Velázquez. If we were looking at the actual scene, it would be appropriate to ask where to find the hidden royal couple, whose small mirror image appears on the back wall. More than one commentator has asserted that the painter is looking at the king and queen while they are standing outside in physical space near the viewer. Others have tried to show that the mirror image reflects a portrait on which the painter is working. These busy studies have served mostly to distract viewers from their duty to take the scene exactly as the artist has rendered it. *duty?*

Since the great painter relegated their majesties to a small reflection in the back of the picture, who are we to give them a full-bodied presence elsewhere? In a painting, what we see is what matters. To ignore the conspicuous fact that the principal figure of the artist's statement is he himself at work, presenting himself to the viewer and turning his back to the king and queen, is to ignore the structure and meaning of the composition. Here again, as in the case of *Moses*, the introduction of an additional center, be it in the space outside the picture or on the easel within it, would totally destroy the intended composition and its meaning. *No, it presents a nice puzzle.*

The problem I have discussed here arises whenever a sculpted or painted figure establishes eye contact with the viewer. Be it the spellbinding glance of a religious icon or a Renaissance figure flirting with the viewer and inviting him to join the scene, the vectorial connection targets the viewer but does not make him a member of the action, as long as the image is to be understood as a composed work of art rather than a piece of nature.[2] *Oh really?*

We are who ever we choose to be.

THE FUNCTIONS OF FRAMES

Sculptures and buildings are quite content to share physical space with the rest of the world as long as they are given enough "elbowroom" to play out their own dynamics. Why then are pictures, more often than not, surrounded by frames, which fence them off from their environment? One reason is that the perceived character of visual things is strongly determined by what surrounds them, so that as long as these surroundings are not defined, any particular thing will be subject to an uncontrollable number of meanings, depending on the relations to other centers. A bird confined to its nest is not the same thing as the bird with its nest in a tree; and by the time the tree becomes part of a landscape, characters and functions and visual weights change again. A small landscape, extirpated from the background of a paint-

visual weight density intensity

2. Compare here, for example, Brunius's defense of contextualism (1959); see also Volk (1978). For eye contact in art, see Neumeyer (1964).

Whoops!

FIGURE 28

ing and enlarged as a picture in its own right, can become unrecognizable. This means that the character of an object can be defined only in relation to the context in which it is considered. Therefore, if things are to be shown in context, as is almost always the case in pictures, the space around them has to be delimited by a border.

The frame defines the picture as a closed entity, a center that exerts its dynamic effects upon its surroundings as well as upon its own inside field. Its function as an enclosure is most uncompromisingly expressed when its shape is circular. Roundness, as will be discussed in the next chapter, devotes the frame most exclusively to the inside and, by the same token, separates the work most thoroughly from the outside. More frequent, however, is a concession to the gravitational coordinates of the outside world: the frame acknowledges the difference between vertical and horizontal by taking the shape of a rectangle or square and thereby runs parallel to the edges of architectural interiors.

Centric symmetry is still partially preserved as long as the four sides of the frame receive equal treatment. The top border presses downward toward the center, the bottom border presses correspondingly upward, and the two lateral borders press inward; and, as always in centric systems, there is also a centrifugal expansion in all four directions.

Even this ambiguity is reduced when the frame is treated gravitationally as a kind of post-and-lintel construction, in which the top extends across and reposes on the two sides. It is a view that is made explicit more often in the frames of windows and doors than in those of pictures, because the former are more directly committed to the surrounding building than are the latter. The top may be emphasized by an arch or cornice, the sides stress their verticality by colonnettes, and the bottom becomes a base or sill (Fig. 28). Best suited for an upright format, such a window or door is symmetrical in

relation to a vertical axis and underplays the balance around the center point. If applied to paintings, this design suggests a strong vertical dominance. Compositionally we are dealing here with frames in which the eccentric vector of gravity strongly overlays the centricity of the pictorial object itself.

There is a second reason for the framing of pictures: a frame separates an image from its surroundings to indicate that it is a world of its own. Indeed, *more likely* the picture is meant in most cases to be a detached representation of the world rather than a part of it. This bracketing of the image, however, is a fairly late and sophisticated development. Originally images are simply added to the world as embellishments or comments, the way graffiti are scribbled on a wall. Typically such additions cannot be said to be composed; they obey no centricity other than their own. An animal painted on the wall of a prehistoric cave is essentially unrelated to what occupies the space around it, although in a purely visual sense the paleolithic artist may display some sensitivity to the distribution of shapes on a surface. In spite of all the crossings and overlappings, the artist seems to focus on the single animal, devoid of context. But as soon as art undertakes to show man in his world, it must show him in space; and to show him in space, a definite delimitation is almost indispensable. *to show space one must de-limit & differentiate it*

Even murals generally need clearly defined borders. This does not mean they are independent of their surroundings. On the contrary, murals conceived and made for a particular place in a building cannot be seen correctly in isolation. For example, the long mosaic friezes on the walls of the nave in Sant' Apollinare Nuovo in Ravenna showing processions of virgins and martyrs must be seen as complements facing each other and directed toward the altar of the church. They are really elements of a larger and comprehensive work of art, namely, the interior of the building as a whole.

Only when a work occupies a central position in its larger spatial context can it be truly self-sufficient and at the same time an integral component of the whole setting. Leonardo's *Last Supper* (Fig. 29) is an entirely complete composition. On the head wall of the elongated refectory at the cloister of Santa Maria delle Grazie, the mural acts as the crowning center of the interior's structure; but one is equally justified in calling the room a mere amplification of the painting. Centric composition remains essentially the same when it is looked at in isolation. The same cannot be said, for instance, about Picasso's painting *Guernica* (see Fig. 91), because the main axis of the space for which this painting was designed runs parallel to its principal eccentric axis. Visitors entering the Spanish pavilion at the 1937 World's Fair in Paris walked along the painting, thereby strengthening the lateral movement from the right toward the figure of the bull on the left. This means that the balance

FIGURE 29
(after Leonardo)

between the centric and the eccentric vectors of the composition in situ was different from what is seen when the painting is viewed head-on and in unrelated space.

Around the fifteenth century the organic connection between artworks and their surroundings began to be loosened in Western art. It is especially true for paintings that the artist's work turned into an ambulant object, made for nobody in particular and at home anywhere. When artists began to produce their religious images, their landscapes, and genre scenes for what we would call the art market—that is, for a whole class of consumers rather than for a particular patron—the pictures had to become portable. A frame provided the necessary detachment physically and psychologically.

Portable space, a curious notion.

FRAMED SPACE NOT QUITE CLOSED

A principal function of defined space is that it creates its own center. The combined action of the vectors issuing from the linear enclosure in an inward direction results in the establishment of the balancing center, which coincides more or less with the geometric center of, say, a rectangle or circular tondo. E. H. Gombrich has written: "The frame, or the border, delimits the field of force, with its gradients of meaning increasing toward the center. So strong is this feeling of an organizing pull that we take it for granted that the elements of the pattern are all oriented toward their common center. In other

words, the field of force creates its own gravitational field."[3] This center is indispensable because, whether or not it is explicitly marked, it serves the entire composition as the hub around which it is organized. Since spatial confinement is an indispensable condition for such an organization, it is necessary here to discuss the curiously twofold character of spatial limits in some styles of painting.

As soon as one draws even the simplest shape on a piece of paper, the empty expanse acquires a distinct spatial function: it becomes the "ground," in front of which lies the drawn shape as "figure." The ground is seen as continuing unbroken behind the figure. A frame also operates as a figure if it is at all substantial and particularly if it protrudes physically, as it does so often in our Western tradition. Accordingly, the pictorial space of a picture does not simply stop at the frame but continues underneath it. This does not matter much as long as the background is bare and does not penetrate the depth dimension beyond the simple distinction of figure and ground. Even the blue foil of a Holbein portrait or the gold ground of a medieval icon exerts no strong spatial effect. But when in a realistic painting of the Renaissance tradition the picture develops into a three-dimensional world reaching far back into space and suggests similar extension on all four sides, a solid frame is needed to serve as a window behind which the world continues. How indispensable the frame is for such a picture can be realized when one looks at the reproduction of a painting printed on white paper. There the painting acts as figure lying on top of the white ground, which creates an awkward visual contradiction at the borders. The picture space is set to continue but instead is cut off by its own contours and thereby defined as a flat surface.

When Poussin's *Nurture of Jupiter* (Fig. 30) is seen under proper conditions, it suffers no such frustration. It appears as continuing beyond its frame in all directions. Even so, the composition is remarkably undisturbed. The heavy tree trunk stands in the center of the scene, not in a nowhere of the wilderness on Mount Ida. The episode of the child being nursed by the goat is clearly in the focus of the action, which thins out with increasing distance from the center. What, then, enables the composition to function in an essentially closed space?

The answer is that although Poussin's scene continues beyond the frame, it does not really do so with the explicit completeness it possesses within the picture. The big tree trunk does not go on to a rounded top of foliage, nor does the landscape extend sideways with more vegetation, rocks, and per-

3. Gombrich (1979, p. 157).

FIGURE 30.
Nicolas Poussin, The Nurture of Jupiter. 1635–1636.
Dulwich Picture Gallery, London.

haps animals. Rather, we are dealing with a typical centric structure petering
out in all directions when the articulating power of the center ceases. The
space extends somewhat beyond the frame, but the objects cannot add any-
thing to what is already given. The composition functions the way our dia-
gram Figure 6 does. It is an open centric system spreading out in all direc-
tions and overlaid by an eccentric grid that is established by the frame and
echoed by vectors throughout the picture.

A background space's power to continue underneath the frame of a paint-
ing is quite weak, simply because plain space possesses hardly any structure
of its own. The strength of a given object's structure determines its ability
to complete itself perceptually when it is presented in a fragmentary state.
In the example of Figure 31, taken from Mondrian, the incompletely shown
square is a gestalt of great coherence. Enough of it is given, and it is sup-
ported by its vertical/horizontal orientation. Under such conditions one sees
a complete but partly covered square, and the compositional weight of its
center is hardly impaired.

Compare this with the disturbing effect of a head lacking its profile, from

FIGURE 31
(after Mondrian)

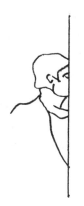

FIGURE 32
(after Toulouse-Lautrec)

a painting by Toulouse-Lautrec (Fig. 32). Here, too, the main weight of the object is well within the compositional space, but the object's structure is unable to make up for the covered section. The effect is that of an amputation in need of being undone, and the viewer's glance is forced to penetrate the covered space in pursuit of the missing part of the face. The painter insists on the incompleteness of the sight offered through the window of his frame by moving some of the compositional weight into the outer space.

Notice here that the effect is so violent not simply because we know that the face is an indispensable part of the head. Knowledge alone would not call for the completion if the roundness of the head did not make the claim on purely formal grounds. If, for example, the frame cut the hand from an arm, the effect might be equally unpleasant, but the call for completion would be much less compelling because a hand has enough integrity as a separate form not to be strictly necessary to the shape of the arm. There are no phantom limbs in visual perception.[4]

4. Brunius (1959) asserts that the perceiver "will reconstruct the fragmentary bodies inside the frame into complete wholes according to the gestalt laws. A part of a horse is reconstructed

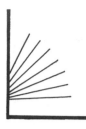

FIGURE 33

When knowledge of what an object ought to look like is all but absent, a purely formal incompleteness may suffice to create an external center of strong compositional weight (Fig. 33). On the other hand, the contribution enabled by the viewer's knowledge of the subject matter cannot be discounted. A seated figure cut below the knees by the frame does not behave entirely as would a mass of similar shape and color in an abstract painting. It is true that in both instances the shape will be seen as continuing beneath the frame, true also that no feet will be provided for the figure. But the visual knowledge that a human figure continues at a known length below the knees is likely to displace the figure's center of gravity within the picture. The center will be lower than it would be for the visible part of the figure alone.

The compositional effect of incomplete visual objects can now be formulated: the balancing of weights within a painting does not depend simply on the purely quantitative extent of the areas displayed within the frame but rather on the weight and location of the centers supplied by the pictorial objects. When the main weight of an object lies within the frame, it matters little that peripheral pieces of it trail off into invisibility. If, however, the given parts of an object point compellingly toward a center outside the frame, that center, although not seen, will participate with its weight and location in the play of the compositional forces.

RECTANGULAR FORMATS

The format and spatial orientation of a frame are determined by the nature of the picture and, in turn, influence the picture's structure. We know already that a circular frame gives the strongest support to the centricity of a composition and accentuates what is going on in the middle. This holds also for more complex centrically symmetrical shapes, such as the quatrefoil

into a whole horse in our experience, etc." This amounts to confusing the spontaneous completion of perceptual shapes demonstrated by gestalt psychologists with the completion of familiar objects on the basis of past experience.

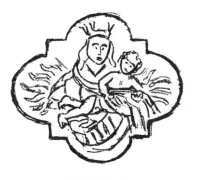

FIGURE 34

frames of certain Gothic or Renaissance reliefs (Fig. 34). A rectangular frame makes the eccentric axes dominate and thereby favors the comings and goings in goal-directed activity. In representational painting, a landscape or crowd scene will normally call for horizontal extension, whereas a full-length portrait or a waterfall calls for verticality. The upright format strengthens the verticality within the picture. It makes the portrayed figure taller and the waterfall narrower and longer. In a landscape of horizontal format, the waterfall would lose some of its intensifying support, but it would also acquire a particular accent through the contrast it offers with the horizontality of the total scene.

The compositional vectors of a picture are likely to influence the way the proportions of its frame are perceived. This influence may account in part for the differences G. Th. Fechner discovered experimentally between people's preferences for certain proportions of rectangles and the proportions artists preferred for their frames. When Fechner presented observers with rectangles of various proportions (cut out of white cardboard and laid on a dark table), he found they tended to prefer ratios approaching that of the golden section, which he represented as 34:21. But upon investigation he discovered that other ratios were used more frequently for the frames of pictures in museums. For upright pictures the favorite ratio was 5:4, for horizontal ones about 4:3. This means that the preferred frames were more compact than the golden section, the upright ones to a greater degree than the horizontal. These preferences may simply reflect the requirements of the compositions. But they may also indicate that when a rectangle is filled with a pattern that stresses certain vectorial tendencies, its proportions look different. Under such conditions the otherwise well-proportioned rectangle of the golden section may look unbalanced. In Figure 35 the 34:21 rectangle is subjected to two different directional stresses.

A similar problem arises for architectural interiors. The walls of a room

FIGURE 35

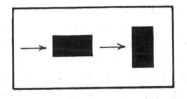

FIGURE 36

Did Palladio design the Palladium?

may be called its frame. If the room is cylindrical—as, for example, the interior hall of a baptistery—its center claims the place of greatest importance. This is true also for square-shaped rooms, where the equality of the eccentric axes supports centricity. A rectangular room will emphasize eccentricity and will have some of the connotations of a passageway. It will make a table look longer or shorter, depending on which way it is placed (Fig. 36). It will also give the table the connotation of either conforming to the flow of action in the room or blocking it as a counteragent. Here again, the content of the room may influence the appearance of the room's proportions. When Palladio designed his rooms according to the simple ratios that correspond to the basic musical harmonies, he based his reasoning on abstract geometric shapes.[5] Such a formula could not include the modifying effect of the patterns structuring ceiling, walls, and floor, or the arrangement of furniture. The position of light sources, the distribution of brightness and color values, as well as the placement of doors and windows will also affect the perceptual appearance of a room's basic proportions.

The ambiguity of rectangular enclosures has been mentioned before. They serve centricity by surrounding the middle, but they also form a grid of eccentric vectors crossing one another at right angles. The longer dimension of a room creates axial rather than central symmetry. This spatial axis

5. Wittkower (1962).

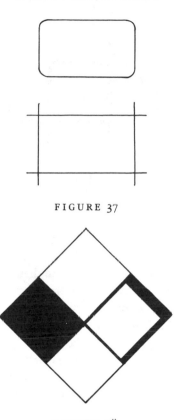

FIGURE 37

FIGURE 38

introduces a time factor by the directed movement it suggests. The unequal function of the walls is stressed. The shorter walls serve as base of departure or as goal, depending on the direction of the room's movement, and the two longer walls form the lateral bed of a channel. The difference between the two conceptions is reflected also in the different function and perceptual character of the corners. In the centric version, the corners are merely breaks in what is essentially a unitary wall, enclosing the room almost like a cylinder. This view of the corners is made explicit when they are actually rounded off (Fig. 37). In the axial version, the corners are the crossings of vectors, each proceeding in its own direction.

The rectangularity of frames is demanded and supported by the gravitational coordinates of terrestrial space. In a habitation floating in outer space no such preference would make sense. On earth, the pull of gravity determines the way we hang pictures perpendicularly. The verticals and horizontals of the frame supply the basic "framework" for the spatial orientation of the various eccentric vectors within the composition. A tilt is visually defined

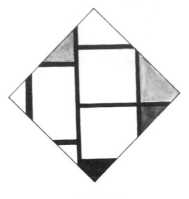

FIGURE 39
(after Mondrian)

as a deviation from that framework, just as in diatonic music the tones of a
melody owe their dynamics to their deviations from the keynote. When this
base is missing—for example, when a painting of Mondrian is turned 45°
(Fig. 38)—stability is weakened. At times Mondrian did use the diamond
orientation of the frame (Fig. 39, and see Fig. 31); but he then shifted the
gravitational coordinates to the inside. The composition creates an internal
skeleton for the deviations perpetrated by the frame. Like the body of a
vertebrate, the picture is supported by an armature.

CHALLENGES TO THE MIDDLE

The frame is the foundation on which a painting's composition is built. It
determines the content and the limits of the work. Taken by itself, the empty
frame establishes its own center simply through the dynamic interaction of
its four sides—a center based on visual equilibrium but roughly coinciding
with the geometric center. This center of the frame is also the center of the
composition, in the sense that all the weights of shapes and colors arranged
by the painter balance around the middle. Does this necessarily have to be
so? Is the artist compelled to balance his composition, or is he free not to do
so? The answer is, I believe, that balance is necessary to make the artist's
statement definitive. If a composition is unbalanced, it will appear to be an
interrupted movement, an action paralyzed in its striving toward a state of
rest. Similar to what musicians call a half-cadence, such an intermediate state
will make the viewer sense that the needed solution is in the offing but not
actually supplied. Thus if the artist wishes his work to convey its meaning
itself rather than simply stimulate the viewer to embark on some shaping of
his own, the composition will have to be in equilibrium.

FIGURE 40.
Claude Monet, Gare Saint-Lazare. 1877.
Fogg Art Museum, Cambridge, Mass.

This does not mean, of course, that visual weight is distributed evenly across the canvas. Such homogeneous compositions do exist, but they are exceptions. More commonly the theme of the work calls for a hierarchy of centers, some more weighty than others. I will begin to explore the relation between this hierarchy and the balancing center of the frame by a look at Claude Monet's *Gare Saint-Lazare* (Fig. 40). The composition is carefully balanced around the middle—a stable structure, emphasized by the symmetry of the station's roof, which peaks on the central vertical of the canvas. That is, the center is not given as a point in the middle but as an eccentric vector pointing upward and downward. The central vertical is a contribution of both of our compositional systems: it is centric through its position and function and eccentric through its vectorial extension in space. We shall meet such central axes again and again.

The centricity of the composition is powerfully challenged by the dominant mass of the dark locomotive, from which smoke spreads throughout

the upper area of the shed. The eccentric position endows the locomotive with a strong tension; and this deviation from the balancing center of the picture, together with the obliqueness of its position and the wedge-shaped contraction of its foreshortening, gives it a powerful dynamics. The challenge of this off-center colossus to the stability of the setting is, of course, the theme of the painting.

I hope the double meaning of the word "center" will not be too confusing if I say that Monet's locomotive is the second most powerful center of the painting, in spite of its eccentric position and, in fact, because of that eccentric position; for its deviation from the middle adds tension to its focus of energy by what I have called the "rubber band effect." The compositional relation between the dominant centers is what concerns us here.

For the argument's sake, let us suppose that Monet had overthrown the equilibrium of his composition by shifting its center from the middle to the locomotive, which is after all the most important object of the picture. What would happen? The composition would lose its finality. The locomotive, no longer anchored to its place by the balanced distribution of all weights, would seem to want to move to the middle and thereby establish equilibrium. This would wipe out the meaning of the picture. With its eccentricity lost, the belching monster of modern technology would no longer upset the stability of established urban existence.

A similar interference would occur if Monet's painting were left intact but the viewer, persuaded by the importance of the locomotive, decided to station himself in front of it rather than before the middle of the canvas. Once again the hub of the composition would shift toward the right. Now the locomotive would sit at its place as a static mass, no longer animated by an eccentric position.

Actually, however, the viewer would not feel free to examine this state of affairs. He would be bothered by the sensation that he was standing in the wrong place. The picture insists on coordinating the viewer with its own structural framework; his body would feel out of line with the framed picture as an object on the wall. He would feel the discomfort we know well from times when we are forced by circumstances to look at a picture from the side. The viewer would also feel that he was unable to see the composition correctly.

PERSPECTIVE CREATES A CENTER

When an eccentric accent is essential to a composition and its meaning, one must accept its eccentricity. This has created a problem for the viewing of paintings done in central perspective. The convergence of perspective

radii generates one of the most powerful compositional centers because its vectors reach across all areas of the picture. The vanishing point of such a perspective system—I am limiting myself to one-point perspective—can be positioned wherever the artist pleases. It can lie even outside the frame. When the viewer stands in front of the picture, no conflict arises as long as the vanishing point is placed on the central vertical. This is sometimes the case—for example, in the way *The Last Supper* is arranged by Leonardo or by Dieric Bouts (see Figs. 29 and 134). Often, however, the stability created by this coincidence of two principal centers is unwelcome to the artist. In Mannerist and Baroque works especially, the tension arising from an eccentrically located focus of perspective fits the style of the period. ← *Periods have styles? Of course they do!*

This creates an optical problem. The pattern of converging edges is distorted by optical projection when one looks at its center obliquely. This happens, of course, with any shape whatever. A simple square is projected as something approaching a square shape on the retinas of the eyes only when one faces it "squarely," that is, when the line of sight meets the object orthogonally. Otherwise the optical image of the square is distorted. This means that when one fixates the center of a picture, all off-center shapes appear out of kilter. In practice these distortions remain all but unobserved owing to a compensatory mechanism known to psychologists as perceptual shape constancy. *Here we psychologists bring in our own secret professional knowledge. It's meant to impress the laity.*

All this is true for the patterns of central perspective, and I am not sure why in this case theorists have paid so much more attention to the optical distortion than they have to that of any other shape. What happens when a purist who wants to see the perspective "correctly" places his eyes at the point where a photographic camera would have stood if it produced the perspective projection that we see represented in Tintoretto's painting *The Discovery of the Body of Saint Mark* (Fig. 41)? The vanishing point is at the raised hand of the standing saint, which means that if the picture had been taken photographically, the camera lens would have been placed at that level, very close to the left border. The line of sight coincides with the axis of the loggia, so that the viewer is in spatial conformity with the architecture when he stands next to the left border.

That location recommends itself also because it lets the viewer face the protagonist of the story from the vantage point of what one might call a good seat—a privilege obtained, however, at too high a price. By putting the saint at the center of the scene, the viewer misses the decisive point of the arrangement: Tintoretto has placed the main figure way off the middle of the painting and way off the axis of the architectural setting to illustrate the unexpectedness of the saint's miraculous appearance.

This ingenious compositional device is revealed to the viewer when he

FIGURE 41.
Jacopo Tintoretto, The Discovery of the Body of Saint Mark.
1562–1566. Pinacoteca di Brera, Milan.

places himself properly in front of the painting's middle.[6] Looking forward, he now faces a rather undistinguished sight somewhere along the row of suspended tomb boxes—a place, however, which represents the compositional center and thereby determines the location of every item of the picture as being relatively distant from or close to the center, above it or below it. The problem is, however, that the obliquely running right wall of the loggia still appears the way it looks from the station point near the left border, even

6. In practice, of course, the viewer is not likely to stand still but will walk back and forth and sideways to see the large picture in all its aspects. The required attitude, therefore, amounts to something more complicated than standing still in the right place. The viewer must perceive the composition from the reference point of its balancing center, regardless of where he actually happens to be at any moment.

though by now the viewer has moved. If he had moved in real physical space from the left wall to the middle of the loggia, the vanishing point together with all the perspective edges would have moved with him toward the center. Instead, the perspective has remained immobile, so that now there is a mysterious contradiction between the walls, which are no longer seen as perspectively converging parallels. Similarly paradoxical is the orientation of the principal architectural axis, which runs along the line of sight on the left but is crossed by it in the middle. The viewer faces a sight that can never be had in physical space. Nobody can ever experience a situation in which the vanishing point of the perspective stays in one place while the viewer, moving to a different station point sees the very same perspective projection yet again. One cannot walk away from one's own vision. or one's own shadow.

In the preceding chapter I mentioned examples in which the viewer's line of sight crosses the main axis of a visual space. This produces a situation in which the viewer takes cognizance of a framework that is at odds with his own. Even so, in those instances both frameworks belong in the same continuous space. In the example I just discussed, however, the discrepancy increases to spatial incompatibility. The viewer is made to see a world that he could never see in any physical reality.

In this chapter I have discussed the frame as a compositional structure that offers its own centricity and its own eccentric coordinates, mainly the vertical and the horizontal in the frontal plane. This structure had to be considered in its relation to the composition created by the artist within the frame, a composition that introduces its own centers and eccentric vectors. I shall now apply this discussion to two formats in which centricity is particularly powerful.

The vanishing point moves with the viewer. In a sense the vanishing point belongs to the viewer.

TONDO AND SQUARE

[handwritten: Def: Tondo = a round painting or relief see rotund]

[handwritten: A vs. ∀]

T HE MOST RADICAL promoters of centric composition are the round enclosures—circular frames, disks, spherical volumes. Such fully symmetrical structures are entirely determined by their focus in the middle, and to that focus they convey uncompromising dominance. Pure roundness spurns any relation to the eccentric coordinates of terrestrial space. Even though in and by itself it points in no one direction, it encourages mobility: it belongs everywhere and nowhere.

FLOATING SHAPES

One may say that circular and spherical objects are privileged foreigners in our midst. A ball touches the ground with one eccentric vector only, and that vertical vector is not distinguished from all the others, as far as centric structure is concerned. Since all diameters are equal, no one can be singled out. Having no angles and no edges, round objects point nowhere and have no weak spots. Roundness, therefore, is the appropriate shape for mobile things. The wheel revolutionized transportation because it rolls freely. *[handwritten: bowls move?]* Coins, shields, mirrors, bowls, and plates are round so that they can move smoothly in space. Look at a French miniature showing the Creator as he measures the world (Fig. 42). Unrelated to the coordinates of the frame, on which the Creator stands, the small centric universe is closed and not anchored to any particular place *in* the setting. It floats, and it can be moved around with ease. It has a center of its own, from which the compass makes the measurements. It can turn or be turned without undergoing any change.

The spatial independence of radical centricity is most strikingly demonstrated in spherical buildings, since architecture dwells in physical space and therefore is most firmly committed to the coordinates of the vertical and the

FIGURE 42.
The Creator Measuring the World.
From a French *Bible Moralisée*, probably Reims. 13th century.
National Library, Vienna.

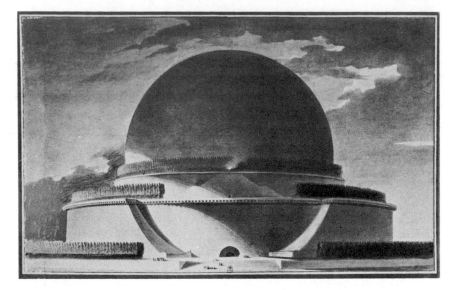

FIGURE 43.
Etienne-Louis Boullée, Project for a Newton Cenotaph. 1784.
Bibliothèque Nationale, Paris.

horizontal. Spherical buildings represent the utmost challenge to the rule of gravity short of flying. The architectural balloon touches the ground at only one point and is ready to take off. By its independence from the rules that govern terrestrial activity, spherical shape is reserved for buildings whose purpose suits such nonconformity. The world's fairs both of New York in 1939 and of Montreal in 1967 featured spherical structures conspicuously and quite appropriately, since such pavilions are meant to look like temporary statements, symbolic monuments to buoyancy, rather than utilitarian structures rooted in the common ground of practical business. In a similar mood of exaltation, Etienne-Louis Boullée in 1784 designed a cenotaph for Newton, "a hollow sphere, its vault pierced with holes through which natural light filters, creating the illusion of stars in the night sky" (Fig. 43). In this visionary building, visitors were to feel entirely removed from their customary spatial framework and directly exposed to the centricity of the solar system. It is characteristic of the seclusiveness of round shapes that such spherical structures appear all but inaccessible. Holes must cut into the integrity of the shell to admit the viewers to Boullée's vision, and Buckminster Fuller's American pavilion at the Montreal fair had openings pierced for the minirail trains that carried the public into and through the exhibition space.

I mentioned earlier that in painting, circular frames, adopted in the fif-

teenth century, are visual symbols of a social development that loosened the connection between works of art and the places for which they were made. Tondi came into fashion, especially in Florence, at a time when art was no longer exclusively commissioned for particular settings but went wherever a customer wished to put it.[1] During the Renaissance the so-called *deschi da parto*, tablets painted with religious images on both sides, assumed a circular shape. Masaccio's *Nativity* in Berlin and Botticelli's *Adoration* in London were probably intended as *deschi da parto*. Equally designed for mobile use were the Madonna tondi, such as the well-known Florentine terra-cotta reliefs produced by the della Robbias and other artists in large editions as devotional images for private homes.

In addition to expressing the portable character of art objects, circular enclosures underscored the detachment of subject matter from the environment. When religious images aim to stress their transcendence, they can do so effectively by choosing a format that estranges them spatially from a secular setting. On the other hand, the detachment from earthly gravity predisposes circular enclosures also for playful decoration and frivolity by evoking a "floating world," unencumbered by the burden of practical chores.

TONDI STRESS THE MIDDLE

In a round composition the emphasis on the middle is so strong that by mere position it can bestow primacy on an area or object that would otherwise be visually inconspicuous. The geographical maps of the Middle Ages represented the world as a flat disk with Jerusalem near its geometric center. The so-called T-O map of Isidore of Seville (Fig. 44) used three bodies of water—the Dnieper, the Nile, and the Mediterranean—to subdivide the world into three continents, with Jerusalem understood to be located near the hub. Botticelli, painting an Adoration, could place the Virgin and her child in the midst of a crowd of attendants without distinguishing her visually either by size or by spatial detachment. He had no reason to fear losing her. The compelling geometry of the tondo could be trusted to indicate her as the centerpiece of the scene.

Central position can give dominance to the Christ child when, sitting on his mother's lap, he would otherwise be reduced to a subordinate position. In Botticelli's *Madonna of the Pomegranate* (Fig. 45) his head profits from the stability of the center. He is surrounded by the body of his mother as though

1. An extensive monograph on the tondo was published by Moritz Hauptmann (1936). I have also profited from a senior thesis by Elaine Krauss, done at the University of Michigan under my supervision (1977).

FIGURE 44

he were still protected by her womb. But his formal enthronement already makes him the ruler. In fact, by giving the blessing with his right hand and displaying the fruit like a terrestrial globe in his left, he anticipates playfully the traditional posture of the pantocrator. *What's a pantocrator?*

The visual relation of the Madonna and the child symbolizes often the delicate theological problem of the competition between the Virgin Mary and Christ. In Michelangelo's Pitti relief at the Bargello (Fig. 46), the right hand of the Madonna offers and supports the book, which stands for the Christian creed. But the child has, as it were, the upper hand, planting his *the upper hand* hefty little arm on the book as a column rests on its base.[2]

Michelangelo's relief also offers a first example of a device I will call the microtheme. The microtheme presents at some prominent center of the work, usually in the middle, a small, concentrated version of the subject that is played out in the composition as a whole. The microtheme of the prayer book in its relation to the child's arm translates the work's spiritual topic into concrete visual action.

Another, even more striking example of a microtheme can be found on a cup by the Greek painter Duris (Fig. 48). We see Athena pouring wine for Hercules, a complex scene we can decipher only by untying the intricate visual organization and relying on our knowledge of classical mythology. In

2. A similar example, in which the significant theme is moved to the side, is given in another Botticelli tondo (Fig. 47) where the mother, leaning her right hand on the prayer book, dips her pen into the inkwell; but the boy has placed his hand on her arm as though to control the action.

FIGURE 45.
Sandro Botticelli, Madonna of the Pomegranate. 1487.
Uffizi, Florence. Photo, Anderson.

fact, the two partners of the dialogue are relegated to the sidelines of the round picture as though they were mere bystanders. Instead we are led by the centric aspect of the composition to the simple and unencumbered microtheme in the middle—where two containers, the jug and the cup, act out a condensed and abstracted replication of the larger subject, namely, the relation between hostess and guest, the pouring and the receiving. Such microthemes can be discerned remarkably often, especially in the action of hands, whose expressive behavior finds its place quite frequently in the middle of a work.

FIGURE 46.
Michelangelo, Madonna and Child. 1504–1505.
Museo Nazionale, Florence. Photo, Alinari.

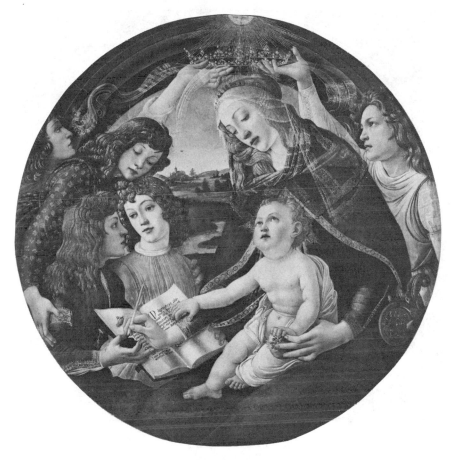

FIGURE 47.
Sandro Botticelli, Madonna of the Magnificat. 1483–1485.
Uffizi, Florence.

THE ROLE OF ECCENTRICITY

Thus far, my dealing with round enclosures has made me concentrate on centricity and neglect the role of the other compositional system, eccentricity. As we know, however, both systems are almost always in force. They have to get along with each other, and they enrich the visual and symbolic substance of the whole. Their basic complementary duality can be seen in the traditional symbolism of circle and square. "The square has always been considered inferior to the circle, and hence was employed to symbolize the earth, whereas the circle expresses Heaven or eternal existence," says George

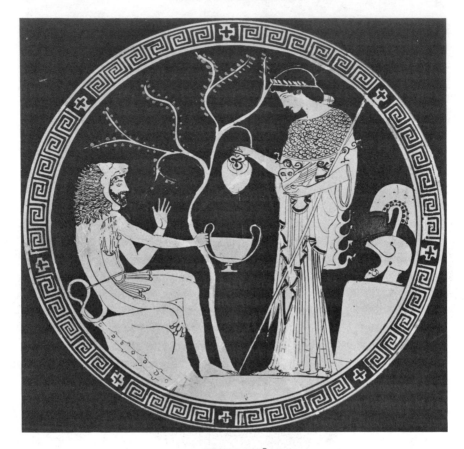

FIGURE 48.
Duris, Hercules and Athena. c. 480 B.C.
Staatliche Antikensammlung, Munich.

Ferguson in his book on Christian symbols. The interaction between the two shapes is represented schematically in a typical form of the Indian or Tibetan mandala, which depicts the integration of mundane nature with the divine (Fig. 49).

In representational art, circular compositions face the problem of how to cope with the terrestrial scene of upright figures, trees, or man-made furnishings and buildings, where the eccentricity of verticals and horizontals rules supreme. One partial remedy is the adaptation of the subject matter to radial patterns. T. B. L. Webster, in a study of the pictorial decorations of classical Greek bowls, calls centric symmetry one of their main compositional features. He finds many scenes reducible to a triangle, quadrilateral,

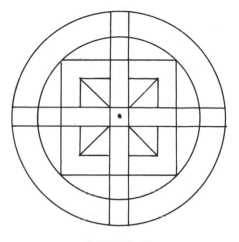

FIGURE 49

pentagon, or hexagon placed within a circle. A running figure may rely on a scaffold of three radii, and more complex scenes may make use of what Webster patriotically calls the Union Jack principle, that is, the sunburst formed by the eight main radii, which divide the round surface into eight equal parts (Fig. 50). Wherever such an interpretation fits the facts, the composition conforms to our concentric model.

Some attempts to accommodate the eccentric coordinates look as though the artist had limited himself to simply clipping the corners of a structure that calls for rectangularity. In one nativity scene by Masaccio, for example, the strong architectural verticals and horizontals are incongruously overlaid by a circular border. There is no spatial rapport between the two systems, and the center of the picture, promoted by the tondo, focuses as if by accident on a group of visiting women, who distract from the painting's principal theme. Similarly, when Perugino composes a tondo in which the Madonna and her child are surrounded by saints and angels, we see an arrangement of upright figures who have to tilt their heads sideways to avoid hitting the curved rim. "Only gradually painting discovers the inherent laws of this species," writes Jacob Burckhardt in an important article on our subject. *important?* "At first it represents its figures and events with the same realism of costume and expression as in paintings of other formats. It places buildings and landscapes in a space equally close to nature. Only toward the end of the century it becomes evident that the circular format has an essentially ideal character, which accepts only tranquil subjects of ideal beauty and does best when it renounces any more explicit background."

A glance back at the Duris cup (see Fig. 48) will convince us that a great

FIGURE 50

artist was capable of using the inherent incongruities of the circular format to his advantage. All the upright shapes are made to conform to the centricity of the composition. Hercules' back is curved, the tops of the seats turn somewhat toward the center, the tree denies its verticality, and even the eccentric straightness of the standing hostess is mitigated by her gracefully inclined head and neck.

The challenge posed by circular enclosures is not limited to pictorial art. A few examples will suffice here to indicate problems that arise in architectural ground plans. A cylindrical building points to its center as the most important place of its interior—a demand that is met in baptisteries when the baptismal font is set in the middle. In the Roman Pantheon the center is empty, although it is distinguished as the place from which visitors observe the magnificent symmetry of the ancient temple. The center is crossed by the eccentric axis, which is introduced by the entrance and points to the recess on the opposite side of the circular interior. This recess, however, is not particularly distinguished from the others that punctuate the circumference, so that in its present appearance the relation between the centric space and the eccentric axis may be said to be somewhat unclear. In Chapter X

I shall come back to this problem and discuss a similar theme offered by the ground plan of Saint Peter's Square.

But I will now return to the interaction of our two compositional systems in the pictorial tondo. I have referred to the difficulties faced by the artist when he undertakes to accommodate the grid of the terrestrial world in a circular enclosure. The easy solution of eliminating eccentricity entirely is rarely satisfactory, for two reasons. In a purely formal sense the unopposed harmony of an exclusively centric structure does not do justice to the tension created by the antagonistic tendencies in human experience. We well remember the boredom and triviality of the shields of concentric circles that some "optical" artists of the 1960s used for target practice. William C. Seitz, curator of the 1965 exhibition "The Responsive Eye" at the Museum of Modern Art in New York, wrote on that occasion: "Exaggerated emphasis on centrality and an attempt, which is all but futile, to avoid its tyranny are poles between which perceptual composition oscillates." *I guess Arnheim went to the show.*

In a more material sense, we find in representational art the second obvious reason for not neglecting eccentric structure: it is needed to do justice to the framework of terrestrial space. Even in Raphael's *Madonna della Sedia* (Fig. 51), which relies so thoroughly on curved shapes, the upright post of the chair keeps the picture from rolling out of control. Actually, that explicit post is by no means the only visible reference to the coordinates of earthly life. Raphael's genius ensures that the shapes composing and clothing his figures do not simply surrender their own character to the demand for swinging curvature. Each element visibly preserves the norm from which it was bent to assume its present appearance. The inclined neck maintains its potential uprightness, and the arms retain the muscular strength of pivoting limbs. This inherent angular straightness of terrestrial subject matter, which is made to yield without disguise or coercion to the harmony of the sphere, seems to be the finest solution the art of painting can offer to the problem of the tondo.

In fact, Burckhardt has written of the *Madonna della Sedia* that "it contains, as it were, the entire philosophy of the round picture so clearly that any unhampered look can realize what this most difficult and most beautiful of all formats, and indeed any format in general, means for representation." The tondo may indeed be called the most beautiful format—it transports us from the limitations of earthly gravitational space to the more fundamental model of cosmic concentricity; and it may be called the most difficult format because it cannot effectively suggest removal to the cosmic sphere without incorporating the devices of earthly eccentricity.

Funny looking ear

But then we have
Piet Hein's super ellipses

FIGURE 51.
Raphael, Madonna della Sedia. 1514.
Galleria Pitti, Florence. Photo, Alinari.

Eccentricity, however, is not merely tolerated in the tondo as a necessary concession to the human condition. It is also indispensable as a counteragent to centricity within the composition. In Michelangelo's Bargello relief (see Fig. 46) we noticed the weight given to the Christ child by his closeness to the center. In comparison, the head of the Virgin, relegated to the rim of the tondo, looked remote and secondary. Obviously, however, this centrically oriented view is one-sided. On the eccentric scale of the central vertical the head of the Virgin towers in dominant position, making the child a mere subordinate. We realize that the tilt of the child's head, when centrically observed, connects him actively with the sacred center but that the same tilt subjects him to a more passive leaning on his mother's shoulder when we

recognize her as the protective power. This same double standard, playing the dominance of the child against that of the Virgin, is conveyed by the interaction of the two compositional systems in the Botticelli *Madonna of the Pomegranate* (see Fig. 45).

Observe here that within the centric structure the effect of a removal from the middle is not limited to establishing a subordinate position. An immobile stability is the privilege of the central location—giving, for example, the Christ child in Figure 47 a dignity not otherwise granted to a baby on his mother's lap. But stability is also a lack of action; when the actors of a circular composition are placed off center, they gain in dramatic timeliness. The dialogue between Athena and Hercules on the Duris cup (see Fig. 48) is made more vivid by the eccentric position of the partners.

The effect of this device is particularly impressive in Michelangelo's tondo of the *Madonna Doni* (Fig. 52), where the very nucleus of the scene is raised to the upper rim. The central base is the mother's womb, from which the story arose. From that base we are elevated by the woman's raised arm to the family constellation. How much less intensity would there be in the closely packed triad of interacting heads if it were not placed high above the center!

DISKS INSIDE

The character traits of roundness are not limited to the outer enclosures, which I have been discussing so far; they hold also for circular shapes within compositions. If we look back at the disk of the little universe in the medieval book illustration of Figure 42, we find it tucked away in the lower-right corner of the frame but nevertheless curiously independent of the spatial coordinates. Its compactness isolates it and also gives it more visual weight than can be attained by any other shape. It behaves so much like a tondo in the external environment that we may call it an internal tondo.

The distinctness of round shape can also be observed in the head of the Creator, which is surrounded by a circular halo. Centric roundness accentuates the two principal shapes of the composition and helps to connect them by an eccentric vertical axis, which anchors the two flighty centers to the rectangle of the frame. The action of the picture culminates in the interplay between the intensely active head of the Creator and the world he moves and measures.

We can also look back at the head of the Madonna in Michelangelo's relief (see Fig. 46). Its roundness, supported by the immaculate symmetry of the face, gives it seclusion, completeness, and enough weight to let it act as the apex of a compositional pyramid that organizes the bodies of mother and

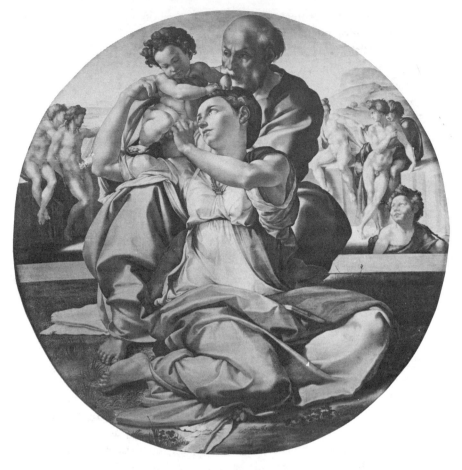

FIGURE 52.
Michelangelo, Madonna Doni. 1504. Uffizi, Florence.

child through a sheaf of fanned-out vectors. The Madonna's head acts thereby as a powerful countercenter, whose relation to the balancing center in the middle of the tondo determines the theme of the composition.

Explicit internal circles are rare in the realistic style of painting that develops in the Renaissance and the centuries thereafter. One of van Gogh's spectacular suns demonstrates how a circular shape, scarcely detached from a similarly colored sky, is nonetheless strong enough to assert itself against the foreground shapes of the sower and the tree (Fig. 53). Although the yellow disk is pinned in place by compositional balance, it is much less subservient to the painting's eccentric coordinates than the other shapes. Let loose, it might roll along the horizon. The uniqueness of its perfection gives

FIGURE 53
(after van Gogh)

it so much visual weight that it creates a center on the left, enthroned on the dark figure of the man and diagonally attracting the heavy tree, from its corner at the lower right, with so much strength that the trunk is barely stopped by the central vertical. Even the perspective lines of the fields seem to stream in the general direction of that glowing focus.

The geometry of the circle rules many of the Constructivist and Suprematist abstractions in the early twentieth century, in works by such painters as Moholy-Nagy, Lissitzky, and Rodchenko. A 1935 relief by Ben Nicholson (Fig. 54) will serve to show how a pair of hollow circles creates two conspicuous foci and thereby helps to subdivide the horizontal wooden slab into two foreground components, one of them large and expansive, the other weaker and compressed. The circular hollows have enough weight to serve as nuclei for the two angular shapes and to organize these shapes around unbalanced centers. This eccentricity adds dynamic tension to the composition. From the base of its round center the larger panel advances sideways like the blade of an axe, crossing the central vertical and invading the right half of the composition. By overstepping the bounds of symmetry it creates a strongly dynamic effect.

A round shape is so complete and stable in itself that it adapts itself badly to the context of a composition unless it can hold the center and have all the other shapes conform to it. This is seen most clearly in the wheel windows of medieval churches. Such a window is always located on the central vertical of the façade. Its strictly centric tracery is arranged like the spokes of a wheel (Fig. 55). Its independence is complete, and its visual weight is so strong that it influences the position of the balancing center. The façade of Notre Dame in Paris (Fig. 56) is organized around the wheel window, framed by the vertical and horizontal components of the structure. Keep in mind that the central position of the window is not a purely formal one. Adolf Reinle

FIGURE 54.
Ben Nicholson, White Relief. 1935. Tate Gallery, London.

[handwritten marginalia: What about Chinese Yang & Yin?]

has pointed out that this architectural motif derives from illustrations of medieval treatises, where cosmological schemata are represented in circular drawings, often dominated by the central figure of the enthroned Christ or the sacrificial lamb.[3] The round window, then, stands for the hub of the cosmos, and its role within the organization of the façade spells out various ratios between the centric and the eccentric compositional systems. At Notre Dame, the centrality of the wheel is relatively uncontested, but in the later, more Gothic cathedral of Reims the upward stream of pointed windows and gables introduces eccentric vectors that strongly challenge the stability of the organization around the center.

[handwritten marginalia: upward stream of vectors]

The influence of the wheel window's position on the central vertical can be observed, for example, on the façade of San Pietro in Toscanella (Fig. 57), where the window is placed very high up, just below the roof. From this height, the window counterweighs the powerful portal. It raises the balancing center and thereby gives the whole architectural design a sense of almost winged suspension.

THE OVAL

A discussion of the relation between centricity and eccentric linearity will profit from a reference to the enclosure whose shape integrates the two. Com-

3. For examples, see von Simson (1956, pls. 8, 9, 10).

FIGURE 55.
Wheel window, Cathedral of Troyes. 13th century.
Photo, John Gay.

pared with the circle, the oval pays with a loss of centric symmetry for an increase in tension. The Renaissance cherished the circle as the shape of cosmic perfection, whereas the Mannerist phase of the Baroque took to the high-strung ellipse, which plays on the ambivalence of roundness vs. extension.[4] It is true that the ellipse has a stabilizing symmetry of its own. Its

4. See Panofsky (1954).

FIGURE 56

FIGURE 57.
Church of San Pietro, Toscanella. 12th century. Photo, Alinari.

radius

An interesting
construction

an approximate
ellipse

FIGURE 58

derivation from the circle is truly compelling only when the distance be-
tween its two foci remains small and its shape approaches circularity. A
painter or architect can select a particular shape from a whole series of el-
lipses, each with its own character and expression. As the ellipse becomes
longer and flatter, it acquires the qualities of the rectangle.

Even more than the tondo, the oval is a playful shape, prescribed by the
demands of the setting it bedecks rather than those of the composition it
encloses. In many routine productions of the eighteenth century, therefore,
pictorial subject matter fills the frame without much consideration given to
the particular structure congenial to the elliptical format. A landscape
stretches through the horizontal expanse, or one of Boucher's young women
lounges on her bed. The oval serves to round off the corners and thereby to
fit the subject more snugly. The same is true for upright ovals, so frequently
used for portraits. We note, however, that, in the case of the portrait the oval
lends welcome assistance in the painter's struggle with the human figure,
which carries its head high above its center. The upper focal point of the
ellipse offers the head of the portrayed figure a compositional resting place
not available in either the tondo or the rectangle.

Compositionally the ellipse is the format of choice for the presentation of
a duet or dialogue, two antagonists or partners—or, more abstractly, two
centers of energy coping with each other. This structural property of the
ellipse is evinced in the workshop practice of Renaissance draftsmen, who
constructed approximate ellipses by means of two overlapping circles, the
so-called *ovato tondo* (Fig. 58).[5] The ellipse can be perceived as the result of
interaction between two spheres of forces. An anecdote about the historian

5. See Kitao (1974).

FIGURE 59
(after Charlier)

Aby Warburg deserves mention here. The Hamburg city planner Fritz Schumacher reports in his autobiography that when Warburg's brothers offered to construct a building for his growing library, Warburg insisted that at the center of the building there be an auditorium in the shape of an ellipse. He had just recovered from a severe mental illness and conceived of the elliptic centerpiece of his library as a commemoration of his new health. In a conversation with the philosopher Ernst Cassirer he explained that the ellipse represented a turning point in human thinking. To Plato, he said, the circle had been the symbol of perfection, the creative figure for the concepts of the universe. Actually, however, "the ellipse was this creative figure because its two poles were characteristic of the universe: they controlled the motions of the cosmos, and they were the symbol of man with his polar structure of spirit and soul. Wherever there was life, the duality of the poles was in evidence; not only in electricity but in day and night, summer and winter, man and woman."[6]

The solemnity of this symbolism has failed to reverberate in Western painting because of the lighthearted use to which the elliptic format was put. Furthermore, the duality of the two compositional centers appears clearly only in the horizontal ellipse. In the vertical, the symmetry is overlaid by the hierarchic difference between above and below. But in a horizontal oval Boucher, for example, makes good use of the two foci when he shows Aeneas presented by Venus to the other gods. The two groups are more clearly clustered and more clearly detached from each other by the bipolarity of the elliptic space than they would be in a rectangular frame. Similarly, Jacques Charlier places Leda on the left, the swan on the right (Fig. 59).

6. Cited by Füssel (1979).

FIGURE 60.
Anonymous (after François Boucher), Love Allegory (with Egg
Basket). Snite Museum of Art, University of Notre Dame.

In the upright oval, the weight of the upper focus can be used, as I mentioned, to make the dominance of a portrayed person's head more convincing. Although the central area of the canvas may be preempted—for instance, by the decorations of the male or female chest and by the play of the hands—the head, surrounded by the vault of the top, holds the upper center quite firmly. Conversely, a group of persons may fill the bottom of an upright oval as though gathered in a basket around the lower focus of the ellipse, while the top is filled with lightness, the empty space of an interior, or clouds, animated perhaps by a pair of floating putti.

Finally, there is an assonance to roundness, by which the format of the frame influences the shapes of the composition. In the *Madonna della Sedia* (see Fig. 51) we saw this exemplified by the rounded volumes of the limbs constituting the composition of the tondo. A perfect example of an oval frame emphasizing the theme of the picture's subject is Boucher's egg merchant girl (Fig. 60). The affinity between the oval frame and the eggs in the basket is underscored by the suitor, who grabs the eggs with his right hand and the chubby girl with his left. The youthful abundance of rounded shapes so crowds the picture space that it all but overshadows the eccentric vectors of chests, heads, and arms.[7]

SQUARES BALANCE THE COORDINATES

As we turn to the square, we are dealing once more with a centrically symmetrical shape. In this respect a square-shaped frame resembles a tondo. But whereas a circle has infinitely many symmetry axes, the square has only four, namely, the two paralleling the edges and the two diagonals connecting the corners (Fig. 61). The difference is not only a matter of number; it indicates the qualitative difference between a shape fully committed to centricity and one primarily determined by the linear vectors of an eccentric grid. In consequence, the two shapes relate differently to their environment. The tondo, we noticed, behaves like a foreign object flown in from outer space, controlled by a structural pattern of its own and without a stable location. The shape of the square enclosure and its internal structure are subject to the eccentric grid and therefore are intimately related to the vertical/horizontal framework of architectural settings.

This structural difference between the shapes of the two enclosures also

7. In his introduction to an exhibition of oval paintings, Jean Cailleux has written: "In any case we may note that more than one oval painting, especially portraits, could have been rectangular without fundamentally altering the presentation. Even so, it seems to me striking that the oval format permits, encourages, and indeed inspires a play of curves and countercurves within the ellipse of the canvas" (1975, p. 12).

[handwritten marginal note: Until you choose one of them.]

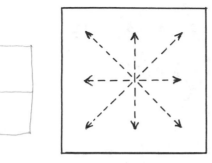

FIGURE 61

affects the character of the balancing center. The center of the tondo is a stable, firmly determined spot. The center of the square is more nearly a crossing. Think of the difference between a circular city plaza and a street crossing. Unless the crossing is marked by a central island, a monument, or a traffic policeman, it is absorbed by the linear vector of each of the streets along which the traffic is moving. Quite in general, the crossings of straight lines in any two directions are somewhat undetermined; the lines slide through each other without much interaction. Consequently, the proportions of quadrilaterals tend to be somewhat indefinite. It is well known, for example, that geometrically correct squares look too high: one has to shorten them a bit in the vertical dimension to obtain the appearance of a correctly proportioned square. As I mentioned earlier, this phenomenon is due to the so-called anisotropy of space, which makes us overestimate distances in the vertical. It is a phenomenon that in principle affects all shapes; characteristically, however, it has no power over circles. The circle has too much inherent strength to be squashed by this asymmetry of perceptual space. Given the looser structure of the square, it is legitimate to define its visual proportions more broadly than the geometric measurements permit.

On the one hand, then, the square is a quadrilateral characterized by the right-angled crossings of horizontals and verticals. On the other hand, the centric symmetry of its shape emphasizes the balancing center. This makes for an ambiguity that sometimes is not fully resolved. In an early work by Raphael, for example (Fig. 62), we notice that when we read the composition along its vertical vectors, the standing women tower over the sleeping knight. In the horizontal direction they flank him laterally. To reconcile these two eccentric versions, one needs to see the composition as organized around the balancing center of the picture. But that middle is too weak. Granted, it accommodates a symbolic microtheme of the painting's subject: the choice between virtue and the pleasures of beauty, between book and flowers. Vi-

FIGURE 62.
Raphael, The Knight's Dream. 1504–1505.
National Gallery, London.

sually, however, the central area is all but empty. It is explicitly transgressed
by the trunk of the tree. And since the composition fails to supply the hub
demanded by the format, the picture oscillates between horizontality and
verticality instead of integrating the two in a balanced whole.

The formal complexity of the square format, where the network of the
linear grid is in competition with centricity, influences the subject matter for
which it is best suited. We found that the dominant centricity of the tondo
tends to lift the subject matter above the weightiness of the human condition
by evoking religious transcendence or to nudge it below that condition by
encouraging lighthearted play. The square, with its allegiance to the gravi-

tational grid, shares the ability of rectangular formats to report solidly about existence in this world. Not that it excludes spiritual subject matter; but just as the balancing center of the square tends to rely on the crossings of the linear coordinates, its subject matter has a way of elevating its theme by defining it through the crossing of the terrestrial horizontal with the ethereal upright.

By compensating for the dominance of either spatial dimension, the square can arrest the mundane action and create a state of timelessness. It is thus a format congenial to artists who aim at presenting a stable world. In representational art two paintings by Piero della Francesca may serve as illustrations. His *Resurrection* in Borgo di San Sepolcro (Fig. 63) is about 10 percent higher than it is wide; but considering that the painting represents the rise from death—that is, the vertical theme par excellence—its near-squareness is striking. In an almost diagrammatic manner it transforms the active event of the removal from earth into a hierarchic arrangement of reposeful dignity. The rising Christ is pinned to the balancing center of the painting, which favors stability rather than action. Together with the frontal symmetry of his stance, the centric position turns him into a statue, an enthroned monument, remote from the vicissitudes of change.

The verticality of the Christ figure is seconded by the trees on either side, but even they are standing guard rather than rising as pointed vectors; and the verticality of the upper scene is strongly compensated by the horizontality of the group of sleeping guardsmen along the bottom, which is held together by the massive cornice of the tomb. A significant compositional paradox transforms the vertical action of the Resurrection into a timeless celebration while simultaneously presenting the sleep of the mortals as the restlessness of unredeemed souls.

An overall stillness rather than pervasive turbulence is the mood that suits the format of the square. The change of the trees from wintry defoliation to the verdure of summer life is depicted not as a process but as the static confrontation of two opposite conditions. Similarly in the entire composition the event of the Resurrection has become a map of separate, immobile states of being. The picture space is divided into three horizontal layers, which overlap but hardly interact. Christ's head and shoulders reach into the sky, and two of the sleeping guardsmen have their heads locked into the middle ground. But there is a clear distinction between the state of true life, which unites earth and heaven in the figure of Christ, and the two other layers, the empty sky above the horizon and the realm of beastly insentience below the cornice, marked as the baseline by Christ's foot.

Just as Piero's *Resurrection* stops the vector of action in the vertical, his

FIGURE 63.
Piero della Francesca, Resurrection. 1463–1465.
Borgo di San Sepolcro.

Nativity (Fig. 64) turns the story of the Adoration into a solemn group por-
trait on the horizontal plane. Here the centricity of the square does not check
the rising and falling but the coming and going on the ground. Divided by
the central vertical into two groups, the scene shows the angelic musicians
on the left and the Holy Family and shepherds on the right. The horizon-
tality of the roof along the top and the parallel row of heads counterbalances
the uprightness of the figures. Once again interaction is not consummated.
Within the compact square of the scene, which parallels the format of the
frame, the angels play and their audience meditates, each group by itself in
its own quarters.

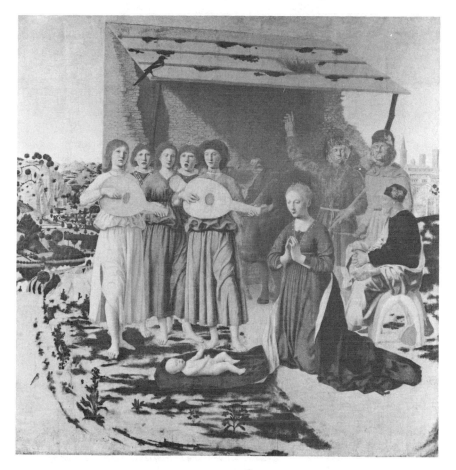

FIGURE 64.
Piero della Francesca, Nativity. 1470.
National Gallery, London.

The very opposite would seem to be true of Raphael's *Deposition* (Fig. 65). There everything sways in the obliqueness of motion, and the vertical is barely stated by the powerfully upright legs of the two carriers and the straight-necked head of the younger one at right. Even so, the squareness of the format stabilizes the scene in its given location. The performers come from nowhere and go nowhere. They are grouped around the immobile body of the dead man. Even the main dynamic theme, the sagging weight of the corpse, is not permitted to follow its downward impact through. It is checked by the diagonals that hold it in their crossing.

Diagonals, although dynamically active through their deviation from the

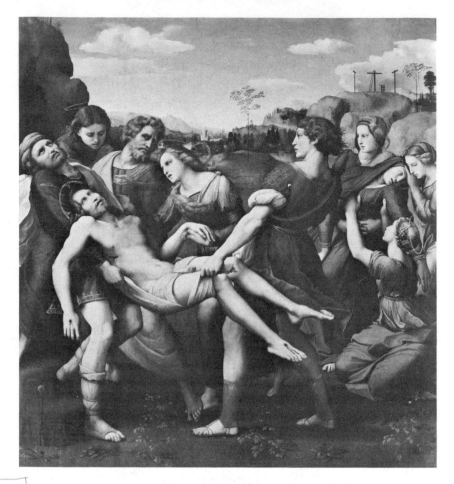

FIGURE 65.
Raphael, Deposition. 1507. Galleria Borghese, Rome.

grid of spatial coordinates, perform like the trusses in a building. By cutting across the dichotomy of vertical vs. horizontal and mediating between the two dimensions, they add stability to the square. Sustained by the V-shape of the two carriers, the group of mourners is a solid scaffold rather than a passing scene. And once again the centric symmetry of the format points to a symbolic microtheme in the middle. This time it is the theme of support, acted out in two versions: the dead man's hand raised gently from below by the hand of the Magdalen, and the cloth pulled up robustly from above by the hand of the young man.

ALBERS'S NESTS OF SQUARES

There has been a revival of the square format in the last hundred years or so. This is in keeping with a tendency to overcome the sense of weight in the artifacts of our culture. As long as art wishes to reflect the experience of living within the constraints on human existence, it is likely to display the anisotropy of space, the coping with weight. Its formats reflect the asymmetry of gravitational space. The horizontal oblong represents the subservience of man and nature to the pull of gravity, the spreading along the ground and the action along that dimension. The upright format depicts the overcoming of weight. The rectangular formats reflect abstractly the struggle with the encumbrances of life, which are spelled out more explicitly in realistic subject matter.

But just as the art of the last hundred years has increasingly detached itself from realism and moved toward abstraction, a tendency toward a more even distribution of visual weight replaces the bottom-heaviness of traditional art. A sense of suspension keeps the work afloat, as we can observe in much modern architecture, sculpture, and painting. The square or cube is in harmony with this tendency. Among the many examples in modern painting, a quick comparison between works of Josef Albers and Piet Mondrian may be instructive. Albers's series *Homage to the Square* offers the more traditional solution, since it explores the role of gravity in a realm of suspended weight.

The centricity of the square format determines Albers's composition, which is limited to echoing this one shape (Fig. 66). If, in addition to having the same shape, the squares would also be grouped around the same center, the balancing center of the composition would coincide with that of each internal shape and the resulting pattern would be as static as a set of concentric circles. But, as we know, the centricity of circles is more rigid than that of squares. Squares are more easily persuaded to slide along one of their axes, so that Albers can displace the components of his nest of squares quite smoothly, creating a compression at the bottom and an expansion at the top. Dynamically this means that the centricity of the system has been subjected to an eccentric vector, representing the gravitational pull toward the ground and the escape from gravity toward the height.

The gradual expansion and contraction of size help create dynamic tension, and so do the different sizes of the steps from square to square. They are smallest at the bottom, larger on the sides, and largest at the top. The centers of the squares add to this tension by deviating from the balancing center of the total composition. This deviation is strongest for the smallest

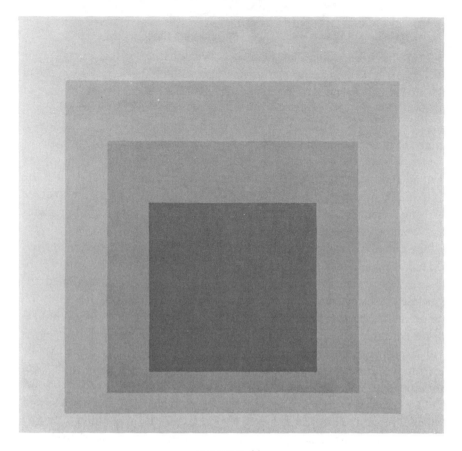

FIGURE 66.
Josef Albers, Homage to the Square: Silent Hall. 1961.
Museum of Modern Art, New York.

square, which has moved the balancing center of the whole close to its upper edge. Notice, however, that even this largest deviation keeps the principal balancing center within the range of the square's area and thereby lets that center maintain its internal control over each square. The "rubber band" that holds the deviants tied to the base is not allowed to snap. Perhaps for this reason Albers has not used the smallest square supplied by his geometric schema, as shown in Figure 67.[8]

8. Although the scheme of Figure 67 is at the base of all paintings of the series, in practice Albers varies it by omitting one or the other square in some of them. The resulting irregularity modifies the rhythm of the set of squares but leaves the underlying "beat" of the regular intervals sufficiently evident to the eye. A diagram similar to mine appeared in a catalog for an Albers show in Hamburg (1970).

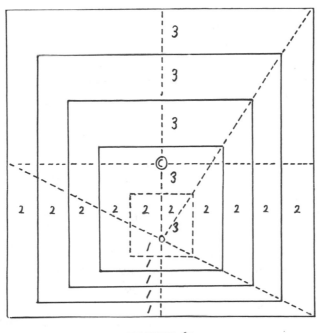

FIGURE 67

Even so, it is in keeping with the square format—and the artist who se-
lected it—that Albers counteracts the dynamic tensions in his composition
by simple geometric relations. Figure 67 shows that the diagonal lines con-
necting the corners of all squares meet in the center of a rectangle that is
exactly half the size of the total square. Also the distances between the
squares are limited to multiples of a module I have marked "1" in the dia-
gram. That module separates the squares at the bottom of the pattern. Twice
the module determines the distances on the sides, and those on top are three
times the module. All such simple relations increase stability and decrease
tension.

The role of the frame should be mentioned in relation to what I discussed
in the preceding chapter. In Albers's composition the limiting function of
the border is practically absent. The repetitive pattern of nested squares
could continue forever, and the enclosure, being just one of the squares, does
not interrupt it. The frame does not overlap the pictorial space like a win-
dow, nor does it confine that space. No effective limit checks the expansion
of the centric focus of energy.

Let me add an observation on the different functions attributed by Albers
to color and shape. In the series of paintings we are discussing, his colors

promote centricity by making every square look the same all around. The colors are not affected by the gravitational difference between top and bottom, nor by the dynamic contrast between <u>expansion</u> and <u>compression</u>. Shape, on the other hand, is described by the composition as afflicted by the powers of weight, and thereby as interfering with the serene choir of concentric colors. Cosmic harmony comes from color, earthly impediment from shape—the message of a colorist.

MONDRIAN OVERRIDES CENTRICITY

At first glance, the late paintings of Piet Mondrian (Fig. 68) seem closely related to Albers's squares. Both artists rely on a starkly rectangular geometry, and in fact art history assigns them stylistically to the same generation. Yet their differences are fundamental. I pointed out that despite the radical abstractness of his shapes, Albers is still concerned with the traditional problem of how to deal with gravitational weight in a balanced setting. This is a problem posed by realism. Realistic also is Albers's reliance on the entire gamut of hues and brightness values in his color. His palette is as rich as that of nature. Mondrian, on the other hand, limits himself to the three fundamental primaries, whose renunciatory purity conveys a minimum of expression, a minimum of association with the things of reality. The three primaries are structural elements that exclude from Mondrian's late paintings the property on which Albers's entire effort depends, namely, mutual interaction. Pure red, blue, and yellow establish three independent poles. The only way one can interrelate them is by adding them up as complementaries to achieve the completeness of grey.

Thus, while Albers kept his shapes simple and constant to concentrate on the varieties of color relation, Mondrian restricted himself to the simplicity of right-angled shapes for another reason. His interest was in shape relations, which he wished to reduce, however, to horizontality and verticality. He needed to minimize the complexity of shapes and directions found in physical reality and carry abstraction to the purity of the two fundamental spatial directions.

For two reasons he eliminated the strong vertical vector that deflects Albers's squares from their concentricity. First, the vertical pull was a representation of earthly gravity and therefore a leftover of the reliance on nature, to which Mondrian objected. Second, the predominance of the vertical vector created a disequilibrium he experienced as tragic and wished to overcome in his art. His intention was to show the perfect balance between vertical

[handwritten in left margin: Red blue & yellow are the primaries here.]

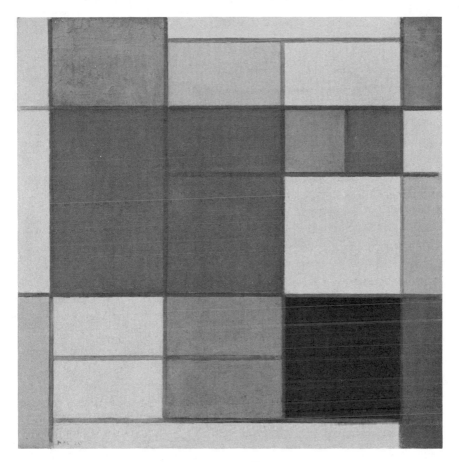

FIGURE 68.
Piet Mondrian, Composition. c. 1920.
Museum of Modern Art, New York.

and horizontal, a weightless universe, homogeneous and endless, beholden to no one and to nothing.

For this reason he also avoided any explicit reference to the center. To be sure, his paintings are delicately balanced around the middle to give the composition its needed validity. But one discovers that center not without trouble. Albers, too, had avoided marking the center explicitly; but in his paintings the place of the balancing center is clearly indicated by the squares' pointed deviation from it. In Mondrian all such reference to the center is avoided. Instead, every unit is a center of its own, and the weights of the

variously sized and proportioned quadrilaterals are distributed so irregularly over the surface that no one weight can be said to dominate. Neither the composition as a whole nor any of its parts is permitted to act as a center around which neighboring shapes might organize hierarchically. The colored units make their appearance here and there, but without calling undue attention to themselves at the expense of other shapes. There are rich and delicate patterns, but in the more characteristic examples of this type of painting there is no theme. As Robert Welsh has observed about Mondrian's works, "one's attention to the compositional structure is forced to shift constantly from a single or small group of units to the next, and . . . a visual comprehension of the total configuration is virtually impossible, except as a broadly perceived pattern."

Any emphasis upon the middle is further underplayed by the openness of the enclosure. As in Albers, the shape of the frame resembles the shapes of the composition so much that it seems to belong to them. Even so, many of the shapes look as though they continue underneath the frame, and the same is true for the black contour lines. Thus we face a homogeneous and basically unlimited weave of shapes, a grid of eccentric vectors moving in the vertical and horizontal directions with no anchorage.[9]

I hasten to point out that my description of Mondrian's compositional principles is one-sided. Some of his late paintings, which I am discussing here, are organized around a theme in a classical manner. Some of his square-shaped canvases derive their organization from the centric symmetry of their frames. I am using one type of his late paintings to exemplify a kind of composition in which the role of the center is reduced. This stylistic tendency has been widespread. Color-field paintings with evenly stained canvases, abstract-expressionist textures filling the picture space, and other similar procedures show the same tendency, which can be traced back to the Impressionists, most clearly to Monet's late work. They all underplay the center, they underplay the constraints of boundary and format, and they replace hierarchy with coordination. They approach the structural level of homogeneity and thereby signal an undifferentiated state of being. In the world at large, the curtain walls of the so-called International Style of the 1920s and 1930s provide the architectural equivalent. They, too, dispense with organization around a center and could expand and contract their limits without modifying their character.

The basic question raised by this tendency toward unfocused homogeneity is, of course, whether it does not militate against my claim that centricity is

9. Mondrian's preference for an even distribution of weights probably made him prefer to paint on the horizontal surface of a table rather than on an easel. See Carmean (1979, p. 37).

an indispensable aspect of all visual composition. I do not think it does. Remember here first that the claim for the omnipresence of the balancing center is limited to compositions, and to closed ones at that. The blue sky is no composition and has no center. Open compositions like certain wall decorations or Japanese hand-scrolls have no one center, but a number of local ones. As soon as we are faced with a closed space, however, the enclosure mobilizes a field of visual forces that creates a balancing center and organizes around it. This is centricity in empty space, which may or may not be supported by the structure of the composition. When centricity is supported, it carries all the symbolic connotations that make it psychologically meaningful. When it is overridden, its ineradicable perceptual presence gives the overriding its meaning. Only when the center is potentially there does its denial become an artistic statement. Emptiness and homogeneity as positive presentations of a desirable or undesirable state of being are sharpened and strengthened when a rallying point is potentially available. The psychological connotations of floating in the nowhere, in a space where no one place differs from the next, exert their bliss or terror artistically when an anchorage is explicitly represented as being denied.

A SQUARE BY MUNCH

A beautiful and characteristic example of a square-shaped composition will complete this discussion. A stillness of action in which neither verticals nor horizontals seize the intiative is the mood of Edvard Munch's painting *The Sick Girl* (Fig. 69). The square is divided in half by the edge of the white pillow, separating the realm of the sick daughter from that of the grieving mother. The subject matter reminds us of the Attic sepulchral monuments of the fifth and fourth centuries B.C., the dialogue between departure and mourning; but how different is the composition of the modern painting! The mother's head is placed on the central vertical and thereby connects the two realms as what I shall call a compositional latch. She is trying to breach the vertical barrier to join her child, but proximity no longer fosters communication. The bent head hides eyes and mouth. In contrast, the profile of the daughter is fully exposed, but it is transfigured by the light that lifts the square-shaped pillow from the dark ground of the environment. Within this smaller precinct centricity excludes action even more radically. The girl's head is stabilized by its central position; and although her eyes are open, her glance loses itself in the infinite, moving through the head of the mother as though it were not there. Although the girl sits in an upright position, her body is not really raised; it seems suspended from the centrically anchored

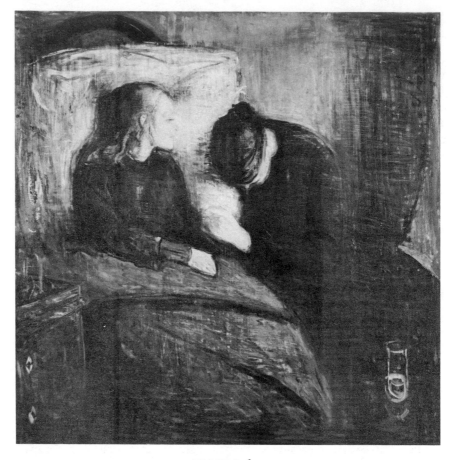

FIGURE 69.
Edvard Munch, The Sick Girl. 1896. Göteborge Konstmuseum.

Is she sick? Or is she dead?

head. The suspension of the gravitational pull within the transcendent realm of the pillow contrasts with the darkness of the sickroom, in which the mother, still subject to the law of the living, is bent under the load of earthly grief.

Action is arrested also in the microtheme of the hands, which synthesize the painting's subject in the balancing center of the canvas. The mother's hand reaches for the lifeless hand of the daughter but can no longer touch it. There still is correspondence, a parallelism of direction, but the small distance between the hands is no longer bridgeable.

CHAPTER VI

CENTERS AS HUBS

centrifugal ⊙ ↗ *centripetal* ⊙ ↖ ↘

or ⊙ →

THE NEXT TWO chapters are meant to offer additional evidence on struc-
tural features we have encountered in our preceding explorations—fea-
tures that emerge in the practical application of our compositional pattern,
the interaction of centricity and eccentricity. I turn first to the balancing
center as the stable base of composition.

One of the attractions of country fairs in my childhood was a large wooden
disk rapidly rotating like a merry-go-round. It would fling us off by its cen-
trifugal power when we tried to ride on it. The center of the disk was the
only spot where one could hold on in relative security, and the competition
for space near that center was frantic.

PROVIDING STABILITY

A similar stability distinguishes the visual balancing center. Throughout
the ages and in most cultures, the central position has been used to give
perceivable expression to the divine or some other exalted power. The god,
the saint, the monarch, dwells above the pushes and pulls of the milling
throng. He is outside the dimension of time, immobile, unshakable. In look-
ing at such a spatial arrangement one senses intuitively that the central po-
sition is the only one at rest, whereas everything else must strain in some
specific direction. In the Byzantine churches the dominant image of the di-
vine ruler holds the center of the apse. In portrait painting a pope or emperor
is often presented in a central position. More generally, when the portrait of
someone shows him in the middle of the framed area, we see him detached
from the vicissitudes of his life's history, alone with his own being and his
own thoughts. A sense of permanence is entailed with the central position.
Geometrically, of course, the center is a point. Perceptually it reaches as
far as the condition of balanced stability holds. It may be a small spot or the

Not necessarily.

head of a person or indeed a whole figure. It may also be a compact cluster of objects, such as a bowl of fruit, or the kind of locus of intertwining shapes that I shall describe in Chapter VIII as a node. In the extreme case of a Byzantine painting of the thirteenth century, the Madonna with her child and the cylindrical throne surrounding her may be said to be one large center filling nearly the entire picture space (Fig. 70). Symmetry, in particular, creates centricity and makes the center extend as far as the symmetry reaches. It may be a face with its vertical axis and its pair of eyes, or a frontal figure with symmetrical limbs, or the façade of a building.

Even within a crowded scene, dominance may be given to a particular figure through its central position. Such a figure possesses a timeless stillness even when it is engaged in vigorous action. The Christ of El Greco's *Expulsion from the Temple* (Fig. 71) chastises the merchant with a decisive swing of the right arm, which forces the entire body into a twist. The figure as a whole, however, is firmly anchored in the center of the painting. This raises the event above the level of a passing episode. Although entangled with the temple crowd, Christ is the stable axis around which the noisy happening churns.

A similar effect is obtained by Giotto in his *Deposition* (Fig. 72). Here again the agitation of the mourners had to be counteracted by stabilizing factors, to impart the surpassing dignity and significance of the scene. The sweeping gesture of the bending disciple is fastened by the position of his head to the balancing center of the composition. This stabilization compensates for the momentariness of the gesture and gives it the permanence of a monument— a monument to grief. If the figure were placed away from the center, this effect would not obtain.

In a profile portrait by Picasso (Fig. 73), a long neck sustains the heavy mass of the head like a tree trunk. The striking simplicity of the large eye adds so much weight to the face that it would throw the head off balance were it not placed on the central axis of the painting. By virtue of its location the weight of the eye stabilizes the figure rather than acting as an unwieldy cantilever that would make the head tip over. Tied to the central axis, the head's bold thrust is held in a repose that underscores the classical beauty of the face.[1]

When a part of a visual object is placed on the balancing center, it can

1. In a book of 1922, Hans Kauffmann pointed to a centrically symmetrical "style ornament," which, in his opinion, characterizes the composition of Rembrandt's figure paintings. A dynamic system of radii is said to create centripetal rosette shapes and centrifugal star shapes around a compositional center. Since I no longer have a copy of the book available, I am citing from a review by Ludwig Münz in *Kritische Berichte zur kunstgeschichtlichen Literatur*, Leipzig, 1927–28 and 1928–29, pp. 149–160.

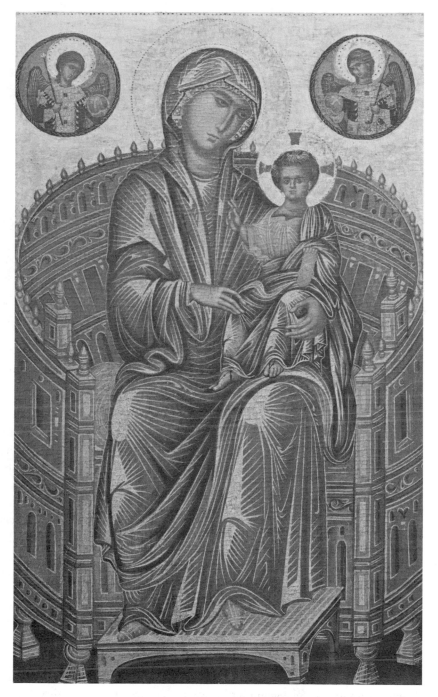

FIGURE 70.
Enthroned Madonna and Child. Byzantine School. 13th century.
National Gallery of Art, Washington, D.C.

FIGURE 71.
El Greco, Expulsion from the Temple. 1595–1605.
Frick Collection, New York.

acquire a curiously paradoxical weight. We noticed, for example, that the
head of Munch's *Sick Girl* (see Fig. 69) becomes the pivot from which the
torso is suspended, because the center of the pillow gives the head a weight
it would not have had at another location. A similar effect is achieved in a
painting by Gentileschi (Fig. 74), where the head is the only part of the
young woman's figure that is located on the central vertical. This emphasis
upon the top center gives the oblique movement of the figure a mooring in
pictorial space. The very opposite can be observed when the body of a figure
is gathered along the central vertical while the head alone sharply deviates
from it. Caravaggio's *Magdalen* (Fig. 75) looks all but decapitated—a shock-
ing effect strengthened by the compositional weight of the balancing center,
which is so clearly established by the folded hands. This strong centricity
makes the deviation of the head all the more compelling.

I have shown earlier that the central position can be used by the artist to
affirm which part of a composition is intended to be the most important.
When the subject is the encounter between Oedipus and the Sphinx, atten-

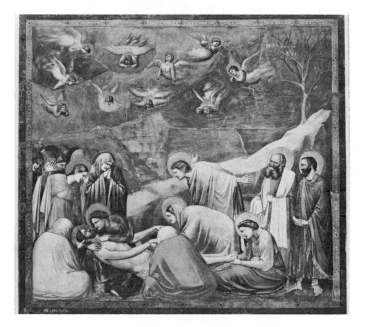

FIGURE 72.
Giotto, Deposition. 1304–1306.
Cappella degli Scrovegni, Padua.

The title of the book

tion can be focused on either figure. Ingres places the man's head and supporting leg on the central vertical (Fig. 76) and indicates thereby that his story is about Oedipus, not the monster.

The power of the center can be exploited to create a teasing contradiction between an element kept deliberately small and its crucial importance for the story being presented. The tension generated by such a paradox was much in vogue during the Mannerist phase of Baroque art. For example, Pieter Bruegel's complex landscape with the fall of Icarus (Fig. 77) is centered around the tiny figure of a shepherd, who peers at the place of the deadly fall from the heavens. Although his is the only response to the cosmic tragedy taking place, the viewer's attention is distracted by the large and colorful plowman, who, right next to the shepherd, turns his back, concentrating on his own business. Once discovered, however, the little man, spellbound in his central position, holds the key to the entire scene.

The preceding examples have served to demonstrate the strength that compositional elements derive from a central position. Even broader and more varied, however, is the effect of the balancing center on the areas surrounding it. The indirectness of this effect may be illustrated by an obser-

FIGURE 73
(after Picasso)

vation of Roland Barthes. Quoted by Bruno Zevi in his book on the language of modern architecture, Barthes points to cities in which the center is not the "culminant point" of any particular activity but a focus of sorts for an image created by the community. He speaks of a "somehow empty image needed for the organization of the rest of the city."

A single example from painting may suffice to indicate the visual power of a center not marked on the retinal image and therefore, strictly speaking, not there at all. As one approaches Franz Kline's *Painting #2* (Fig. 78), one sees at first a mere assemblage of eccentric vectors distributed all over the canvas, running in different directions, crossing each other, and so forth. The place of the balancing center is empty, but what matters here is that the positions and spatial interrelations of the shapes make sense only if one sees them as related to that center. The central vertical is occupied solely by the cluster of smaller shapes perched near the top. The crucial compositional importance of this node is emphasized by its position, and its height is defined as a height above the balancing center. Similarly absent is the central horizontal, to which I am drawing attention here for the first time. But it, too, is virtually present and defines the nature and position of other shapes

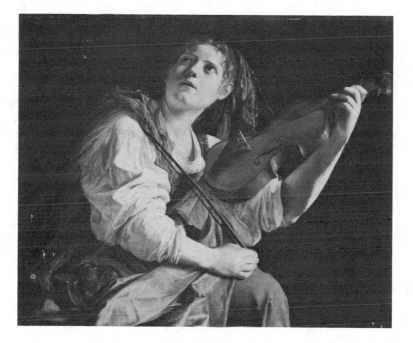

FIGURE 74.
Orazio Gentileschi, Young Woman with a Violin. 1611–1612.
Detroit Institute of Arts.

as approximations to and deviations from its own place and orientation: two rough shapes below it and a more tilted one above it.

For its visual meaning, tilt must be seen as a deviation from the standard spatial framework. Dynamically, tilt is experienced as a shape pulling or pushed away from its standard or straining toward it (Fig. 79). This can be seen in the behavior of the two uprights in Kline's painting. The bar on the left leans toward the distant balancing center, and the heavier one on the right would smash through the center if it descended like a barrier, pivoting around its base at the frame. The picture comes to life and acquires organized unity only if the play of its vectors is seen as oriented toward the central focus—which is given, however, only indirectly by perceptual induction. The rectangular frame and the shapes of the composition create the center, which, in turn, creates their order.

But by omitting any direct reference to the center, the painter understates the basic stability of his composition. He entrusts it to the interaction of his vectors and charges the viewer with organizing what he sees by referring it

tilt

FIGURE 75.
Michelangelo Caravaggio, Saint Magdalen. 1594–1596.
Galleria Doria Pamphili, Rome. Photo, Alinari.

FIGURE 76
(after Ingres)

FIGURE 77.
Pieter Bruegel the Elder, Landscape with the Fall of Icarus.
1558. Musées Royaux des Beaux-Arts, Brussels.

FIGURE 78.
Franz Kline, Painting #2. 1954.
Museum of Modern Art, New York.

FIGURE 79

VARIETY

FIGURE 80

to the indirectly given center. This more dynamic type of composition calls for more sophisticated perception than is required by a work safely and stably built around a visible center.

TENSION THROUGH DEVIATION

We are led to realize that deviation from the center enriches the dynamics of visual shape. This can be seen, for example, in the frequent practice of making shapes play around the center, comparable to the way a music composer weaves his variations back and forth around a theme. In the visual arts, William Hogarth has given a diagrammatic formula to this enlivening variety by his "line of beauty" (Fig. 80), which, I believe, is meant to spiral around the central axis of the pyramid. This embodiment of Hogarth's ideal of beauty is obtained by the interplay of the centric spine with the vectorial outward swings of the spiral. *Did he really believe this? I wonder.*

How does such play around the center operate in practice? Compare the caduceus (Fig. 81) with Michelangelo's drawing of the crucified Christ (Fig. 82). The herald's wand of Mercury represents two serpents entwining symmetrically around a staff. The rigidity of the central axis is enriched by the dynamic theme of opposites compensating each other. To appreciate the other example, Michelangelo's drawing, we remember first that in medieval art the figure of Christ was often represented so schematically that the hanging body with the outstretched arms all but coincided with the bars of the cross. In the sixteenth century, Michelangelo differentiates the vertical axis of the body into a tilted head, a chest slanting in the opposite direction, and another countermotion in the legs. All this adds up to a series of deviating eccentric vectors, which oscillate as the viewer's eyes move along the suspended body.

Historically, Michelangelo's figure is a late and refined example of what

FIGURE 81

Huge limbs, small head

FIGURE 82.
Michelangelo, Crucifixion for Vittoria Colonna (detail).
c. 1538–1541. British Museum, London.

—OK. Here's contrapposto.

began in ancient Greek sculpture as the practice of the counterposition, or *contrapposto*, introduced to relieve the rigid symmetry of the archaic standing figures, the *kuroi*. The classical prototype of the *contrapposto* became the spear carrier or Doryphoros, of Polyclitus, known to us through a Roman copy (Fig. 83). By shifting the weight of the body to the right leg, the artist tilts all horizontal axes and converts their sequence into a play of oscillation. The central axis is not given explicitly but is arrived at by induction from the swinging axes of the counterbalancing knees, hips, and shoulders.

In classical practice the *contrapposto* is essentially a variation within the principal, frontal view, that is, within the second dimension. This early version of the device is carried into the third dimension, as David Summers has shown, by the Italian artists of the Renaissance. At that time the oscillation of the frontal figure develops into the continuous movement of the serpentine figure, which spirals around the internal axis of the sculpture. Read from the bottom up, the movement of Michelangelo's sculpture *Victory* (Fig. 84) begins with a steep diagonal, created by the ascent from the standing right leg to the bent left leg. From the hips the torso continues the counterclockwise twist toward the shoulders, where the spiral is suddenly and violently reversed by the clockwise turn of the head.

The preceding examples can be described as dynamic elaborations of the central axis. Even more frequently, separate centers provided by the composition are intensified and given a particular meaning through their deviation from the central axis. A striking illustration is provided by Rembrandt's famous *Night Watch*, which was cropped in the eighteenth century in such a way that the principal character of the painting, Captain Cocq, appears in the center, whereas Rembrandt had placed him somewhat to the right. In a recent article, Gundolf Winter pointed out that by appearing on the central axis the captain assumes a dominant position—as though his gesture commanded the civic guard to depart—whereas the eccentric position given him in the unmutilated painting was more transitory. The captain was then more nearly just one of the marchers, proceeding with them toward the left, in conversation with his lieutenant.

In another work by Rembrandt, a subtle interplay between the central vertical of the canvas and the main axis of the compositional theme seems to take place. In his *Self-Portrait* at Kenwood (Fig. 85) the head is in a somewhat eccentric position to the left of the central vertical. But since the head's dominant position is not challenged by any representative of the basic compositional framework, the head is strong enough to impose a framework of its own upon the picture. It shifts the central vertical to the left, thereby upsetting the equilibrium and creating a discrepancy between the compo-

FIGURE 83.
Doryphoros, Roman copy after Polyclitus statue of 5th century B.C.
Museo Nazionale, Naples. Photo, Anderson.

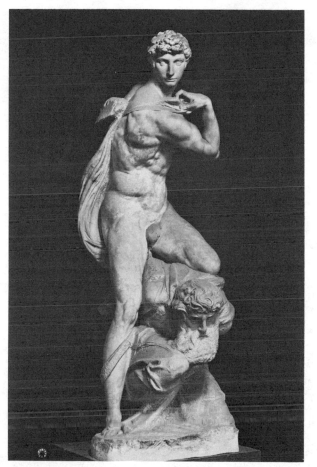

24 Oct 2002

Another tiny head in relation to huge legs. Contrast the proportions of the two figures on these 2 facing pages.

FIGURE 84.
Michelangelo, Victory. 1532–1534.
Palazzo della Signoria, Florence. Photo, Anderson.

sition and the rectangle framing the painting. The relation between the squeezed space to the left of the head and the expanded area to its right looks provisional.

The spontaneous symbolism of this perceptual configuration gives us the powerfully dynamic image of an old man who keeps a deviant balance of his own by pulling himself away from the framework prescribed by the world. His repose is maintained at the price of constant resistance to the magnetism of the central vertical. But there is also another, more stable way of perceiving the picture. In this alternative version, the central vertical wins out. The

FIGURE 85.
Rembrandt, Self-Portrait. 1660. Iveagh Bequest, Kenwood,
London.

figure arranges itself obligingly around that vertical, the head to the left and
the countercenter of palette, left hand, and brushes to the right. Now the
figure, instead of rebelling against the framework of the composition, is sus-
tained by the central axis and in turn sustains it. The painter is at peace with
the world.

FIGURE 86.
El Greco, The Agony in the Garden. c. 1510.
Museum of Art, Toledo, Ohio.

It seems to me that the ambiguity that encourages both these readings is characteristic of the Baroque. The Baroque style is known for generating tension in many different ways. In this case it achieves the effect through the viewer's vacillation between two equally significant views, which are close enough to combine in the unitary image of an intrinsically contradictory stance.

As a further example of this kind of ambiguity I will cite the placement of the kneeling Christ in El Greco's *Agony in the Garden* (Fig. 86). Here again the figure is close enough to the balancing center of the painting to be perceivable in two contradictory ways. It can be seen as located off center, straining toward the central vertical but also holding back. At the same time, it is strong enough to claim the central vertical and pull it toward its own axis. The rock, which surrounds the figure, holds it back, but the dialogue with

the angel promotes a pull in the opposite direction. The dialogue ties the figure of Christ to a secondary balancing center between the two figures. This union of the two principal figures is reinforced by the dominant color scheme, with the triplet of the primaries presented by Christ's red garment, his blue coat on the ground, and the angel's yellow robe. The primaries demand one another for their completion and thus tie the two figures together. When the viewer tries to reconcile the dynamic effects of the various relations, he comes to sense the complexity of the Mannerist composition, a tug-of-war that may offer no definitive outcome. The tension between the advance and the hesitation in the location of the central figure conveys a problematic state of mind, torn by conflict.

El Greco's painting reminds us that pictorial compositions are often based on more than one influential center of their own. The relations between those several centers must be seen with reference to the balancing center of the whole. In *The Agony in the Garden*, the two dominant centers—the angel and the kneeling Christ—are connected by an oblique vector, and the theme of their dialogue is eccentrically related to the balancing center of the painting.

DYNAMICS OF THE HUMAN FIGURE

The centers provided by the compositional theme can be accommodated within a single visual object. The most prominent example of such a combination is the human figure, which is organized around two main centers, one of them in the area of the navel or the groin, the other in the head. The ratio of the weight allocated to the two centers varies greatly; it corresponds symbolically to the relation between the material or instinctual nature of man, associated with the intestinal and genital regions of the body, and his intellectual and spiritual nature, associated with the head, which carries the brain and the principal sense organs.

Visually as well as physically, the human figure balances around the "animal" nature of man, located in the pelvic area. This can be seen in one of the Vitruvian illustrations produced during the Renaissance (Fig. 87). The balancing center is in the navel, the biological point of origin. Seen from that base, the other compositional center, the head, is far removed and therefore subordinate. We recognized, however, when we looked at Michelangelo's Bargello tondo (see Fig. 46), that on the competing hierarchic scale of the vertical vector the head reigns high up in a dominant position. It is this double standard for the evaluation of the two rival centers that leaves the

FIGURE 87

artist free to work out his particular conception of human nature. In fact, it is a decision that must be made every time the human figure is represented.[2]

In the history of the dance there is a distinction between styles centering around the upper region of the body and others emphasizing the pelvic area. La Meri, describing the difference between the oriental and the occidental dance, states that "the occidental dances from the waist down; the oriental from the waist up," and she adds that "the occidental dance is eccentric, all movement going outward from the motive force; the oriental dance is concentric, movement curving inward about the motive center." The modern Western dance derives its action from the balancing center of the body. In an earlier article of mine, I quoted John Martin as reporting of Isadora Duncan that, "through watching, apparently quite objectively, her emotional and motor impulses and relating them to each other, she discovered to her complete satisfaction that the solar plexus was the bodily habitation of the soul and the center in which inner impulse was translated into movement."[3] In that connection I also mentioned D. H. Lawrence, who in his booklet on psychoanalysis and the unconscious asserted that the primal affective center of the unconscious is located behind the navel in the solar plexus. These, then, are attempts to derive not only the material but also the spiritual nature of man from the center in the middle of the body.

A comparison of two figures taken from Edvard Munch's paintings

} Oh?
Really?

2. See Knott's article on Klee and the mystic center (1978–79).
3. Arnheim (1966c).

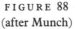

FIGURE 88
(after Munch)

(Fig. 88) may illustrate the two extreme attitudes here under discussion. In the figure on the left the centric visual weight is in the pelvic area, and a downward-directed vector issuing from the head draws the attention to the seat of sexual experience. In the figure at the right the emphasis is on the head as the center of bewildered thought; here the vertical vector points upward to the concentration of energy at the top of the figure.

Any number of examples could be cited to describe the compositional means by which artists of different ages and cultures manipulate the relation between the two principal accents of the human body. When the figure is arranged in a reclining position, the head loses much of its dominance and is degraded more nearly to a counterpart of the feet. Francisco de Goya makes the balancing center of his *Maja Desnuda* (Fig. 89) coincide with that of the rectangular space of the painting and thereby concentrates the viewer's

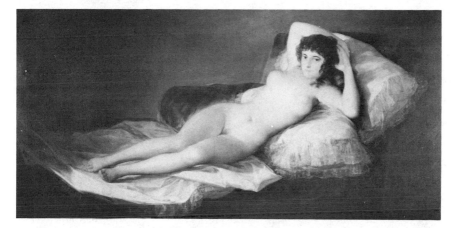

FIGURE 89.
Francisco de Goya, La Maja Desnuda. 1795–1797.
Museo del Prado, Madrid.

attention upon the woman's sexuality. The oblique position of the body axis leaves the head considerable weight, but the appeal to the viewer through eye contact is clearly intended to lead him on in the direction of the primary center.

The very opposite compositional strategy is evident in works that stress the spiritual or intellectual nature of man. This is true for much religious sculpture of the Middle Ages. In the Byzantine mosaic shown in Figure 8, the vertical vectors of the standing figures move across the middle centers without stopping and reach their uncontested climax in the row of heads.

SALTIMBANQUES AND GUERNICA

I will complete this discussion of visual centers serving as hubs with a comparison of two well-known paintings by Picasso—an early one and one from his middle years—which display unexpectedly similar compositional schemes. At first glance, the *Family of Saltimbanques* of 1905–1906 (Fig. 90) presents itself as a conglomerate of five standing figures, separated from a seated woman by a spatial interval. It is an uneasy sight because the large cluster on the left looks out of balance with the single figure on the lower right, giving the impression that the composition has failed to reach its final shape. If we trust our own first impression less than Picasso's judgment, we search for a more adequate apperception of the work, and having been alerted to the crucial function of the balancing center, we come to focus our

FIGURE 90.
Pablo Picasso, Family of Saltimbanques. 1905–1906.
National Gallery of Art, Washington, D.C.

attention on the two boys. Standing in the middle, they are invested by their spatial location with the full power of the balancing center. This makes us experience a sudden, dramatic restructuring of the scene.

We now realize that a difference of compositional function splits the cluster of five figures into two groups. The two boys hold the middle and are separated thereby from the lateral group of three—a separation supported by the massive jester, who turns his back to the central pair and closes the trio on the left. This reorganization leaves us with three principal centers: the boys in the middle, the three figures on the left, and the woman on the right. Dynamically, a curious tension is created by the contradiction between the close spatial contact of the central group with the lateral one and its functional separation from it. This tension, however, is balanced by the very

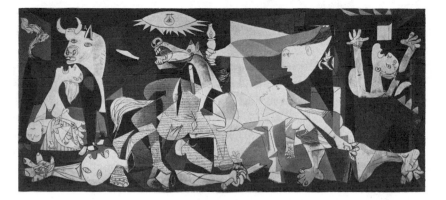

FIGURE 91.
Pablo Picasso, Guernica. 1937. Museo del Prado, Madrid.

opposite contradiction in the other half of Picasso's picture. Here the spatial distance of the boys from the woman is bridged by the strong diagonal vector that leads through their heads to the head of the woman and is supported by the direction of their gaze.

The composition now reveals a centric symmetry between two inverted contradictions: functional detachment counteracted by physical contact on the left and functional attraction overcoming physical separation on the right. This symmetry constitutes a stable centricity, very unlike the disturbing lack of balance we noticed at first glance. But there is more. The overall centricity of the composition is overlaid by a strong eccentric vector that moves from the left all the way to the right. It is carried by the overall curve of the heads and the direction of the glance in all figures but one. So powerful is this vector that it must be counteracted by the heavyweight figure of the jester.

The lateral vector of the five standing figures points like a wedge toward the seated woman; but she is not the final target. She participates in the orientation toward the right and therefore represents only a way station to an undefined goal that lies in the infinite, beyond the confines of the frame. Reaching past the perceptually given target there is a spiritual longing that transcends the episodic genre scene of the strolling acrobats.

A remarkably similar compositional pattern can be discerned in a later work by Picasso, in spite of its very different subject matter. The *Guernica* mural of 1937 (Fig. 91) is also built on a tripartite centric symmetry, and it is also traversed by a transcendent lateral vector. In this case the eccentric

vector moves from the right to the left, probably, as I mentioned earlier, because the visitors to the Spanish pavilion, for which the painting was commissioned, approached it along that direction.

The central component of the composition has the shape of a pyramid, which peaks on the central vertical of the canvas in the small lamp near the horse's head. The principal subject of the pyramid is the horse as the victim of the Fascist attack. Its wounded body, pierced by a projectile, represents at the balancing center of the painting a microtheme of the total subject. The central scene is flanked by the triptych's two wings, which feature oppositely oriented vertical vectors: on the right a woman, her clothes on fire, falling from a house; on the left the towering figure of the bull rising above the carnage.

The stability of the centric symmetry describes the state of affairs as given—the murderous attack to which the Spanish republic was being subjected at the time. The mural's mission, however, went beyond that of accusation. It also embodies the hope for survival. This theme is carried by the eccentric vector that overlays the centric theme with goal-directed action; it overlays space with time. All the figures of the central and left areas of the painting are oriented toward the bull, the emblem of Spanish prowess, as the aim of their hope.

Here again, however, just as in the *Saltimbanques*, the bull is only the immediate objective of the choral appeal. The bull, although facing the scene with his body, turns his head in the direction of the pervasive movement toward the left. This means that here also the striving toward the goal transcends the tangibly given target and moves beyond the confines of the picture to a distant fulfillment.

CENTERS AS DIVIDERS

Center and off center
Centric and eccentric

T HUS FAR, WE HAVE seen the balancing center serving as a stabilizer of
weight. Compositional objects located in the central area or on a cen-
trally located axis gained in power and were protected from the pushes and
pulls of eccentric positions. Even objects located outside the middle area
could be seen as united and stabilized when they grouped around the bal-
ancing center.

BIPOLAR COMPOSITION

But striving for unity is only one of the tendencies that help composition
to do its work. The visual objects that make up compositional patterns also
need some independence, some sovereignty of their own. When this auton-
omy of the parts is strongly pronounced, the composition presents itself as
an encounter of separate agents, which respond to one another in various
ways. The most common form is that of a duality, the meeting of two part-
ners, divided and balanced by a central axis: we may call this form a bipolar
composition.

Such a dichotomous encounter can have the character of a dialogue be-
tween parties seeking each other, as for example in the representations of the
Annunciation. It can also show the confrontation of enemies or the contrast
between opposites, such as that between light and darkness. I will begin with
one of Edvard Munch's stark depictions of the theme of jealousy (Fig. 92).
A white streak in the middle of the picture divides a world of total darkness
on the left from the tattered pattern of blacks and whites on the right. It
separates the brooding isolation of the husband from the equally sinister
tryst of the adulterous couple. The husband's staring face, although in-
tensely outward-directed, is paralyzed in the fixation of his thought by its

133

Oh, I missed the man's figure on the right.

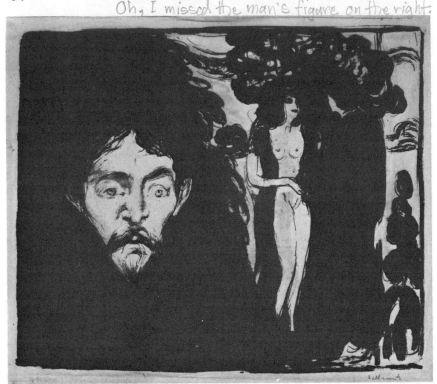

FIGURE 92.
Edvard Munch, Jealousy. 1896. Art Institute of Chicago.

frontal symmetry and centric position.[1] In contrast, the couple of lovers is wrapped in dialogue but animated by its dynamic elongation. The vertical axis in the middle balances the two halves of the picture and invites comparison. This lateral relation is made more specific by the central horizontal axis. It fastens the husband's eyes to the pubic center of the woman—an eccentric vector, which connects subject and object actively by carrying the significant items as a microtheme.

Much less noticeable but equally essential for a proper reading of the composition is the vertical separation in Bellini's landscape (Fig. 93). The separation is barely indicated by the profile of the rocks in the foreground, cutting through the open vista of the background. The lateral axis stresses a

1. Isak Dinesen, like Munch a Scandinavian, observes in one of her stories, "The Bear and the Kiss," that jealous persons "when they are sitting and guarding someone . . . like a cat in front of a mousehole, . . . take one's breath away so that it is difficult to move—and they themselves shrink until there is life only in their eyes."

FIGURE 93.
Giovanni Bellini, Saint Francis in Ecstasy. 1480–1485.
Frick Collection, New York.

further separation between the monk and his stony abode in the lower right and the panorama of flourishing nature in the upper left. Up there is also the exalted location of the invisible apparition, toward which Saint Francis's glance is oriented. This transversal eccentric vector moves diagonally across the central vertical. The latter, however, is indispensable for the definition of the man's attitude. He approaches the place of the revelation as closely as possible but is stopped as though by a glass wall from further advance and falls back with a gesture of passive surrender.

In our gravity-controlled environment vertical divisions come easy whereas horizontal ones take special circumstances. Also the balance between left and right, which makes for equal partners on the horizontal plane, differs substantially from the hierarchic inequality of above and below. In *Narcissus*, attributed to Caravaggio (Fig. 94), the horizontal symmetry axis

FIGURE 94.
Michelangelo Caravaggio, Narcissus. 1594–1596.
Galleria d'Arte Moderna, Rome. Photo, Alinari.

is placed slightly below the geometrical center and increases thereby the surpassing weight of the boy in the upper half. The mechanical symmetry of the two images, which would be conspicuous and deadening if it occurred around a vertical axis, is all but overruled by the dominance of the top; and the paradoxical disproportion between the heavy weight above and its diaphanous reflection below gives the scene a floating unreality, appropriate for a mythological anecdote.

THE NECESSARY LATCH

When a composition is built on two segregated halves, the weight of a central axis, be it vertical or horizontal, divides the two parties effectively. More than separation is needed, however. If those parties did not interact, there would be no good reason for them to be united in the same composition. Therefore, the dividing axis commonly carries a bridging element as well.

In Fra Angelico's *Annunciation* (Fig. 95), the central column separates the celestial realm quite harshly from the domestic abode of the Virgin. In fact, it seems to block the angel from conveying his message. At the same time, however, the central column is a part of the arched colonnade that surrounds and unifies the scene. In its architectural context it helps to strengthen the internal space, which connects the messenger and the recipient without interruption.

Consider here the double function of the Tree of Knowledge, separating Adam from Eve in the many representations of the Fall. In most cases, the tree stands on the central vertical as a weighty barrier between the tempting woman and the tempted man. But, for example, in Tintoretto's composition (Fig. 96) Eve holds on to the trunk as though to a possession, and she reaches across it in such a way that the apple, the *corpus delicti*, appears at the compositional center as the microtheme of the story. Similarly, Manet in his *Rendezvous of the Cats* (Fig. 97) has the central chimney separate the carrier of darkness from that of whiteness; but he counteracts the separation by having the tail of the white cat sweep across the chimney and the head of the black cat poke into it. What better way could be found to depict the ambivalent relation between suspicion and attraction and, in its symbolic resonance, the equally ambivalent relation between vice and virtue.

Gauguin uses a bipolar composition to depict an artist's separation from his work (Fig. 98). He places the figure of van Gogh close to the right border and his easel as far away as possible at the left border. We are reminded of Michelangelo's *Creation of Man* (see Fig. 117), where the gap between the

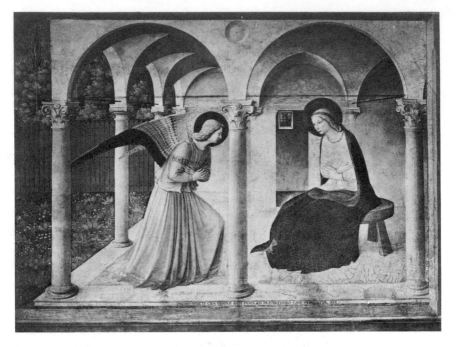

FIGURE 95.
Fra Angelico, Annunciation. 1439–1445.
Museo di San Marco, Florence. Photo, Alinari.

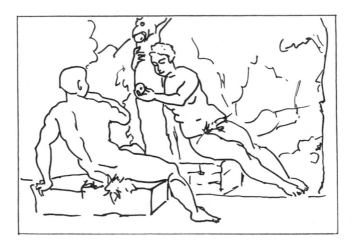

FIGURE 96
(after Tintoretto)

FIGURE 97.
Edouard Manet, Le Rendez-vous des Chats. 1870.
Boston Museum of Fine Arts.

two distant centers is similarly bridged by the eccentric vector of the creator's arm. In both instances, the creator on the right faces the creature to be animated on the left, and a touch of the fingers accomplishes the miracle of creation. But the resemblance ends there. Michelangelo has the two figures lean toward each other, eager to overcome the gulf between spirit and matter; Gauguin uses the portrait of his friend to depict creativity as a problematic struggle. The palette on the central vertical connects the maker and his work as a ponderous base, but the two principal masses lean away from each other like the arms of a V. It is as though the clustered sunflowers shied away from the animating touch, and the painter's hand is all but disconnected from its

FIGURE 98.
Paul Gauguin, Portrait of Vincent van Gogh. 1888.
Stedelijk Museum, Amsterdam.

owner by being relegated beyond the central vertical to the left wing of the picture. The painter himself is turned away as far as possible, reluctant, it seems, to face his task.

The tension created by the oscillation between attraction and withdrawal in a work of the nineteenth century is also evident when we compare Georges de la Tour's *Education of the Virgin* (Fig. 99) with a double portrait by Edgar Degas. In both cases a book is placed on the central vertical as the connecting link between two figures. In the religious image the book has the additional weight of being the target of both partners' concentrated attention. The radiance of the prayer book sends strong eccentric vectors to the faces of both mother and daughter, who are united by a common devotion.

In Degas's *Violinist and Young Woman* (Fig. 100) the conspicuously empty book, occupying a dominant position near the balancing center of the painting, is not being regarded by either person. It was meant as the vehicle of the woman's advance toward the man, but the relation is not consummated.

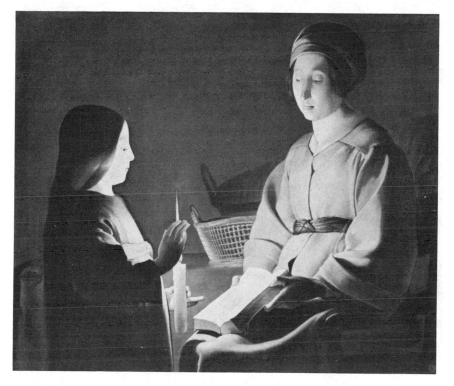

FIGURE 99.
Georges de la Tour, The Education of the Virgin.
Frick Collection, New York.

Their proximity does not make for communication but rather underscores the lack of it. Confined in separate halves of the picture, the two persons are united only by the parallelism of their response to some object of common interest outside. They both do the same thing, which makes them ignore each other, and the blatant whiteness of the upturned book keeps them apart rather than bringing them together.

A subtle combination of connection and separation is offered by Titian in his *Holy Family* (Fig. 101). Few renderings of this subject permit the figure of Joseph to dominate the center. Here his central position is justified by his twofold function as a mediator and a guard. It is he who introduces the shepherd boy to the Madonna, but at the same time he also makes sure that the sacred realm remains properly detached from the mundane. Joseph's head occupies the central vertical at the apex of the triangular figural arrangement, but his body emerges obliquely from the right lower area, the realm of the ordinary mortal, from which Joseph himself originates. The

FIGURE 100.
Edgar Degas, Violinist and Young Woman. 1870–1872.
Detroit Institute of Art.

ambiguity of this diagonal vector is nicely exploited. The leaning figure of
Joseph conducts the boy to the sacred scene of mother and child, but Joseph
also withdraws from the boy toward his family, thereby expressing protective
detachment. This separation is explicitly represented by the vertical bound-
ary line of Joseph's staff and by his fist, which blocks the boy's view. The
boundary, however, is not strong enough to disrupt the central avenue of
communication. Along the horizontal axis, an eccentric vector sweeps across
the picture, connecting mother and child symmetrically with the head of the
boy.[2]

2. The mediating role of Joseph is reflected also in Titian's use of colors. The foreground
composition is based on his favorite theme of blue and red. These two stable primaries are
reserved for the Virgin and the shepherd boy, whereas Joseph is clad in the secondary colors
purple and orange. Secondaries, being combinations of two colors, express transition. Thus the
theme of mediation between the object of adoration and the earthly worshipper dominates the
scene.

FIGURE 101.
Titian, Holy Family. 1516. National Gallery, London.

DIAGONALS

I have discussed bipolar compositions where the two parties are separated by a central axis and connected by an eccentric vector either in the horizontal or the vertical direction. Horizontal connection puts the two partners on an equal footing, like tennis players on a level court. Vertical connection creates a hierarchic difference by giving the upper center more weight, greater power. When the connecting vector is tilted, an in-between relation results. In an elongated painting, Lucas Cranach places King David high up on the left side (Fig. 102). This puts him in a clearly dominant position in relation to his prey, Bathsheba. The lady, however, does not appear strictly below the king. The diagonal connection between them has the potential of a meeting on more equal terms. In addition, the tilt of the relation greatly increases the tension of the scene. I observed earlier that tilted shapes are perceived as deviations from the static framework of the vertical and horizontal. Thus the oblique spatial relation between the king and the lady reads as a struggle between total subjugation and a confrontation on a more equal level.

The second diagonal in Cranach's painting, running from the lower left to

FIGURE 102.
Lucas Cranach the Elder, David and Bathsheba. 1526.
Staatliche Museen, Berlin (West).

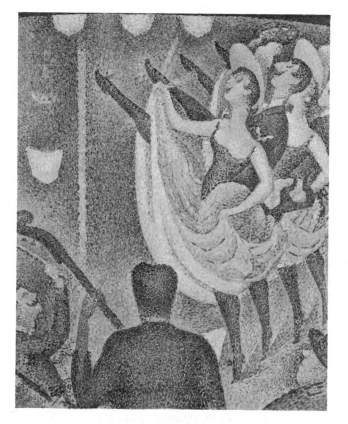

FIGURE 103.
Georges Pierre Seurat, Study for *Le Chahut*. 1889.
Albright-Knox Gallery, Buffalo.

the upper right, separates the two parties from each other. This division is spelled out by the oblique line of the three female heads. We recognize here that a diagonal axis, although structurally not as strong as the basic gravitational framework, has a stability of its own and therefore gives some strength to the division it supports. In Seurat's *Le Chahut* (Fig. 103) the dominant diagonal separation strongly increases the dynamics of the scene. At the same time, however, it acts as a solid truss, tying two opposite corners of the painting together and all but freezing the high kick of the dancers' legs. Together with the hefty symmetry of the bass player on the central vertical, this arrangement paralyzes the action in a manner most characteristic of Seurat's style. *paralyzed action*

We have observed that in many bipolar arrangements the balancing axes

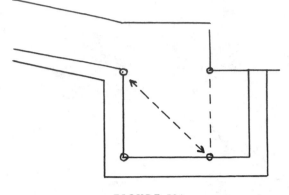

FIGURE 104

serve as dividers and therefore are trenches rather than positively marked elements of the composition itself. But we also have found that the balancing center in the middle tends to be overridden, although its virtual presence is always needed to hold the composition together. This is true not only for upright works of art, such as paintings on the wall, but equally for compositions on the horizontal plane, especially on the theater stage. In the base position of the actors on the Japanese Noh stage (Fig. 104) the balancing center is empty. The square-shaped stage area is marked by four corner pillars; the principal actor (*shité*) is placed at the rear left pillar whereas his antagonist or respondent (*waki*) operates from the near right. This establishes the diagonal as the principal vector of dramatic action, producing stability and dynamics alike.

NOLI ME TANGERE

To conclude this discussion of bipolar composition, I will analyze Titian's *Noli Me Tangere* (Fig. 105) in some detail. By dividing the area of the painting in four quadrants, we find the nucleus of the dialogue between Christ and the Magdalen in the lower left, the territory assigned to Christ. The kneeling woman, placed diagonally below her master, is prevented by the central vertical from trespassing, even though the aggressive action of her raised arm approaches the center of the man's masculinity. She is undeterred by his staff, which acts as a visual boundary between the figures. Remember here how the story told in the Gospel of Saint John plays on the ambiguity of the Christ figure, removed from mortal existence by his death—he is an apparition—but still endowed with the visible presence of a living man. He is still

[handwritten marginalia, left margin: How delicately he puts it. That she wants to grab his cock? What's he trying to say?]

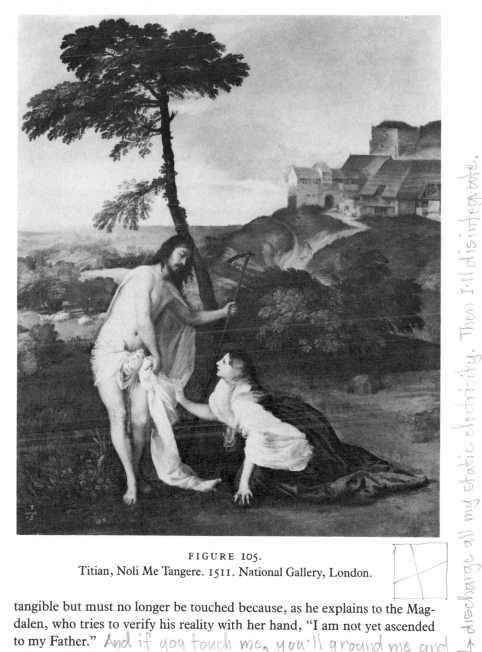

FIGURE 105.
Titian, Noli Me Tangere. 1511. National Gallery, London.

tangible but must no longer be touched because, as he explains to the Mag-
dalen, who tries to verify his reality with her hand, "I am not yet ascended
to my Father." *And if you touch me, you'll ground me and*
The Christ figure responds to the woman's advance by the concavity of its
withdrawal, achieved primarily by the inclination of the torso. But this in-
clination has all the ambiguity of a tilted vector: when read downward, it

→ discharge all my static electricity. Then I'll disintegrate.

makes Christ recoil from the touch; when read upward, it makes him bend protectively to receive his faithful follower. The two centers of his body, head and pelvis, act in counterpoint to represent the ambivalent relationship between the two persons.

The figure of Christ dominates the foreground; but although his head lies on the horizontal balancing axis, the scene of his meeting with the Magdalen is, as it were, under water, confined to the lower half of the painting. This lower region is separated by the horizon from the upper realm of free spirituality, in which the tree and the buildings on the hill reach heavenward. Although Christ is already removed from earthly existence, he is shown by Titian as still sharing it with the Magdalen in this last encounter. He is still subjected to physical forces, held down by the horizon and hemmed in by the trunk of the tree; he has yet to move upward to the sphere of transfiguration, where he will become unreachable.

The distinction between the lower and the upper region is symbolized also by the assignment of the principal colors. The figure of the Magdalen has the active shape of a wedge, trailing along the ground like a snail and reinforced by the bright red of her garment. This identification of the woman with the hot color is answered by the cool counteragent of the blue water, surrounding the man's head in the upper region of the painting.

VOLUMES AND NODES

This is the more correct {Or being held apart by}
description of a {being pulled together.}
tensegrity.

28 Oct 2002

pushes & pulls...
being held together by
being pulled apart.

I N THE PRECEDING CHAPTERS, our two compositional principles have
been applied mainly to the basic structure of a work of art as a whole, the
large features holding it together and articulating its theme. I have discussed
the balancing center of the whole and also the larger masses contributed by
particular compositions. By acting essentially through their weight, these
masses are representatives of the centric system; but by their positions in
space, they also become the bases for the directed action of pushes and pulls,
that is, for vectors representing our second compositional principle, the ec-
centric system. These vectors, in turn, were found to establish interrelations
between the centric masses. I am reminded again of an example given earlier:
the nerve cells, or neurons, of which the nervous system is composed—cen-
tric nuclear bodies that send out stringy tentacles, the axons and dendrites,
by which the cells accomplish their interaction.

pulled together &
pushed apart vs.

1	2
4	3

VOLUMES AND VECTORS INTERACTING

pushed together
and
pulled
apart

It is necessary now to refine this simple picture in two ways. First, the two
systems organize not only a composition as a whole but also each of its parts,
as long as each part has some completeness of its own—a single face or hand,
for example, or a single flower. Second, we must realize more fully that both
principles are always present together. A centric system, for example, is
made up of a sunburst of vectors (see Fig. 1). It is only by their collective
arrangement that the vectors add up to centricity; and it is only by consisting
of vectors that the centric system becomes a focus of forces. Or think of the
balancing axes around which, as we have found, many compositions are or-
ganized. They are certainly centers, defined by their location and weight,
but their elongated shape also stresses that they are vectors, directed forces
pointing like arrows in particular directions. If we distinguish visual objects

*24 Oct 2002
Looks like a
Pratt "construction"
problem*

FIGURE 106
(after Lissitzky)

from one another by calling them volumes or vectors, we are adopting a convenient simplification, to be handled with caution.

Volumes impress us primarily by their *being*, vectors by their *acting*. In Figure 106, a simplified tracing of an abstract composition by El Lissitzky, a massive dark disk qualifies as a volume of considerable weight. Its eccentric position, however, charges it with a strong vector toward and away from the balancing center of the whole, and this off-center location modifies the centric symmetry of the vectors sent out and received by the circular figure. Eccentricity is the main theme of this painting, and in recent years some artists would have been frugal enough to let it go at that. Lissitzky elaborates his theme by exploring the relations of the displaced center to a grid of vertical and horizontal items, with a few diagonals in the background. Those elongated bars function essentially as vectors, pointing and moving in various directions. Clearly, however, they are also volumes, differing in size, proportion, and weight. Together, they define the particular ratio between massive weight and pointed action intended by the artist.

The variation of this ratio accounts for important stylistic traits. Certain early styles, for example, that of the Easter Island monoliths, rely on compact volumes, and at a more differentiated level classicist and monumental styles show a similar preference. Certain still lifes, such as those by Cézanne, use clusters of volumes—for instance, apples piled on a plate—touching and overlapping one another, to form densely accumulated masses. On the other side, the patterns of the high Baroque or of Cubism derive from the tendency of these styles to split and slice volumes into configurations of many individual vectors. *Yes, cubism can be seen as vectors and slices. A slice is a "negative" plane.*

*clusters
of
volumes*

KINDS OF NODES

Volumes create heavy compositional centers by the conglomeration of mass; but vectors are equally effective in producing such centers. They do so by intertwining in complex configurations. The centers created by such combined action of directed forces I term *nodes*. Nodes create centric weight by various means, some of which I shall enumerate.

(1) There are, first of all, the sheaves of concentric radii that emerge from a center. Light sources, such as the sun or halos, are examples; so are the lines and surfaces deriving from the vanishing points of central perspective. In Moreau's *Apparition* (Fig. 107), the head of the murdered prophet is surrounded by the splendor of dazzling rays and creates a node of dominant intensity.

(2) Visual dynamics in the opposite direction, the convergence of vectors toward a common center, also generates nodes. The keystone in which the ribs of a Gothic vault meet becomes a center of concentrated energy. A group of people seated around a table produces a similar convergence. The climactic encounter of this type is the lovers' embrace, and indeed any bunching of objects. The three swords clasped by the hand of the father in David's *Oath of the Horatii* act as a counternode to the tight cluster of the three sons. The intensity of such a center is greatly heightened when the elements shown in physical proximity are struggling to separate. Think of two prisoners tied together, or of Prometheus or Andromeda bolted to the rock, or of two persons back-to-back who have nothing to do with each other—a symbol of estrangement used sometimes by Degas.

(3) Crossings are nodes. Kevin Lynch, in his book *The Image of the City*, speaks of nodes as "strategic spots in a city into which an observer can enter and which are the intensive foci to and from which he is traveling. They may be primarily junctions, places of a break in transportation, a crossing or convergence of paths, moments of shift from one structure to another." The transfer points on a subway map interrupt the linearity of movement for each line and combine the one-dimensional vectors in a two-dimensional network. In a traditional church, the crossing of nave and transept is a node of high intensity, produced by the interaction of two channels, from which it differs qualitatively by being a place of standstill. In general, every node represents a holding point in the composition. But far from being a static point, at which action ceases, the intertwining of differently oriented vectors produces a highly dynamic mutual arrest. In this sense, crossings are elementary versions of knots.

In other words, fucking.

could be a description of a tensegrity

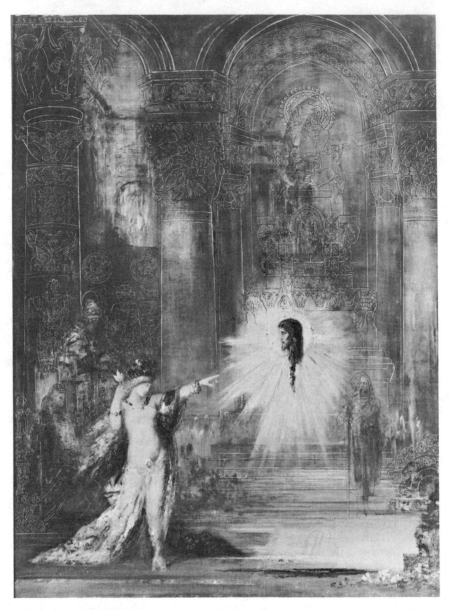

FIGURE 107.
Gustave Moreau, L'Apparition. 1876. Louvre, Paris.

FIGURE 108
(after Degas)

(4) Knots provide a greater interruption than mere crossings because they bend and twist the vectors constituting them and therefore are more compact and self-contained. They also differ from mere overlapping. In Caravaggio's *Magdalen* (see Fig. 75), the area of the balancing center is marked by two nodes, namely, the loosely overlapping hands and the tight knot belting her dress.[1]

(5) Superposition, such as that of the Magdalen's hands, creates less self-contained centers than do knots. It also creates tension, however, by the partial covering of shapes, brought about by overlapping. The Magdalen's right hand has become a fragment, begetting a tension directed toward release, and this tension gives the node energy and weight. The figure of a man playing the violin (Fig. 108) provides a whole bundle of nodes: the player's cheek overlaps the violin, the bow crosses it, the right hand hugs the bow, and the left hand grasps the neck of the instrument. Together, these nodes form a center of considerable intensity.

(6) Any grasping or surrounding involves superposition but delivers a more complete constraint. Tintoretto's Eve (see Fig. 96) embraces the tree trunk between her right hand and her head. A hand grasping a cane provides tension for a node, and so does a scarf or hood wrapped around a face.

(7) Any kind of contraction produces nodes. In the depth dimension, foreshortening creates such contractions. A quietly standing horse gains visual intensity when it is seen from the front or back rather than the side. In the dimension of the frontal plane, the bending of joints in the human body offers the most convincing example. The seated figure of a woman in Manet's

1. On the traditional symbolism of knots, especially in their relation to the one-line paths of mazes, see Coomaraswamy (1944).

FIGURE 109
(after Manet)

Déjeuner sur l'herbe (Fig. 109) is squeezed into a triangle. The torso, the arm, the legs, form acute angles pointing in different directions. The elbow overlaps the knee, the hand is sharply angled at the wrist and grabs the chin, and the neck maintains itself upright against the curve of the back. This sum of contractions adds up to a powerful node. Or recall Rembrandt's Susanna, jackknifed under the attack of the elder, who tries to pull the towel from her body.

NODES OF THE BODY

It appears from these last examples that the human body, because of its rich articulation, is particularly well suited to create expressive nodes. The volume of the torso serves as the base from which the mobile limbs issue, and the torso itself has enough joints to contribute to the nodal dynamics of the figure.

An articulate torso combines expansive and contractive themes. It can supply the hollow of the stomach, the swellings of belly and muscle. The composition of Courbet's *Woman in the Waves* (Fig. 110) is based on the counterpoint between the outgoing breasts and the arms confining the head. This antithesis of expansion and contraction, of exposure and withholding, characterizes the image of woman as temptress in the arts of antiquity and of the Renaissance. The standard gesture of the *Venus pudica* protecting her sex against exposure still reverberates in the nineteenth century in the resolute

FIGURE 110. *This picture should be titled "Tits!"*
Gustave Courbet, Woman in the Waves. 1868.
Metropolitan Museum of Art, New York.

gesture of Manet's *Olympia*—a contractive, centripetal vector counteracting the expansive display of the body. We also recall the two figures taken from Munch (see Fig. 88). They demonstrate impressively strong nodes, giving weight to the two main centers of the body by the covering of the lap and the grasping of the head.

Much help comes from the action of the limbs. In the Byzantine mosaic

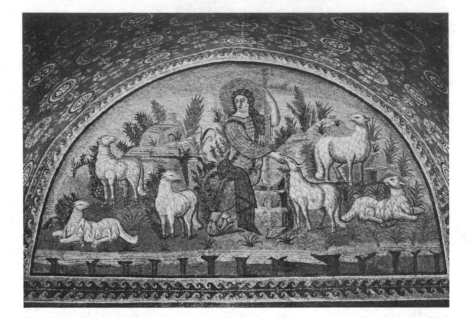

FIGURE III.
The Good Shepherd. 5th century.
Mausoleum of Galla Placidia, Ravenna.

at the Mausoleum of Galla Placidia in Ravenna (Fig. 111), the Good Shepherd dominates the semicircular scene by his surpassing size and central position. Equally significant, however, is the lively action that distinguishes him from the quiet stance of the lambs. His body, organized around the central column of the torso, is twisted through the turn of the shoulders. This turn is acted out by the lateral position of the arms, just as the position of the legs defines and executes the opposing turn of the pelvis. The sideways glance of the eyes, the oppositional gestures of the arms, which combine dominion and compassion, and the enlivening crossing of the feet all characterize the shepherd as the central node of the composition.

Within the human body there is an ambiguity in the relation between torso and limbs. The volume of the torso can be viewed as the base and central agent of the action, sending its impulses to its extremities for execution. This is a centrifugal version of the body dynamics. Conversely and centripetally, the head as the center of reasoning and control can be viewed as conveying its initiative to the body. Similarly the hands can initiate arm movements.

In David's *Death of Marat* (Fig. 112) the nude torso of the murdered man may be seen as rising from the body's hidden center. Chest and arms,

FIGURE II2.
Jacques-Louis David, Death of Marat. 1793.
Musées Royaux des Beaux-Arts, Brussels.

although relatively undifferentiated volumes, carry the vectorial meaning that is spelled out by their terminal accents, the face and hands. The head marks the decisive break in the body axis, the loss of life; and the arms as the conveyors of ceased motion end unexpectedly and paradoxically in the lingering action of the hands still gripping pen and paper. But one can also read the same theme in the opposite direction, starting from the highly expressive face as a displaced and therefore tension-loaded center and petering out in the lifelessness of the abandoned body. Similarly, the hands as the still-engaged executives of the mind, can be seen as left alone, deprived of support.

a term from mining [handwritten marginal note]

FACES AND HANDS

The example of David's painting shows how face and hands are predisposed to add strong compositional centers to the visual structure of the human body. What the limbs do for the body, the face does for the head and the fingers do for the hand. It may seem artificial to separate the face from the head by calling the head a volume and the face a node of vectors. But a glance at the history of sculpture shows that this separation has imposed itself from the beginning as a problem, overcome only in sophisticated realistic representation. In principle, the skull is a sphere, symmetrically organized around its center, whereas the face is a relief surface. Thus in much early sculpture the face is either reduced to a few markings on the ball of the head or conceived as a flat shield, to be somehow combined with the volume of the skull. There is a bronze head by Picasso in which a diamond-shaped face is attached as a separate façade to the ball of the head (Fig. 113). At a more differentiated level of composition the two elements fuse in a unitary conception, as also happens with the relation of torso and limbs.

Can a face be described as a node, that is, as a constellation of vectors? It can if, as we must, we perceive the facial features as dynamic shapes. The eyes are identified with the powerful directional beams of the glance, which often control the spatial orientation of an entire figure. The lips are an unfolding, outward-directed blossom, and the prow of the nose points forward and downward. The exact constellation of these vectors varies with the particular representation. Its symmetrical arrangement can make for an island of classical serenity, often in contrast to a complex pattern of body and dress. But a face can also be loaded with tension, tightened by emotion, foreshortened or tilted by perspective. In a nonrealistic style, the symmetry of the features can be distorted and the tension thereby enhanced (Fig. 114). In

FIGURE 113
(after Picasso)

FIGURE 114
(after Picasso)

cartoons, protruding noses, bulging eyes or lips, receding chins, and so forth, show in their exaggeration the expressive function of facial vectors.

In spite of its vectorial arrows and twists, however, the face is quite limited in its muscular mobility. In this respect, the hand has the superiority of a dancer. Although it lacks the physiognomic connotations of the face—the references to looking, sniffing, and smiling—the highly differentiated play of the fingers can generate a rich pantomime. Also, compared to the action of the body as a whole, it is much less dependent on the pull of gravity. To

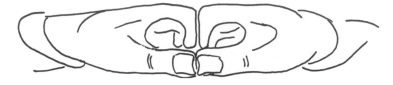

FIGURE 115

be sure, hands can passively drop and actively rise, but being supported by the arms, they can also move in space almost weightlessly.

The play of the hands is particularly enriched by their performance in company. A person's hands are a duo of twins working together in a natural *pas de deux*. The hands of two persons meet in dialogue, embracing, wrestling, cooperating. To get a sense of the infinite wealth of constellations available to a pair of hands, one need only glance at a survey of the hand gestures codified as mudra for use in Buddhist dance, sculpture, and painting.[2] Figure 115 shows the mudra of concentration, representing the divine and human law of the Buddha through the union of two rings, the ring shape meaning perfection. More psychologically, the dramatic hands painted by Grünewald in his *Crucifixion* (Fig. 116a–d) help us to identify some of the types of behavior acted out by hands: (1) expressive; e.g., the spasmodic spreading of the fingers when the hand has been pierced by a nail (Fig. 116a), or the wringing of hands in despair (116d); (2) communicative; e.g., pointing or beckoning (Fig. 116b); (3) symbolic; e.g., folding the hands for prayer, giving the blessing, or giving the communist clenched-fist salute (Fig. 116c); (4) functional; e.g., grasping, poking, tearing, pushing, for practical purposes; (5) sign language; e.g., a number of fingers raised to indicate quantity, or signaling victory.

The most famous example of two hands meeting as emissaries and executives of two persons in dialogue is Michelangelo's *Creation of Man* (Fig. 117). The two hands, meeting at the balancing center of the painting and thereby endowed with decisive compositional weight, play out the essence of the scene: Adam's hand is still limp, barely able to lift itself in response to the approaching giver of life, while the hand of the Creator reaches actively toward its target.

Michelangelo has the two hands perform the microtheme of his painting, the infusion of soul into inanimate matter. I mentioned before that hands lend themselves particularly well to acting as microthemes because as parts of the body they are sufficiently self-contained and articulate to represent

2. See Saunders (1960).

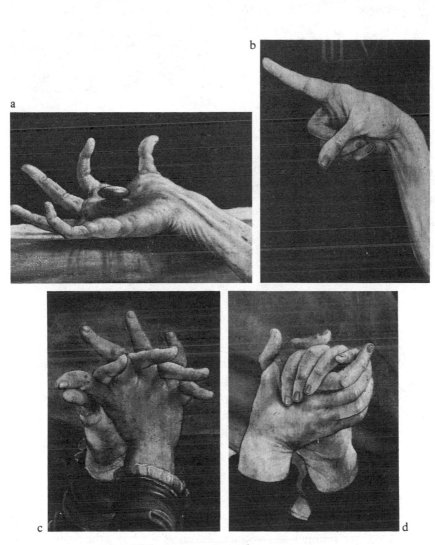

FIGURE 116.
Matthias Grünewald, Details of hands from the *Crucifixion*.
Isenheim altar. 1515. Musée d'Unterlinden, Colmar, France.

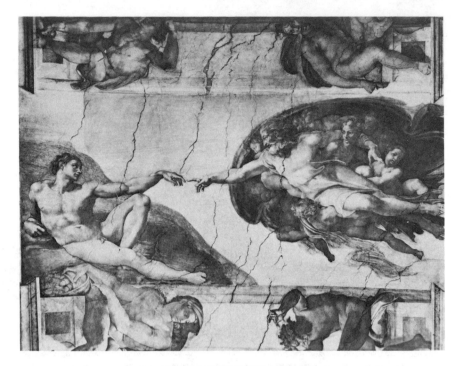

FIGURE 117.
Michelangelo, The Creation of Man. 1508.
Sistine Chapel, Vatican, Rome. Photo, Alinari.

complex action. To further illustrate this, I cite a painting by Manfredi (Fig. 118), where the noisy action of chastising Amor pivots like a propeller around the balancing center of the painting. At the center, the castigator takes hold of the boy's wrist to keep his hand from committing further mischief. Once again, the complicated plot of a painting's story is condensed to a simple, telling theme.

SINGING MAN

A sculpture by Ernst Barlach (Fig. 119) summarizes the compositional roles played by volumes and vectors. Taken as a whole, the figure of the crouching man is a centric focus of energy, sending its forces in all directions. It is a center not made up of a compact mass but of a node of vectors. The balancing center located in the hollow of the navel area organizes the lower part of the body as a stable base against the torso shooting upward in a strongly dynamic diagonal. The main weight, however, is at the bottom and

FIGURE 118.
Attributed to Bartolomeo Manfredi, Chastisement of Amor.
c. 1595. Art Institute of Chicago.

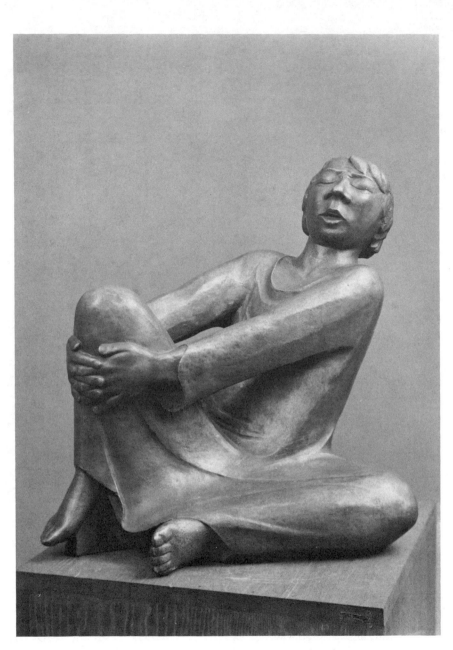

FIGURE 119.
Ernst Barlach, Singing Man. 1928.
Museum of Modern Art, New York.

roots the figure firmly in the ground. The dynamic vector of the torso and the equally oblique pair of arms is given a stabilizing framework by the other pair of vectorial volumes, the legs embodying the vertical upright and the horizontal hugging the ground. The bronze figure has the solid foundation of a building.

The right-angled framework of the legs expresses an openness that magnifies the theme of the singing mouth. Expansion and contraction are skillfully balanced. The arms tighten around the knee to keep the body from falling apart, but by that same gesture the right leg is also drawn upward with its foot lifted from the ground. Equally tightly closed are the eyes of the man, as he raises his head like a singing bird and his mind, too, concentrates on the rousing experience of the music.

SPACE IN DEPTH

IF OUR COMPOSITIONAL principles are to hold for all the visual arts, they must apply to the three-dimensional works of sculpture and architecture as much as to pictures. We found, for instance, that Barlach's bronze figure of the singing man (see Fig. 119) revealed its structure when we saw it as organized around a balancing center in the interior hollow of the figure. The same is true for another crouching figure, Maillol's *Night* (Fig. 120). Here again the work's composition becomes apparent when it is related to the center in the hollow formed by the arms, the torso, and the hunched legs.

PERCEIVING THE THIRD DIMENSION

Both of these sculptural examples and the photographs showing them have been selected to make the location of the balancing center visible. No such access exists in other sculptures, for instance, in standing figures. For such works, say, Michelangelo's *Victory* (see Fig. 84), the place of the center is perceptually induced by the way the vectorial shapes of torso and limbs are seen to issue from it, to point toward it, to move around it. Only by reference to the indirectly given center does the sculptural composition make any sense.

The centricity of such a work becomes evident as one walks around it and acquires a complete image of its three-dimensionality. If one must make do with photographs, an additional problem hampers the presentation. We see Maillol's *Night* from one side only. In this projection, the three oblique vectors of the upper arm, the torso, and the bent legs group perfectly in a triangle around the center. Such satisfying views are available in many styles of sculpture. In fact, more than one good projection is likely to be available. In our example, a frontal view of the crouching woman would display a symmetrical composition as equally well-related to the balancing center as

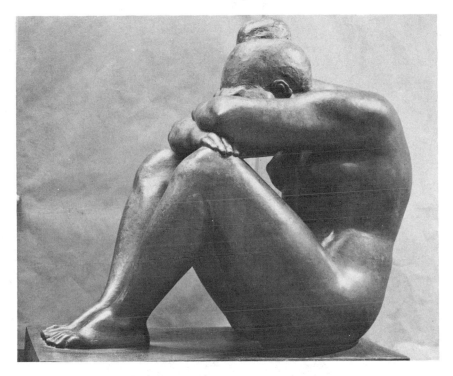

FIGURE 120.
Aristide Maillol, Night. 1902–1909.
Albright-Knox Gallery, Buffalo.

is the profile. But beyond that, only the totality of aspects offers an adequate understanding of the composition in the round, and it is for this reason that my dealing with sculpture is limited to a few references.[1]

A somewhat similar problem exists for styles of painting offering vistas in the depth dimension. They tend to present two different views, one essentially limited to the projection in the frontal plane, the other showing the scene as laid out in three-dimensional space. To put it carelessly: they show the scene as it appears and as it is. A skillful artist can present a frontal projection in such a way that the arrangement not only works in its own right but also gives a clearly readable image of the three-dimensional scene. I will use this welcome assistance to discuss a few examples of compositions in three-dimensional space—the kind of composition that in the physical world would be created on the stage by choreographers or theater directors.

1. Some modern artists, wondering how the one-sidedness of vision could be overcome, seized on the theory of the fourth spatial dimension to dream about the possibility of perceiving and perhaps representing objects in their full centricity. See Henderson (1983).

The Fourth Dimension and
Non-Euclidean Geometry in
Modern Art

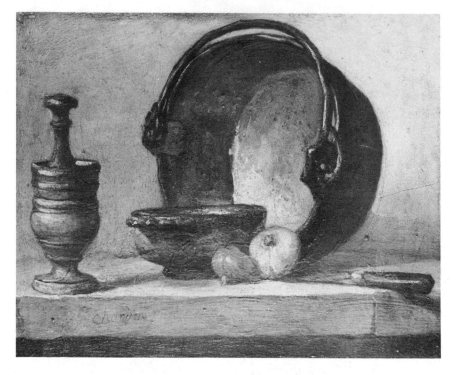

FIGURE 121.
Jean Siméon Chardin, Still Life with Copper Pot. 1734–1735.
Musée Cognacq Jay, Paris. Photo, Bulloz.

OBJECTS BEHAVING IN SPACE

A look at Chardin's kitchen still lifes lends itself to this purpose. It also recommends itself for another reason. The geometric simplicity of household objects reduces spatial relations to their basic elements in an almost architectural fashion and thereby makes them clearly definable. If we compare one of Chardin's paintings (Fig. 121) with the earlier discussed still life by Matisse (see Fig. 22), one difference is evident. Matisse distributed his five objects essentially within the frontal plane; they are juxtaposed on a two-dimensional surface. In the Chardin, the three-dimensional arrangement on the tabletop is at least as evident as that in the frontal plane.

What do we see when we consider Chardin's composition as an arrangement in space? By balancing the objects against one another, we perceive the overall center as located in their midst, in the hollow of the large copper pot. It is at some distance from the front but also near the geometric middle of

FIGURE 122
(after Chardin)

the rectangular canvas. Beyond their dependence on that principal balancing center, the objects are markedly self-contained. Including even the knife, they are all centrically symmetrical, each shaped around its own axis. These axes add up to a configuration of fairly independent vectors, two of them vertical, the others horizontal or tilted. *grinding action*

The little tower of the mortar is the most independent of these units, spatially detached from the central group of two containers and two onions and counteracted in its verticality by the horizontal knife on the opposite side. The heavy central mass has a strong lateral vector, issuing from the cylindrical hollow of the copper pot. It sends out condensed energy like a film studio's klieg light and conversely receives energy with its gaping openness. The axis of the one-sided communication between these two principal centers of the scene is modulated by the supporting group of the bowl and two onions. They are intermediaries and mediators: the bowl is symmetrical around an upright axis like the mortar, but open like the copper pot; and the onions are tilted forward and backward, enlivening the back-and-forth of the principal motion. Add to this the sneaky introduction of the horizontal *sneaky?* dimension by the knife, and you get a sense of what one might call the choreography of the scene.

Any change of the arrangement would alter the composition. There is another still life by Chardin, using some of the same utensils (Fig. 122), in which dialogue is replaced by the coordination of self-sufficient units, each minding its own business. The arrangement is just as perfect as that of Figure 121, but here the hierarchy is dominated by the much less dynamic vertical axis in the center of the composition. Each element contributes by being a volume of its own, rather than by responding with a communicating vector.

There is no reciprocal acknowledgment, no intercourse between the neighbors, no give and take or demand and reply.

So expressive are these objects and their interrelations that one naturally speaks about them in human terms.[2] In fact, when they share a pictorial scene with human figures, it seems artificial to treat them as less animate than the living beings. In a work of art, all things are made equally eloquent by their visual appearance. In Chardin's *Return from the Market* (Fig. 123) the kitchen maid occupies the center as the principal vector but is bent away from the vertical by her effort to hold the heavy bag of groceries. Through this tilt, the round shapes of her body are closely associated with the similarly shaped volumes of the loaves and the jug on the tabletop. The heavy weight of the cluster on the right creates a strong eccentric accent, which serves as the abstract theme of the painting: central uprightness pulled off its position by a wearisome load.

ENCLOSURES REPLACING FRAMES

An indispensable component of this painting is the spatial enclosure provided by the walls and the cupboard. They constrain the woman's spatial freedom but also support her verticality and contribute a highly dynamic framework by their oblique orientation. Thus the spatial setting of the three-dimensional scene fulfills a function similar to that of the frame around a two-dimensional picture. The more the style of painting insists on presenting a stage in the depth dimension, the less capable is its frame to meet this demand. Its role is reduced to that of a mere window, detached from the composition and leaving us with the vista of an unlimited space. Composition, however, requires confinement, and for this reason centric enclosures are frequently introduced into the picture to set the desired limits.

Being a part of the compositional scene itself, these enclosures are more conspicuous than a frame can ever be. In addition to defining the dimensions of space, they also act as contractive fences. Think of the numerous bathtubs in the works of Degas, an artist who likes to constrain his personages in tight surroundings, which move in on them (Fig. 124). Sometimes the centric closure is provided by a shallow basin, which gives the squatting figure little more than a circumscribed foundation. Even here, however, a dynamic

2. The art critic John Russell wrote in the *New York Times* of 2 November 1980: "In every still-life painting worthy of the name, what we see is a scale model of society. The objects live together, mutually incongruous as they may be, and it is for the painter to persuade us that in their way of doing it there is a universal lesson for us. That was one of the great themes of European painting, from Chardin through Cézanne to Picasso, Matisse and Braque."

Another ting head

FIGURE 123.
Jean Siméon Chardin, Return from the Market. 1738. Staatliche
Schlösser und Gärten, Schloss Charlottenburg, Berlin.

FIGURE 124.
Edgar Degas, Le Tub. 1886. Louvre, Paris.

antagonism is provided between the constricting walls of the tub and the expansive flesh of the bather.

The container assumes monumental size in another painting by Degas (Fig. 125). A section of a circus rotunda embraces the entire pictorial space. The main vectorial parameter of this partial centric hollow is the vertical. Rather than oppose the expansion of the figure, the enclosure enlarges the acrobat's upward swing into a huge architectural elevation. Only the ceiling puts a brutal stop to her aspiration. Without this determining setting the figure would float meaninglessly in empty space.

A complex relation between enclosure and figure distinguishes the composition of Carl Hofer's enigmatic *The Poet* (Fig. 126), a painting destroyed during the Second World War. A largely empty space holds a single centric system, the container of the boat enclosing the upright axis of the man. Arrested by his position on the balancing vertical, with his eyes closed to the environment, he withholds his presence by a gesture that stops and deters but at the same time signals some kind of pronouncement. The thoroughly inner-directed figure is prevented from moving and protected from intrusion by the sides of the boat. The boat, however, is also an inseparable part of

FIGURE 125.
Edgar Degas, Lala au Cirque Fernando. 1879.
National Gallery, London.

FIGURE 126.
Carl Hofer, The Poet. 1942. Destroyed by fire.

the figure, displaying a forward-directed vector that is limited in the figure itself to the frontality of the poet's position. The boat gives him advancement but also expresses his mysterious inhibition by stopping at the picture's frontal plane with no place to go.

More thoroughly restrictive is Degas's *L'Absinthe* (Fig. 127). The melancholy presence of the man and the woman is squeezed between bench and tables. The central node of the composition offers the microtheme of the woman compressed from the left by the bottle and from the right by the glass and stabbed quite viciously by the two opposing wedges of the table corners. In the background the partially open vista, from which the two persons are separated by the back of the bench, reduces their images to shadows. As the viewer enters the scene from the front, he stumbles across a table cluttered with newspapers. And when the sitting man's glance is abruptly arrested by the frame of the painting, we realize that Degas's

She's not stabbed at all.

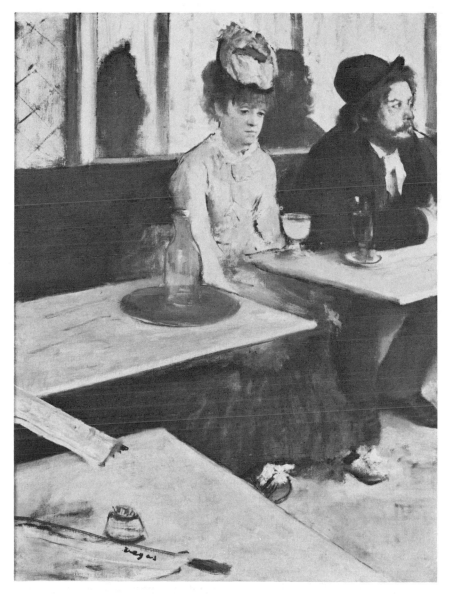

FIGURE 127.
Edgar Degas, L'Absinthe. 1876. Louvre, Paris.

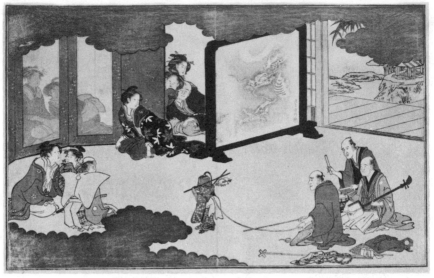

FIGURE 128.
Kitagawa Utamaro, New Year's Day Celebration with
Performing Monkey. 1789. Boston Museum of Fine Arts.

method of having the frame cut across the elements of his scene does more
than simply indicate that the pictorial space continues beyond what is
shown. In this case it also effects the opposite: the frame joins the barriers
and containers within the painting as yet another enclosure, constricting the
whole scene and damming the action in it.

Not all partitions are containers. The Japanese genre scene of Figure 128
takes place indoors, but it looks essentially open. It is organized around the
central figure of the performing monkey and the more conspicuous screen
in front of one of the nodes of figures. The screen cuts across the principal
axis of the theme, the diagonal connection between women and men. Instead
of surrounding the nucleus of the scene, the screen supplies in three-
dimensional space the kind of central partition that made for bipolar sepa-
ration in the two-dimensional compositions we studied earlier.

The central screen does not truly separate the parties. It is not really a
wall for either eye or ear but rather a coy pretense at concealment, like a fan
hiding a smile on a lady's face. Murasaki Shikibu's eleventh-century novel
The Tale of Genji describes a code of social relations based on conversations
through partitions, on fleeting glimpses, transparent disguises, noises, and
shadows. When we are dealing with compositional partitions within pictorial
space, we must not think exclusively of the Western tradition, which prefers

to limit itself to the representation of a single, coherent, and mostly enclosed space. There may be vistas offering a glimpse of a distant landscape or a peek into an adjoining room, but essentially the center of one room is that of the world represented. In a Japanese picture such as Figure 128 there is *←exactly* no such monopoly of one center. The scenes of popular or courtly life, particularly in the woodcuts of the eighteenth century, have no closed cubical interiors. From the bird's-eye view known since the Heian period as the *fukinuki yatai* technique, we see no ceilings, and the walls tend to be transparent or at least translucent. The world is open, although subdivided into loosely centered sections, and the space described in the foreground is one among many—it just happens to be the one we are closest to.

THE ADDED VIEW OF PROJECTION

The preceding examples were presented to illustrate composition in three-dimensional space. But clearly the projection of those scenes on the frontal plane could not be excluded. In the Japanese scene, the spectators surround the performance not only on the horizontal stage we look at obliquely but also within the upright frontal plane of the picture, and the balancing center is located not only at some distance from us above the middle of the floor but also in the middle of the surface on which the picture is painted. Similarly, Degas's absinthe drinkers (see Fig. 127) are so compellingly coerced because the tables cut across them perspectively. The wedges of the tables, which I described as stabbing the woman, are converted from right angles to acute angles by the magic of optical projection. We must now consider the compositional consequences of the interaction between projection and depth effect. *Oh?*

Let me begin with a warning. The perceptual difference between the projective image in the frontal plane and the three-dimensional one in the depth dimension is not as clear-cut and absolute as the terms used to describe it for simplicity's sake may imply. The frontal projection tends to involve some depth, and the three-dimensional space is always subject to some projective compression. Normally a viewer's perception roams somewhere between the two. This is true also in actual physical space, where depth perception is more compelling. Looking along the nave of a traditional church, we see the depth of the interior as somewhat contracted and the columns and walls as diminishing in size and converging toward a vanishing point. Nevertheless, what we see is close enough to objective reality to let us perceive the walls as parallel and the columns as all of one size, and the floor looks trustworthy enough to let us walk down the aisle without hesitation. In a painting of the

nice phrase

FIGURE 129
(after Degas)

same sight the ratio will be reversed. The perspective convergence will be more compelling, space will be more compressed, but even so the depth effect remains.

Although the difference between the two views does not amount to an either/or, we do distinguish them. Look at the two figures taken from one of Degas's ballet pictures (Fig. 129). We can shift from a more projection-oriented conception to a more "objective" one. We can focus on the large size of the ballerina and see her master as small and somewhat above her. Or we can concentrate on the distance between them, with the girl close-by, the man more remote, and the size difference between them much less compelling. Obviously the resulting visual images are quite different from each other. The changed relations of size and distance also symbolize a different relation between the two persons and between them and us. In an actual work of art the two versions and their meanings interact to create the more complex statement of the composition as a whole.

Several factors determine the relative strength of the two views in any given case. The gestalt psychology of visual perception indicates that the more regular, balanced, and symmetrical the pattern, the more likely it is to prevail. Compare the mandala of Figure 7 with the outlines of Bruegel's *Luilekkerland* in Figure 130. The mandala, displaying perfect centric symmetry in the frontal plane, shows no tendency to tilt back into the depth dimension. Bruegel's composition is also centrically symmetrical, with the three lazybones grouped around the balancing axis of the tree trunk like the spokes of a wheel. Here, however, the symmetrical arrangement is located in three-dimensional space. In frontal projection, the pattern is grotesquely

lazybones? Presumably these guys have been harvesting all morning and are resting.

FIGURE 130
(after Bruegel)

distorted. This has a meaning of its own, but the pattern has to be seen first of all as an aspect of the "good" composition in the depth dimension.

CONTINUITY OF SPACE

Genetically, in the development of picture making, representation in depth comes late. The depiction of the visual world does not start out with the faithful rendering of perceived depth. Rather, it originates on the flat surface of the rock or wall or paper on which the picture is produced. In the early drawings of children, for example, there is no depth. The picture presents no fore or aft. Three-dimensional space is translated into the two-dimensional medium. Composition also, to the extent to which it has begun to organize the picture, is limited to the flat surface.

At those early stages the distinction of figure and ground serves to separate positive objects from the negative empty surroundings. It barely begins to indicate the difference between what is in front and what is in the back.

The next step, therefore, is to construct a proper background, for example, a landscape or the back wall of a room behind a frontal figure. This introduces the depth dimension and implies a distance between the two planes, but that distance is not yet spelled out as a continuous space. It is an interval that implies no connecting floor, nor can it accommodate any other

object located within it. It is a discontinuous leap between two scenes that are limited to displays in their frontal dimensions. While the compositional center in the frontal plane is readily discernible, there is no way of looking in such pictures for the center of the three-dimensional space. Strictly speaking, we are still in the second dimension, a set of two or more frontal displays, like a stage set made up entirely of flat wings and a backdrop.

This hiatus, this unstructured distance between front and back, still occurs in otherwise highly developed compositions of the Renaissance and later, especially in portraits. Think of Leonardo's Mona Lisa. The distance between the parapet against which she is leaning and the background landscape exists almost entirely by virtue of our knowledge of size differences. It is not spelled out. You might be able to look for a center within the landscape but not in the space between foreground and background. Striking examples can be found in certain other Italian paintings of the fifteenth century that apply the newly acquired art of central perspective to the architectural setting but not to the figures. In renderings of the Annunciation, the angel and the Virgin dwell in a flat foreground plane, quite detached from the scenery that extends into depth. In the nineteenth century, Degas produces a shocking clash between the fantasy world of the theater and the "real" world beyond the footlights by juxtaposing stage and orchestra as though they were pasted together in a collage.

Whenever figures or other subjects are kept strictly in the foreground of a painting, they preserve some of this primordial depthlessness. They are not really in the front portion of the scene and thus a part of it, but independent of it, outside of space as far as the third dimension is concerned. Or to put it another way: as long as an object is not assigned a definite place on the depth scale by means of some perceptual device, it remains in the spatial no-man's-land of early representation. Gradually, the setting closes in behind and around it; but the traditional interior with its back and side walls may surround the frontal scene without as yet providing a continuous space. And the front wall cannot be said to be "missing"—it has never been there.[3]

Once the depth dimension is introduced, trouble still may be created by the ambiguity of location. The images shown in a projection may refer to objects located at any distance. A tower intended to be seen at the far horizon is painted inevitably on the frontal plane of the canvas. When in Bosch's

3. Erwin Panofsky (1960, p. 144 and fig. 104) gives an interesting example of an in-between stage. In Ambrogio Lorenzetti's *Annunciation* in the Accademia of Siena, the two figures are still placed against an empty gold ground, but three-dimensional depth is partly supplied by what Panofsky calls an "interior by implication." A checkerboard floor presents space as a horizontal base—a first step toward a more complete enclosure.

painting *Saint John on Patmos* (Fig. 131) the evangelist looks at the angel and the apparition of the Madonna, he can do so only in the traditional context of the flat frontal plane. Compositionally, the man as the central volume sends out an oblique vector toward the upper left corner. Three-dimensionally the arrangement does not work. The angel on the hill occupies a displaced center in the middle of the oblique axis, which now connects the saint in front with the Madonna way back in the distant sky. This axis, however, carries no visible meaning. The Madonna is in a medallion lost in the nowhere; the angel does look at John but is not noticed by him as he attentively watches a place in the sky where there is nothing to see.

In Dieric Bouts's triptych shown in Figure 132, the bothersome spatial ambiguity gives way to a double meaning. In the frontal plane, an archaic hierarchy still prevails. The group of the judges, led perhaps by the Roman emperor himself, holds the balancing center of the composition at the highest level, and the two saints, Saint Jerome and Saint Bernard, attending the scene in the wings, keep their heads at the same height. The two torturers are further down, and the martyr lies at the base of the scene. This simple spatial diagram is a leftover from medieval altar paintings, but it is supplemented here by a rendering of the physical event, showing everybody at ground level. The judges now hold the balancing center in the middle of the stage, and their nodal group sends a vector toward the foreground scene of the torture, which is now the target of principal interest.

In the course of the Renaissance and thereafter, the frontal projection rarely preserves the compellingly simple symmetry assuring it primary attention. But even in the more realistic styles of painting, we shall find the same formula at work. The frontal projection always keeps its priority as the perceptually direct sight, the primary surface of the pictorial medium. Although the compositional emphasis may shift to the three-dimensional setting, the projection continues to symbolize the meaning of the scene whose physical configuration is played out in the depth dimension.

When the duality of foreground and background is replaced with the image of a continuous world, reaching from the front all the way to the horizon, the resulting endless space threatens compositional centricity. I mentioned earlier that within the frontal plane the confining frame creates the balancing center by induction. We observed that when the frame is reduced to a window and thereby detached from pictorial space, internal enclosures assume its function. It is instructive to notice in Bosch's *Adoration* (Fig. 133) how much the centric arrangement of the Madonna surrounded by the worshippers is weakened by the lack of a sufficiently strict enclosure. A central vector all but overrides the Madonna on its way to the distant landscape. She sits

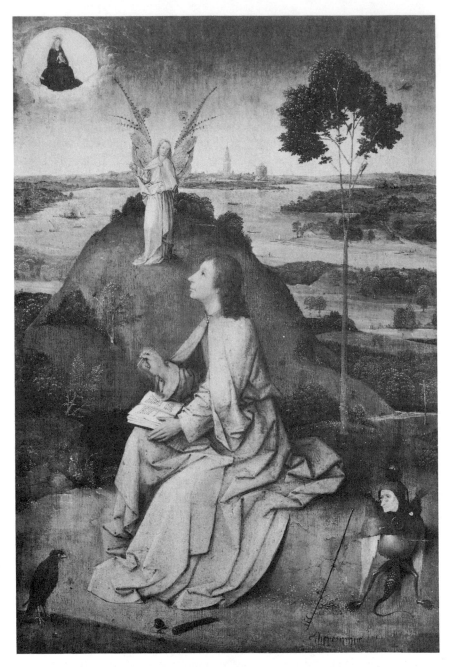

FIGURE 131.
Hieronymus Bosch, Saint John on Patmos. 1504–1505.
Staatliche Museen, Berlin (West).

FIGURE 132.
Dieric Bouts, The Martyrdom of Saint Erasmus. 1448.
Saint Peter's Church, Louvain.

outdoors, barely protected by a cloth strung by the angels across the rudimentary walls. The Madonna herself is stabilized by her central position, but the attendants kneel and stand around in a loose arrangement.

WHAT PERSPECTIVE CONTRIBUTES

The discovery of central perspective is credited primarily with providing a striking likeness of optical projection. Perspective makes, however, other equally influential contributions. For one thing, it tightens the newly developed continuum of the spatial vista by giving it a geometrically precise unity and structure. It also furnishes the spatial expanse with a powerful center— and in the case of two-point perspective, with two such centers—at the horizon, a centric system from which a cobweb of vectors spreads across the composition and defines the locus of every spot in the picture. There is, of course, a curious ambiguity about the spatial whereabouts of the vanishing center. It is, first of all, a point somewhere on the canvas. It is the focus of the optical projection and, as such, an important compositional center in the frontal plane. But it is also seen as located on the far horizon of the pictorial space—a fraudulent presence, since in three-dimensional space no perspective convergence exists. Perceptually, the perspective center hovers somewhere between projective compression and unforeshortened depth.

locus, location

eh? You mean in actual 3 dimensional space?

FIGURE 133.
Attributed to workshop of Hieronymus Bosch, Adoration. c. 1505.
Metropolitan Museum of Art, New York.

Central perspective is of dubious help for the establishment of compositional centricity. In relation to the frontal plane it does provide a strong center; but when seen as located at the far end of the pictorial space, the spread of vectors issuing from the vanishing point makes it difficult for any position within that continuum to establish itself as the center for a system of its own. Let us see how it works in practice.

Dieric Bouts's *Last Supper* (Fig. 134) is fully enclosed in a strictly geometric container. The walls, the ceiling, and the floor point to a perspective vanishing point on the frontal panel of the chimney hood. This perspective center lies on the central vertical of the painting, thereby stabilizing the pictorial space. The symmetry of the spatial framework is taken over by the arrangement of the biblical scene. The leading figure, Christ, is supported by the central vertical, and the disciples are grouped around a symmetrically placed table. Such symmetry, as we learned earlier, tends to give dominance to the frontal plane at the expense of depth. In spite of its otherwise realistic style, some of the flat frontality of medieval icons survives in Bouts's picture.

In its frontal aspect, the composition is hierarchic. The upright format of the picture stresses its Gothic, vectorial verticality. The figure of Christ, framed and solemnly enthroned by the fireplace behind him, rises above the disciples around and below him. Judas sits properly low and off center. Furthermore, Christ's head is placed slightly higher than the picture's geometric center, which coincides with his raised hand—the microtheme of the blessing.

Notice, however, that by locating the scene in the lower half of the picture and so much below the vanishing point, the painter assigns his story to a distinctly mundane setting. As the viewer's glance, coinciding with the axis of the perspective, moves into the pictorial space, the three-dimensional version of the composition changes the character of what is shown. The scene becomes a fairly informal convivial gathering. The box-shaped room, no longer a background foil, envelops and protects the dinner party. The fireplace recedes and ceases to enshrine the Saviour, who now sits in the company of equals, grouped around the table. They are all nearly of the same height, Judas not excluded. The centric system is now organized around the circular plate with the lamb roast. The bare floor of the foreground, weakening the base in the projective version of the picture, now removes the gathering of the diners to the middle of the enclosed space and thereby separates it neatly from the surrounding ground.

Yet the centrality of the group is not uncontested. Although the perspective edges of the room converge at a point of the frontal plane, perception moves the vanishing point farther away. Perspective pierces the background

FIGURE 134.
Dieric Bouts, The Last Supper. 1468.
Saint Peter's Church, Louvain.

of the room and gives an induced presence to a hidden, potentially boundless vista. As the finality of the walls is disavowed, the presence of the scene is no longer exclusive. More broadly perceived, the world continues behind the partition, and the particular episode we witness reaches beyond itself and receives its more exalted meaning only from the wider world around it.

Checkered floors like the one in Bouts's *Last Supper* conform to the centricity of the perspective system by their orthogonal edges, converging toward the vanishing point. Their straight horizontal edges, however, are insensitive to convergence. Occasionally, painters remedy this rigidity. Instead of having those edges run parallel to the bottom of the frame, they curve them slightly around the central scene. John White has pointed to examples in French book illustrations, especially in Jean Fouquet's *Grandes Chroniques de France*. In the *Arrival of the Emperor at St. Denis*, for example, a pavement is drawn in central perspective, but the horizontals crossing the converging orthogonals curve around the parading horses. A comparable example of very different origin is afforded by Vincent van Gogh's *Bedroom at Arles* (Fig. 135), where the cracks across the boards curve similarly toward the perspective center. Psychologists may remember that in the so-called Hering illusion (Fig. 136), a straight line crossing a sunburst of radii is perceived as bent toward the center, thereby yielding to the field of forces created by the concentric beams. Our examples seem to indicate that artists are aware of that perceptual tension exerted by the centric system and at times give in to it.[4]

TIME IN SPACE

The vectorial continuity in the depth dimension lends itself to a visual metaphor of time. The spatial movement from far to close or from close to far suggests the corresponding movement from the past to the present or from the present to things to come. Compositionally, this tends to replace the single central system with several, arranged in sequence and culminating in one in front. The clearest examples tell a story by a string of episodes. Sassetta shows Saint Anthony at the far distance (Fig. 137), taking off for a trip through the desert. A second compositional node shows him consulting

4. There is a tendency among art historians to explain deviations from "correct" representation by searching for optical effects the artist is supposed to have discovered and reproduced while he was copying nature with mechanical faithfulness. In keeping with this tradition, John White asserts that such curvatures are renditions of what the artist sees when he turns his head sideways (1957, pp. 226ff.). My own inclination is to show that such compositional features are responses to problems arising from the perceptual properties of the picture itself, not those of the model. These are features that come about during the interaction between the artist and his medium. On the Hering illusion, see Arnheim (1974, p. 420).

FIGURE 135.
Vincent van Gogh, The Bedroom at Arles. 1888–1889.
Art Institute of Chicago.

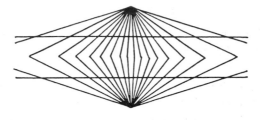

FIGURE 136

a centaur on the way. From there the vector leads along the road to the climax of the journey, the meeting with Saint Paul. Conversely, when Watteau's painting in the Louvre (Fig. 138) is interpreted as the embarkation for Aphrodite's island, it starts with the presence of the lovers in the foreground and has them move toward the boat, somewhat more distant at the left border. Painted three centuries after Sassetta, Watteau's composition is subtler and more complex. The sequence of stages, from the seated couple on the right

FIGURE 137.
Sassetta, The Meeting of Saint Anthony and Saint Paul. 1432–1436.
National Gallery of Art, Washington, D.C.

FIGURE 138.
Antoine Watteau, Embarquement pour l'île de Cythère. 1717.
Louvre, Paris.

to the ones ready to enter the boat on the left, is more spatial than temporal, compressed in a single episode. Also, the vectorial flow of the movement makes a concession to centricity by marking the balancing center of the painting with a large and climactically placed couple, in whose attitude the microtheme of advancing vs. looking back is expressed. Thus, while a linear action in time traverses the space of the picture, the simultaneity of centric composition is given its due.

THE SYMBOLISM OF THE FRONTAL PLANE

Even when the continuity in the depth dimension has come to determine the nature of the pictorial space, the short circuit between front and back is never entirely absent. Poussin, for example, occasionally makes the geometry of his figure grouping explicit by accompanying it with corresponding architectural shapes in the background (Fig. 139)—a parallelism that eliminates the distance between foreground and background.

More commonly, however, the reality of the scene in the depth dimension

FIGURE 139
(after Poussin)

is not only acknowledged but given dominance, and the frontal projection serves to add an interpretation of the intended meaning. An intermediary solution is offered in Tintoretto's *Christ at the Sea of Galilee* (Fig. 140). The realistic style of the Renaissance no longer permitted the symbolism of expressing power by size. In Egyptian art, the huge Pharaoh could overpower his small captives, and even at the era of Cimabue the enthroned Madonna was shown as much larger than the saints and angels attending her. Tintoretto preserves the welcome visual strength of this symbolism by justifying towering size as nearness. The figure of Christ, placed in the foreground, is superhumanly large and closely confronted with the tiny disciples when they are seen in projection. In strictly three-dimensional depth no such discrepancy of size exists, and the boat at the balancing center of the painting has more weight and importance. As Peter obeys the call and steps on the water, he crosses the central vertical, which in the projective frontal view separates the master on the left half of the painting from the disciples approaching from the right. Since the second and the third spatial dimensions do not simply exclude each other in perception, some of the miracle persists in the worldly setting.

I mentioned earlier that the projective scene has the perceptual advantage of displaying its composition prominently in the frontal plane, met by the viewer's line of sight at a right angle. Being a projection, however, it distorts the "geographic" scene, the situation as it actually *is*. It therefore offers a view one would call accidental or subjective were it not used by a skillful painter to supplement the visual symbolism of the composition. The three-dimensional scene, as we observed, is seen obliquely and must be percep-

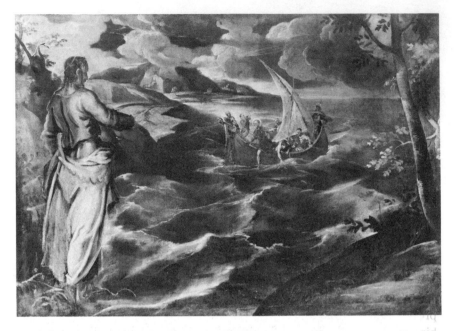

FIGURE 140.
Jacopo Tintoretto, Christ at the Sea of Galilee. 1591–1592.
National Gallery of Art, Washington, D.C.

tually deciphered, as it were, from the indirect sight given in the projection. In my final example, Pieter Bruegel's *Adoration* (Fig. 141) shows the Madonna with her child in the balancing center of the picture, surrounded vertically as well as horizontally by the group of onlookers and worshipers. In the three-dimensional version she clearly dominates the scene in front of the stable. Although the standing figures are seen as taller, the difference in height is natural enough. The centricity of the group is modified by the difference between what is in front and what is behind the figure in the middle. The accent is on the kneeling King Caspar, who is offering his chalice. The background is filled with bystanders.

In the frontal version, centricity is modified by the meaningful difference between above and below. The kneeling king, now more clearly beneath the Virgin, is more explicitly in a subservient position. The standing figure of King Balthazar is not simply that of a man seen from behind. With his dark face all but hidden, he stands like a powerful statue contemplating the scene in foreboding silence. And the seated mother with her child is now topped

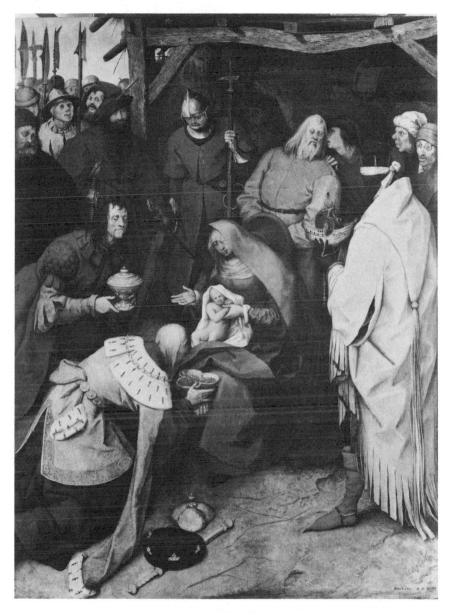

FIGURE 141.
Pieter Bruegel, Adoration. 1564. National Gallery, London.

by a noisy crowd, the figure of Joseph leaning back and lending an ear to whatever skeptical thoughts his whispering friend may suggest to him, and the armed soldier brutally poking his spear into the head of the Virgin. Once again we see a worldly scene symbolically deepened by its appearance in the frontal surface, which remains, after all, the home territory of the pictorial medium. The shallow framed box, eh?

CENTERS AND GRIDS IN BUILDINGS

ARCHITECTURE IS PARTICULARLY well suited to illustrate the compositional principles discussed in our study. The elements of architectural design closely approximate geometrically definable shapes; consequently, most buildings resemble the theoretical diagrams of our analysis more directly than do the works of other art media. Painting and sculpture tend to be diverted by the complications of shape: often committed to the infinitely variable repertoire of human figures, animals, or landscapes, they reveal their compositional structure only indirectly, as an implicit skeleton. Buildings, by contrast, conform in their abstract shapes to the simple rules of physical statics, relying largely on verticals and horizontals, on straight lines and elementary curves, on symmetry and repetition. In such a medium the guiding theme of our investigation shines forth more directly.

elementary vs. complex curves

GRIDS PREVAIL

Buildings, made of heavy materials, depend more than other visual media on the eccentric pull of gravity. They respond to this external power by organizing their shapes around the vertical. Secondarily, because of its symmetrical relation to the vertical, a distinguished role is reserved for the horizontal as well. Just as vertical shape establishes its balance in relation to the force of gravity, so does horizontal shape.

The statics of this basic framework of forces is most economically represented by the Cartesian coordinates. By itself, however, this is not enough of a reason for architectural design to rely so heavily on the two basic linear components. We have seen that painting and sculpture also reflect the influence of the gravitational framework; but only exceptionally does this induce them to limit themselves to those basic shapes. Buildings, being constructed for physical utility, are devoted less to visual expression than to stability and

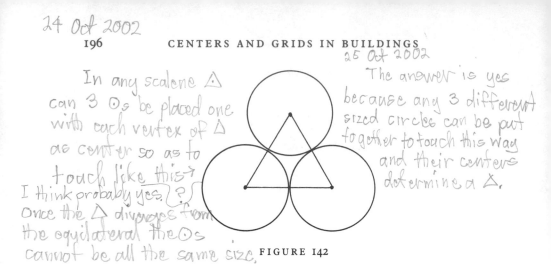

Handwritten notes surrounding figure:

25 Oct 2002

In any scalene △ can 3 ⊙s be placed one with each vertex of △ as center so as to touch like this→

I think probably yes. (?)

Once the △ diverges from the equilateral the ⊙s cannot be all the same size.

The answer is yes because any 3 different sized circles can be put together to touch this way and their centers determine a △.

FIGURE 142

order. They are containers dedicated to enclosing creatures and things in the most simply organized fashion.

This is why the grids of our diagrams (see Figs. 5 and 6) are commonly met in architecture although they are by no means conspicuous in our examples from painting and sculpture. In nature and art, centers can be found in any spatial configuration, and therefore the vectors connecting them will run in any direction, unless special conditions give preference to some. In the practical business of domestic and urban living such special conditions prevail. The need for order calls for the simplest affordable spatial relations, and the artistic expression of architectural design tends to comply closely with this desirable order.

The dominance of grids favors the eccentric system in architectural design, and since grids have no center, the centric system is threatened with neglect. The grid system, however, does not rule uncontested. Even in the realm of physical statics, Buckminster Fuller, the designer of geodesic *(handwritten: Here's Bucky)* domes, has insisted that the right-angled grid conforms to a human sense of order but forces the physical world into a Cartesian straitjacket. The triangles of which his spherical buildings are constructed are based on the stacking of round shapes (Fig. 142); spheres are, according to him, the elementary building units of nature. In our own investigation we find that too much insistence on the vectorial linearity of the eccentric system fails to do justice to architectural composition.

Paul Klee calls buildings our fellow sufferers, reminding us of our dependence on the terrestrial power that pulls us forever to the ground.[1] We have had occasion to agree with him, but it is also true that architectural form does more than reflect the tragic struggle with weight and load. Architectural design tells us also that unless the building has a center around which to

1. Klee (1964, p. 311).

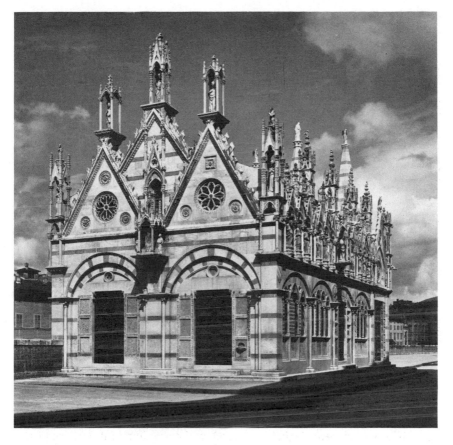

FIGURE 143.
Church of Santa Maria della Spina. 1323. Pisa.
Photo, Anderson.

gather its own being, there is nothing really there to face the challenge of gravity. Without such a center, nothing would be seen but a network of anonymous forces, anchored nowhere and held together by nothing. I have referred to the curtain walls of our office buildings, teaching us that in the absence of a center the eye loses its orientation and roams aimlessly across an unstructured surface of arbitrary size. *So art should have an oriented center. Consider the SUNY campus at Albany and its totally disorienting campus.*

DESIGN IN ELEVATION

The struggle with gravity, of course, is evident only in the vertical dimension. To deal properly with a building, one has to consider it as a three-dimensional volume, extending in length as much as in height and centered

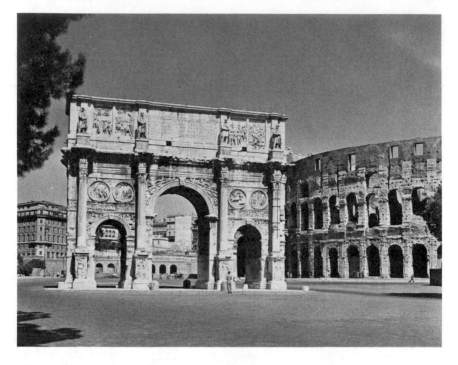

FIGURE 144.
Arch of Constantine. A.D. 315. Rome. Photo, Fototeca Unione.

around a place somewhere in the middle of its interior space. For our purpose, however, it seems legitimate to follow the architectural practice of reducing a building to its vertical elevation and its horizontal plan. We shall find that even on the horizontal plane, where the dominion of gravity does not show, the interaction of our two compositional systems determines architectural design.

The elevation of a building is what strikes our eyes first. The small Gothic church of Santa Maria della Spina in Pisa (Fig. 143) is a compact cube resting heavily on the ground. This downward-directed vector is underscored by the broad bases of the arched doors and the triangular gables at the roof level. But since vectors can be read in both directions, the arches and gables also point upward, and so do the many small pinnacles. The ratio between the visual vectors pointing upward and those pressing downward determines the general effect of the building—its aspiration to spiritual heights and its weighing solidly on the ground.

If, however, the appearance of the building offered nothing but those vertically oriented elements, we would see little more than an agglomeration of

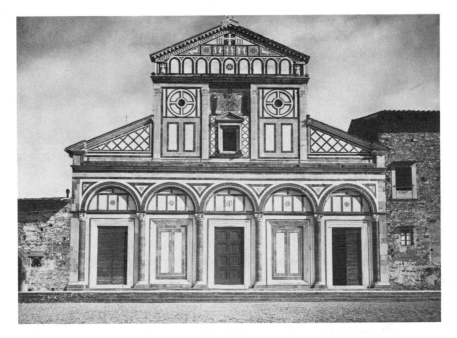

FIGURE 145.
Church of San Miniato al Monte. c. 1300. Florence.
Photo, Anderson.

parallel uprights. The necessary focus of the centric system is supplied by the small canopied figure of the Madonna, marking the central vertical half-way up the building, where the lower and the upper segment meet. Some-where at this level we place also the interior center of the cubic building.

The Arch of Constantine (Fig. 144) reposes on the ground as a broad rectangular shape. Its balancing center is located within the semicircular arch in the middle. An arch can be described as a concession of centricity to a vector, which in upright arches coincides with the gravitational axis. Complete circularity is referred to by the four medallions, which hold a prominent position on the central horizontal axis. The emphasis on the center is strong enough to relieve the columns and their load of excessive verticality and to congregate the total rectangular shape. The grid of columns and cornices groups around the center to disengage the total structure sufficiently from the ground.

When the load-bearing supports on the ground and the entablature above them are separated by a partition placed above the central horizontal, the façade conveys a sense of proud elevation. If, instead, this partition separates the façade into two roughly equal weights, as may be seen in the Romanesque

design of San Miniato (Fig. 145), the effect is one of great stability. Centricity is supported by the bilateral symmetry of the façade, but it is also weakened by the uniformity of the five arches and the lack of an expressly marked balancing center.

DESIGN ON THE GROUND

As we turn from the elevation of buildings to their ground plan, we notice several fundamental differences. First, we know the upright dimension as the realm of sight, whereas the horizontal plane is the arena of action. Elevation is essentially reserved for our eyes. It takes the borrowed facility of staircases and elevators to let us pedestrians move up and down; but our eyes scan the walls freely. Conversely, we move safely on the ground, whereas the design of the ground plan is clearly visible only in the blueprint. Once the building is constructed, we perceive its plan more indirectly by the placement of its elevations.

A second difference between the two dimensions concerns their relations to gravity. In the vertical direction, its emphasis on the interaction of up and down persuaded Arthur Schopenhauer to consider architecture the lowest of the artistic media because, he thought, it was limited to the purely physical struggle between weight and rigidity. On the level plan, however, no such coercion exists. No one direction is distinguished in the manner of the vertical. The main horizontal vector of a building is free to point in any direction. It may be oriented toward the center of town, it may parallel a river, or it may pay religious homage to the East, where the sun rises. If its composition clings to the grid pattern, as is the rule for the elevation, it does so exclusively for the sake of its own internal order. The streets of a modern city are laid out in a planned grid, whereas the map of an old town shows its lanes winding any odd way, in accordance with the accidents of their history. One direction is as good as the next.

A third difference distinguishes the composition of the ground plan from that of the elevation. In the design of a façade, centricity and eccentricity interact so intimately that their contributions can be told apart only by the kind of dissection we are conducting. Remember, for example, how an arch reveals itself as a compound of circular centricity and vectorial extension. In the horizontal plane, however, composition need not be limited to what happens within one architectural structure. We may be dealing with an agglomeration of many buildings, hence with the interaction between compact objects and the linear communication channels between them. On first glance,

our two systems of centricity and linearity therefore seem separately embodied in the two principal components of the architectural setting, the buildings and the streets. But a closer look reminds us that every architectural object is shaped not only by its own centricity, but also by its response to the coming and going of its users; and that, conversely, every channel is also an object and therefore requires a centricity of its own. Accordingly, every component of the architectural setting exemplifies the intertwining of our two systems.

When one looks over the city of Rome from the hills of the Janiculum, one sees the various circular monuments—the Pantheon, the Castel Sant'Angelo, the Colosseum, and so on—detach themselves from the fabric of the streets as self-contained units. Each of them marks a high point of the setting but refuses to conform to it. That is, these buildings behave like the tondos and other circular shapes I discussed in Chapter V.

Once we go beyond this overall difference between containers and channels, however, we find that in each particular case the architect has to decide the weight to be given to the linear aspect of approach and withdrawal in relation to the concentration around the building's core. Traditional church design derives from two archetypal patterns, the centralized church, which embodies full centricity, and the linear channel of the basilica, which is essentially an eccentric vector. Typically, the two are combined: visitors are led through the nave to the focus of the sanctuary. The transformation of the Greek cross in Bramante's original plan for Saint Peter's into the Latin cross of its final form is the textbook example of such a combination.

In any such building, the linearity of the nave and aisles emphasizes the traffic in temporal sequence, whereas the central space, the crossing, is timeless—perceptually by suppressing the linearity of the vectors and symbolically by the devout worshipper's pausing for a moment of concentration. It is true that a crossing can be a mere superposition of two linear passages meeting at right angles; in such cases, the weight of the center is reduced to a minimum. Often, however, the center is given an emphasis and closure of its own, as in Saint Peter's, where Michelangelo's powerful piers blunt the corners of the crossing by creating four façades that face the center and Bernini's imposing baldachin.

The compositional difference under discussion here corresponds to the interaction of space and time in architectural experience. The order in which various components of many a building are arranged is determined not only by their timeless simultaneity—the way the corners of a cube coexist in a timeless configuration—but by a particular sequence. Walking up the steps

Hmmm?

to a doorway, being received by the sudden expanse of the entrance hall, ascending a winding staircase, and so forth—the visitor's progress can be as essential to a building's design as melodic sequence is to music. And there is, in a good building, a correspondence between the structure of the sequence in time and that of the organization in space. For example, when a sequence of spatial experiences leads to a climax at a distinguished place, say, the large reception room on the *piano nobile*, that same place will also be prominent in the "frozen" composition of the building.

When we look at the ground plan of Palladio's Villa Valmarana (Fig. 146a), we are impressed by the static symmetry of the building. Four identical pairs of corner rooms, separated by narrow corridors, surround the domed rotunda. An actual visit to the building, however, is first of all an experience of motion, embedded in the dimension of time (Fig. 147). One climbs up the steps to one of the four entrances, walks through the corridor, and arrives at the center (Fig. 146b). Perceptually the relation between "figure" and "ground" is inverted: on the plan the corridors are nothing more than the background separating the four blocks of rooms from one another. For the visitor, however, the corridors are the positive channels of the vectorial grid, emphasizing the communicative coming and going between outside and inside. From the bird's-eye view of the ground plan, Palladio's villa looks like a closed little fortress. To the visitor it opens itself as the locale of convivial hospitality it was designed to be.

Centricity and vectorial eccentricity are more neatly distinct in the layout of Saint Peter's Square (Fig. 148). The two semicircular colonnades press the crowd inward around the obelisk in the center. Traversing this stable gathering, as a river flows through a lake, is the linear axis of approach to the cathedral. The twofold dynamics is reflected in the ratio of centric to longitudinal features. The crowd, after congregating in its own centric, compacted shape on the round plaza, transforms itself into a linear progression, in response to the attracting power of the sanctuary.

Entering the church, the visitors are channeled through the nave of the basilica. A similar conformity between the vectorial direction of the central axis and the shape of the church obtains when the plan is elliptic, as, for example, in Borromini's San Carlo alle Quattro Fontane (Fig. 149a), and thereby strengthens the linear path from the entrance to the altar. When, however, the ellipse is placed at right angles to the sagittal axis of the building, as in Bernini's Sant'Andrea al Quirinale (Fig. 149b), it counterbalances the symmetry axis of the plan and thereby increases the centricity of the whole.

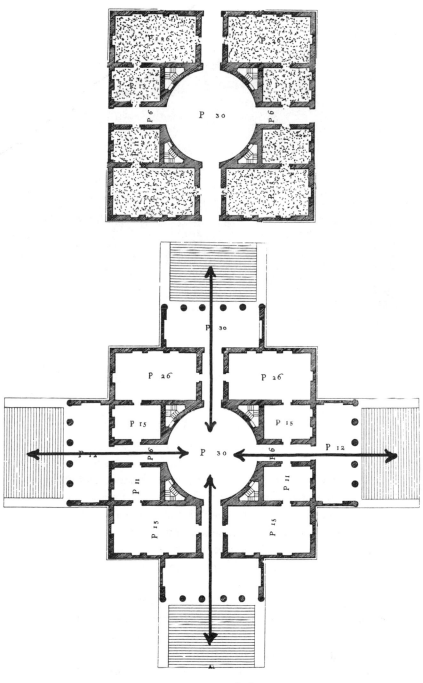

FIGURE 146a–b
(after Palladio)

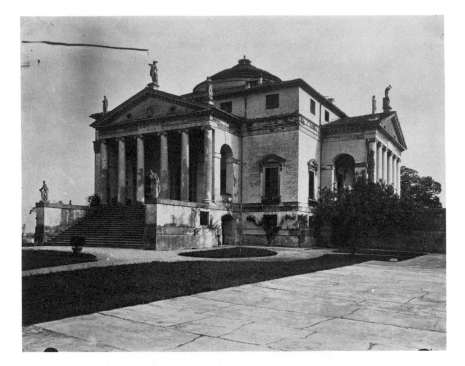

FIGURE 147.
Andrea Palladio, Villa Rotonda. 1606. Vicenza.

COPING WITH FULL SPACE

As long as we limit the analysis to the two-dimensional view of either the elevation or the plan, the balancing center of the centric system establishes itself without difficulty. But the building must also balance around its center in three-dimensional space, just as every physical object has a center of gravity. Such an internal center or central axis is not always directly visible, certainly not from the outside. Façades tend to help us by offering a section of the interior, but not all buildings have façades. In Le Corbusier's Villa Savoye, for example, the outer walls fold at the corners to wrap around the cube, which must be centered around an internal axis.

Even in an open interior, it is not always easy to determine the forces upon which the visual center depends. Look at Panini's familiar painting of the Pantheon's interior (Fig. 150). It places the viewer considerably above the heads of the fashionable ladies and gentlemen scattered around the floor of the rotunda. If the viewer, suspended in space, were to locate the balancing center of the interior, he might place it somewhere halfway up the central

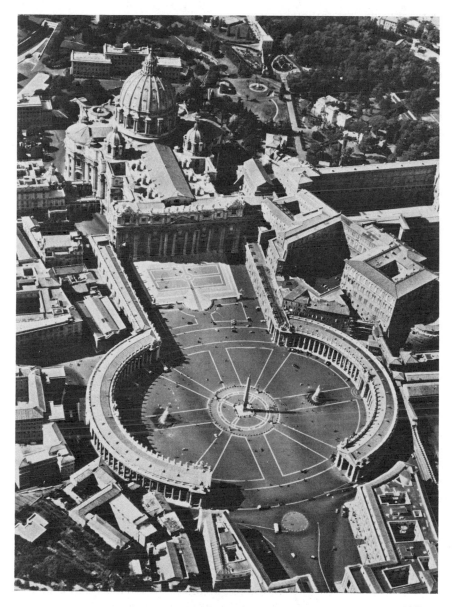

FIGURE 148.
Saint Peter's Square. 1656–1667. Rome.
Photo, Fototeca Unione.

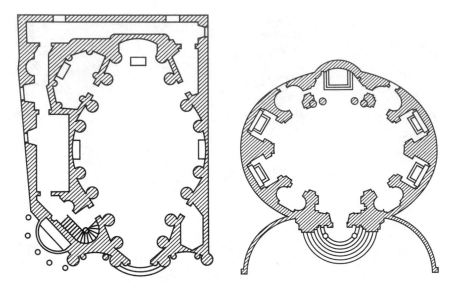

FIGURE 149a–b

vertical, perhaps at the level of the cornice, between the cupola and the drum of the colonnade. A person looking into a small model of the Pantheon might do the same. But would this also be true for the visitors on the floor? A viewer's perspective contributes an influential vector to the play of forces that balances the composition, and this vector may be strong enough to place the perceptual center of the interior lower down, possibly at the visitor's own eye level. Is the architect, then, to determine the balancing center of his design for the three-dimensional volume as such, or in relation to the perspective of the building's users? Or must he consider both views and balance them against each other?

Few buildings are composed so simply of one piece as the Roman Pantheon. In most buildings, therefore, the balancing center of the whole, although indispensable for a check on the ultimate order of the design, is less conspicuous than the centers of the subordinate units that a building comprises. Each room has its own centricity, but it must also be seen in the context of the building as a whole. The architect's vision must transcend the limited views available to visitors at any particular location.

The Roman Pantheon, a geometrically simple combination of a sphere and a cylinder, lends itself as a model to illustrate a speculation on the place of our two compositional systems in the creative process. In practice, of course, a building is so complex an object that, in the mind of the architect, its conception may develop from any of its aspects—its shape as a whole or that

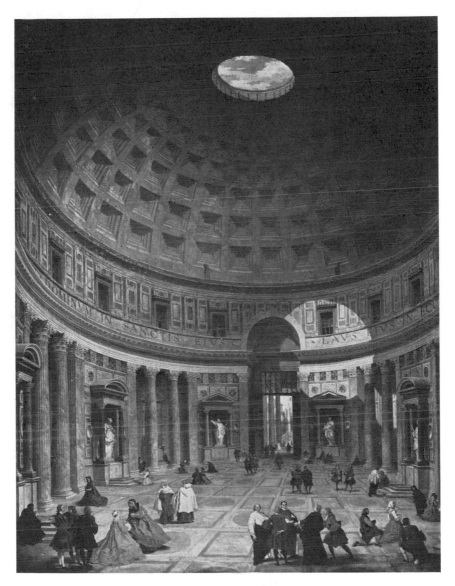

FIGURE 150.
Giovanni Paolo Panini, Interior of the Pantheon. c. 1740.
National Gallery of Art, Washington, D.C.

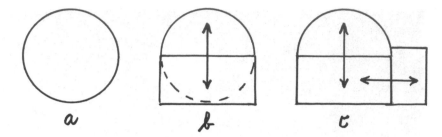

FIGURE 151

FIGURE 152.
Le Corbusier, Carpenter Center for the Visual Arts. 1963.
Harvard University.

FIGURE 153.
Le Corbusier, First sketch for the Carpenter Center for the
Visual Arts, April 1960. SPADEM, Paris/ VAGA, New York.

of one of its key components, the layout of the plan or the spatial diagram
of the functions to be performed in the building. A theoretical schema, how-
ever, may suggest that a building is, first of all, a container, and the arche-
typical shape of a container is that of a sphere. Here again the central system
claims its priority (Fig. 151a).[2] This original, self-contained shape must ac-
commodate to its external duties by vectorial extensions. Elongated into a
vertical cylinder, the floating bubble is tied to the ground, acquiring a solid
foundation (Fig. 151b).[3] On the horizontal level, known to us as the dimen-
sion of social action, a further vector connects the inner with the outer space,

2. The self-contained thing is the primary concept of thought. The drawings of children,
for example, begin the representation of objects with the circular shape, mere "thingness,"
from which more particular images derive by the modification of shape, the addition of further
units, etc. See Arnheim (1974, p. 174). The Pantheon assists our demonstration conveniently,
because its height is equal to its diameter.

3. I owe to Professor Alfred Bader of Lausanne a reference to the work on cymatics by Hans
Jenny (1975), who obtained patterns resembling ours by the effect of sounds on layers of liquids.

Hans Jenny's cymatics

FIGURE 154.
Le Corbusier, Carpenter Center for the Visual Arts.
Ground plan, third floor. Harvard University.

opening the container to the access of its users (Fig. 151c). The vectorial extensions are revealed as secondary modifications of the primary centricity.

To offer an example of how our two compositional systems work in the full three-dimensionality of a building, I will refer to the history of Le Corbusier's design for the Carpenter Center for the Visual Arts at Harvard University (Fig. 152).[4] The completed building, not easily visible in a photograph, presents itself as a compact, roughly cylindrical volume, traversed on the third floor by an S-shaped ramp that rises from the street level and, after crossing the building, descends to the adjacent street. The ramp was intended to prevent the new center from acting as the forbiddingly closed structures that are traditional for the buildings on campus. It was to be a traffic artery channeling student life right through the art center and exposing its internal studio activities to the eyes of the passers-by. Thus, in Le Corbusier's earliest sketch (Fig. 153) the ramp cut the building radically into two confronting blocks of studios. So much emphasis on vectorial eccen-

4. See the monograph by Sekler and Curtis (1978). XI-13.

tricity raised the problem of how to safeguard the centric unity of the art center. More technically, it challenged the architect to reconcile the needs of the vertical structure, staircase, and freight elevator, with the space for the ramp traversing the building.

The persistent difficulty encountered by the architectural team in trying to reconcile the freight elevator with the crossing ramp is most illuminating. Beyond the technical problem of keeping the two means of transportation out of each other's way, one senses the architect's endeavor to obtain the appropriate balance between the self-containedness of the art school and its social interaction with the rest of the university. In the final design, the lateral wings of the studios are integrated with the central vertical core to create a kind of pinwheel (Fig. 154). The ramp, which pierces the building, still strengthens some of the intended subdivisions but does not upset the unity of the whole. A successful compromise combines the self-contained compactness of the centric volume with the sweeping vector of the passageway.

FURTHERMORE

O UR TASK IS completed. The nature and presence of our two compositional principles have been described and documented. There remain further applications to envisage, questions to raise, doubts to assuage. A medley of some of these issues is offered in the following.

COMPOSITION IN TIME

Composition is not limited to immobile works of art. It should prevail also where motion is involved. In paintings and sculpture the balancing center stays in its place, and the arrangement of the shapes around it remains unchanged. A more complex situation must be faced in architecture. Every building, we said, possesses a balancing center somewhere in its interior; and regardless of the particular spot a visitor happens to occupy at any particular moment, he must relate his position to that overall center if he is to comprehend his own location and the composition of the structure surrounding him. As the visitor walks from place to place, however, he perceives also the more immediate spatial situation encompassed by his vision at any given moment, the particular room in which he happens to be and even the particular place within that room. This turns the architectural experience into a sequence in time—a sequence not simply arbitrary or subjective, as is the case with a sculpture explored from different sides or a painting scanned by the moving glance. Rather, the design of many buildings provides for the sequence of views as an essential aspect of its composition. This makes for the almost musical deployment of changing vistas referred to in the preceding chapter.

As the spatial surrounding changes, so does its balancing center. When the space is continuous, as in a hallway, the center may move steadily with the viewer like a guiding star; when the space consists of a succession of

[margin handwritten note: Why not to an edge or some other significant and distinguishable marker? Say, the front door.]

detached rooms, what results is the more complicated experience of a particular center approached, reached, overcome, and then replaced by the center of the next room. The transition between any two such centers can be called unstructured when it makes sense only by reference to the structure preceding and the one following it like a "passing tone" in music.

The composition of sequences in time, however, cannot be described simply as a succession of statically composed highpoints connected by transitions. Such an approach would overlook the very nature of composition in time, concerned with events rather than immobile images. One might compare the architectural experience with that of an oriental hand-scroll. There, too, as in architecture, the viewer must be aware of the timeless totality of the entire work if he is to properly appreciate any of its sections; and there again compositional highpoints punctuate the stages of the progression. As the viewer unrolls the scroll, he is aware of a preexisting entity, if only in the limited sense of anticipating what is still unknown. He builds up the actual experience through gradual accretion. He outruns the galloping horsemen and foot soldiers, passes between the posts of the wooden gate, plunges into the black smoke and flames of a conflagration, is caught in a crowd of paralyzed watchers, and is suddenly left alone in an empty landscape with the lone figure of the villainous court official, who is fleeing the site of his wicked deed. The emphasis of the composition is as much on the action as it is on the way stations of the story, but visual action is more easily seen than described. In the most abstract sense, it deals with such dynamic processes as crescendo or diminuendo, enlargement or constriction.

It is in the nature of sequences in time that the eccentric principle of vectors moving in a given direction dominates the structure. The centricity consolidating the work as a whole, as well as its episodes, risks being overridden by the flow of the action. This flow of the whole composition dynamizes the centric complexes by turning them into obstacles to the course of events, like rocks in midstream, or transforming them into evolving entities that come about, unfold their full power, and are left behind.

In architecture, the stable and timeless composition of the building is revealed in its temporal dimension by the visitor moving through it. In the case of the pictorial hand-scroll, the viewer sits at rest but introduces temporal action by setting the work into motion. This viewing of an action from the vantage point of a stable place of observation becomes more explicit when the visual action is contained in a frame, as happens on the stage or, more noticeably, in the projection of film or television. Here we meet a decisive difference between the immobile and the mobile media.

In painting, the frame belongs to the picture. It is firmly connected with

the picture as a part of its composition, while the viewer moves around freely. The movie screen, on the contrary, is an instrumental extension of the immobile viewer. The screen is a part of the viewer, as would be a pair of binoculars, while the film action, seen through the window of the screen, takes its course independently. We had occasion to discuss the double function of the frame in painting. As an indispensable part of the composition, it determines the balancing center and defines the spatial position of all pictorial elements. It is an inbuilt base of reference like the keynote in traditional music. Only secondarily does the pictorial scene function as a world of its own that happens to be overlaid by the limits of the observer's window.

In film projection the experience is reversed. The balancing center of the film image does not belong as much to what is shown on the screen as it does to the image's frame. Like the crossed threads in a telescope or gunsight, the balancing center of the framework is imposed upon the passing scene. That scene conforms much less compellingly to the framework because, being in motion, it constantly changes its relation to it. Also, it has no static structure within itself; it is a flow of transformations, during which its center moves from place to place. Consequently, composition in performance is more transitory, much looser than in the immobile arts.

Depending on the film viewer's attitude, the experience of watching a film is much less or much more self-centered than that of looking at a painting. Either he finds himself comfortably seated with the screen as his frame of vision, imposing an immobile structure upon the passing action of the film, or he is captured by the plot so completely that he moves along with it—he surrenders to the action; he struggles and races with the actors; he is stopped by obstacles; he reaches the goal. A painting never belongs as much to the viewer as does the framed film screen, which is an instrument of his vision; and he can never lose himself in the stillness of the painter's work with the almost physiological abandonment that pulls him into the rapids of an ongoing action. Visual composition reveals itself more readily in the quiet detachment from time, found in the immobile works of painting or sculpture.

★ ★ ★

ARE THERE EXCEPTIONS?

I can only hope that the examples offered in this book have convinced readers that the compositional principles I introduced do indeed apply, not only in the sense that centricity and eccentricity, the volumes and the vectors, are concepts to which the shapes in the various media conform without coercion but, more pointedly, that reference to this particular compositional

scheme is necessary if we are to understand a work's nature and meaning. A reader may concede this much and still wonder whether the scheme in fact applies universally. The very assertion that the same rule, across the board, governs various styles and media antagonizes the fashionable preference for individual differences and freedom from uniformity. This is a preference that has its stronghold in the arts, philosophy, and the social sciences; but it necessarily stops short of the natural sciences, where the universality of the laws of nature rules as an indispensable premise. The problem comes down to the question of whether the schemata of visual organization discussed in this book extend deeply enough into the foundation of human functioning to tap what all mankind has in common or whether these schemata operate at so high a level of human complexity that difference outweighs sameness.

In the next section I shall offer a few suggestions on the physical basis of our perceptual scheme. For the moment I shall remain with the evidence available in the visual experience itself. We had occasion to observe that the balancing center of a composition does not need to be explicitly marked by the artist to play its crucial role in the arrangement of shapes. This was illustrated, for example, by a painting of Franz Kline's (see Fig. 78). The assumption was that the tendency of a confined visual field to balance its dynamics around a center is fundamental and that therefore this centricity will be present and active even when the artist endeavors to overrule it. In fact, I tried to show that the effort to deny centricity can become evident only if the center is potentially present in the awareness of the viewer. The homogeneity of a color field or pervasive texture, for example, declares itself as something different from what is expected when it goes beyond simply omitting what was taken for granted. The center is not abolished but over-ruled during its virtual presence. Think of somebody painting a face with one eye left out. What the viewer sees is not a new species of human creature, as would be the case with the portrait of a Cyclops, but rather the picture of an incomplete human being. Our discussion of some of Mondrian's late paintings showed that the overriding of centricity presupposes its presence.

If we want to show what happens when the balancing center is absent, this can be done only by examples that, although visual, do not depend on visual dynamics. When we look at a chessboard, its center will inevitably figure in our perception. But in the strategy of the chess game the central area of the board is only minimally distinguished from the rest of the field. Each figure is characterized by its potential action, and this prescribed char-acter is also perceived as a corresponding visual expression. The wide-ranging linear sweep of the queen's moves differs from the crooked jumps of the knight the way the performances of dancers differ from one another.

FIGURE 155.
Giovanni Michelucci, Church of San Giovanni Battista. 1964.
Autostrada del Sole, near Florence. Photo, Gaio Bacci.

But the power of a piece is not larger when it holds the center of the board, even though its spatial opportunities may be. Otherwise, both our compositional principles apply. Each piece is a centric power of given strength, and the configurations of pieces make for nodes, on which the constantly changing configuration is based. No balancing center, however, holds the whole together. The components of the pattern balance one another purely by their vectorial interrelations. There is no parallel for such a centerless composition in the world of visual dynamics. We do know it from atonal music, if indeed it can be said that no tonal center exists when the tonic is missing.

There can be works, however, where the interaction of centers and vectors does not create the balanced unity that we have asserted to be the indispensable condition for the functioning of a composition. Let us assume for the argument's sake that this would be the case for one of the more daring architectural designs of recent times, Michelucci's church on the Autostrada del Sole (Fig. 155). We would see the expected centers and vectors, but they would not add up to a meaningfully unified visual statement. This would put us in the delicate position of having to admit that our criterion is not

universally valid or that we had failed to read the structure of this particular work correctly; or else we would have to assert that the example does not meet the conditions for a successful design.

Who would want to be put in the position of a theorist who excludes the specimens that do not fit his hypothesis? And yet, indubitably the assertions of any science hold only for certain specified conditions. If observations do not agree with the prediction, either the law has to be abandoned or modified or the observations have to be considered irrelevant to the proposition. Additional factors may be at work to which the proposition does not apply, or the materials of the demonstration may be contaminated. Similarly, an artist may be unable to meet the conditions of his trade; or he may decide, for reasons of his own, to throw things together at random or to arrange them for a purpose other than that of visual organization. If so, his product may fail to exhibit the kind of structural order described in our study as artistically indispensable and universal. My work is based on the conviction that one of the most necessary human occupations is the creation of objects or performances whose visual structure elucidates and interprets human experiences by its directly perceived expression. To do such work successfully, the artist meets certain conditions. Some of these concern composition, and to specify a few of them is the only task of this book. Art materials, however, can be used also for other purposes—for instance, to illustrate political statements, furnish faithful copies, satisfy personal yearnings, make money, look different, or gain popularity. Those occupations may or may not use the compositional devices I have analyzed. If they do not, they cannot be cited as refutations of our rules, since they pursue different objectives.

★ ★ ★ *That is, they are not "art".*
Oh... really?

A PHYSICAL FOUNDATION

If a principle of human experience or behavior is found to apply universally, one cannot hope to account for it as a mere convention, something transmitted from culture to culture and from generation to generation. No such mechanism of communication could overcome the barriers in time and space existing in our world. In some instances it seems plausible to assert that since human beings everywhere are exposed to certain similar natural conditions, they will respond to them in similar ways. This kind of reasoning is used, for example, to explain basic similarities in the myths of various cultures. Thus Joseph Campbell, in his preface to a book on this subject, has written of the need "to bring together a host of myths and folk tales from every corner of the world, and to let the symbols speak for themselves. The

parallels will be immediately apparent; and these will develop a vast and amazingly constant statement of the basic truths by which man lived throughout the millenniums of his residence on the planet."

The same is true for basic symbols, such as the difference between light and darkness or rise and fall, and I have referred to this principle of explanation to account for the general psychological significance of centricity and eccentricity. Since this involves us with the universality of perceptual patterns, however, an even more direct reliance on the physical basis of human experience is indicated. When human beings, regardless of their cultural background, exhibit certain common characteristics in their vision, we are led to refer these similarities to conditions inherent in the nervous system.

The gestalt psychologist Wolfgang Köhler has pointed out that the organizational processes creating visual perception derive from causes we cannot directly observe. We see the results of perceptual organization, and to some extent we can even experience the dynamic tensions these processes entail, but their causes are hidden in the nervous system. The most economical assumption on the nature of the neural processes underlying perception would seem to be that they are structurally similar to those exhibited by the visual images. To use the gestalt term, the dynamics operating in the pertinent projection areas of the brain may be assumed to be *isomorphic* to the dynamics observed in perception.

The organic physiology of the brain is a part of the world of physics and subject to the same laws of nature. Thus, if we come across physical forces creating patterns that resemble the ones we have found in visual perception, we have at least an indirect indication that our centric and eccentric shapes may have a physical basis. I was delighted, therefore, to discover our very pattern in a ceiling design by the great architect Pier Luigi Nervi (Fig. 156). The design is derived from the statics of a system of ribs "following the isostatic lines of the principal bending moments," which means in layman's language that the ribs show centric systems generated around the points at which the columns support the ceiling and resist its weight (Fig. 157). The radial vectors issuing from the centers are crossed and complemented by horizontals and verticals connecting the centers.

It will be understood that the connecting vectors form a regular grid because the architect arranged his columns in simple rows meeting at right angles. Other architectural examples have shown us similar grids, based on requirements of physical statics and visual order. The Nervi design is particularly striking because it shows the interaction of centric systems and vectorial connections in direct dependence on causal physical forces.

A more direct parallel to our own approach comes from work on the phys-

(handwritten margin note: What exactly is an isostatic line?)

FIGURE 156.
Pier Luigi Nervi, Ceiling design for Gatti Wool Factory.
1951–1953. Rome. *25 Oct 2002*

iology of vision by Peter Dodwell and William Hoffman. These authors con- *vector fields*
sider "vector fields as the formal mechanism underlying the organization of
visual patterns." They assert that vector fields in the brain have become *A fetching theory*
equipped during biological evolution to carry out transformations needed to
obtain perceptual constancy. Such mechanisms are said to be indispensable
because visual information about the environment is displaced and distorted
by our movement in space and by the optical projection of light messages
upon the retinas of the eyes. The vitally important task of compensating for
these displacements and distortions requires three kinds of transformation, *No shear?*
namely, lateral translation, dilation and constriction, and rotation. Accord-
ing to Hoffman and Dodwell, the basic patterns giving manifest appearance

What about cross ratios?

FIGURE 157.
Pier Luigi Nervi, Interior of Gatti Wool Factory. Rome.

to these mechanisms are vertical and horizontal sets of parallels and concentric shapes (Fig. 158). Experiments carried out by Dodwell with infants and kittens have suggested a distinct native sensitivity to these patterns.

The remarkable resemblance of the patterns arrived at in our own study of composition to those arrived at in this research on the physiological mechanisms underlying perceptual constancy deserves our attention. Only future work will show whether this similarity of appearance derives from similar neural processes. It also remains to be seen whether these processes are controlled by specific hereditary mechanisms geared to provide perception with the necessary invariants, as Hoffman and Dodwell assert, or whether they are due more generally to what happens to visual stimuli when they are subjected to the dynamic self-distribution of forces in the pertinent brain fields, as gestalt psychology would make us expect.

Whatever the answer to these more technical questions, it is encouraging to find that, independent of our own observations and in the pursuit of very different objectives, the same patterns are being called universally prominent in the functioning of the nervous system. Our assumption that this same

LTG's ORBITS

translations

translations

dilations

rotations

FIGURE 158.
By permission of Peter C. Dodwell.

prominence controls composition everywhere in the arts looks less daring when we learn that it coincides with findings concerning the very nature of the sense of vision.

* * *

COMPOSITION CARRIES MEANING

The centric and eccentric shapes we discussed are clearly seen only in the diagrams of Figures 5 and 6. They do not appear explicitly in any of the illustrations I took from the arts. In what sense, then, are these shapes visually present? In no "sense", literally

We need to remember here that perception does not consist in the mechanical scanning of the infinitely many details of shape and color projected upon the retinas of the eyes. In order to be biologically useful, vision must be geared to grasping coherent units and segregating these units from one another. Neither humans nor animals would be much helped by being made aware only of the hundreds of nuances that constitute the optical image of, say, an apple and continue beyond the apple to its environment; what needs to be primarily perceived is the apple as a thing. That this is a thing of a given shape and color is what is needed to identify the object as an apple.

We see the roundness of the apple—which does not mean that we perceive a round shape instead of the complex optical image. What takes place is the much more sophisticated operation of seeing roundness as the appropriate generality adumbrated by the given shape. To see the apple *as* round creates what I have called a perceptual concept or category.[1] The difference between roundness as its naked, conceptual self and roundness as the inherent schema giving shape to the image in which it is embedded is fundamentally relevant to composition in the arts. As an example we may refer to an essay by Rosalind Krauss, in which she describes what happened when artists of our century began to paint grids. To paint such diagrams, she says, amounted to the most thorough break with the pictorial tradition. The grid erected a barrier that walled the visual arts into "a realm of exclusive visuality." It was a fortress turning into a ghetto. "Never," she says, "could exploration have chosen less fertile ground."[2]

The aesthetic sterility of these diagrams tempted some artists to become suspicious of any compositional schema—a misunderstanding that comes about when the distinction to which I just referred is overlooked. We must ask: If such schematic patterns are indispensable for the order and meaning of artistic composition, why do they tend to look deadly when they are used as compositions in their own right?

Observe here that even when the lines of a diagram are meant to represent vectors, as they are in our Figure 6, they do not necessarily manage to look dynamic. I have used arrow heads to distinguish the vectors of Figure 6 from the shapes of Figure 5, which are intended to describe a purely geometric order. But the effect is at best very modest; and since visual dynamics is the indispensable carrier of artistic expression, diagrammatically simple shapes

1. See Arnheim (1966, pp. 31 and 95).
2. See Krauss (1985, p. 9). In the preceding chapter I noted that architecture comes much closer to geometric shapes than other media commonly do. Wherever the design of buildings in the International Style approached grid patterns too mechanically, a lack of lively expression became evident.

are plagued by the poverty of expression that afflicted so-called minimalist art in recent decades. When art is kept free from schematic simplicity, it has many ways of generating expressive dynamics, through variations of shape, color, and relation. Once alive, it will profit rather than suffer from being organized by compositional patterns.

In textbooks of composition, the underlying patterns are sometimes made explicit by lines drawn upon pictures of the works to be analyzed. We observed that in the works themselves these patterns are only implicitly present, even though perception tends to seek them out spontaneously. This lack of straightforward presence often raises the question of whether artists whose works conform to our compositional principles applied them consciously or only intuitively. Intuitive application is entirely possible when we assume that centric and eccentric structure is inherent in all perception. But one could also—perhaps through perusing this book—become consciously aware of these compositional patterns and apply them deliberately. Learned rules, however, are known to be risky in studio work: they may tend to dim the intuitive visual judgment of the artist. As long as this risk is avoided—that is, when intuitive judgment is in ultimate control of the composition and uses general principles as mere tools of artistic creation—it does not matter much whether these principles operate below the level of consciousness in direct and immediate interaction with the other components of perceptual organization or whether the relationship is more mediated and more indirect. In actual practice, some artists rely on structural principles intuitively, others do so more intellectually; and it is not uncommon for one and the same person to shift his guidance back and forth from the one to the other level.

It remains for me to return to what I consider the strongest argument in favor of spending much time and effort on the problems of visual composition. What is the purpose of composition? What is the justification for calling it indispensable? The general assumption would seem to be that composition serves to produce a well-organized whole for the purpose of creating a pleasantly harmonious order; and certainly order is necessary to make an artistic statement readable. Order, however, is only a means to an end. By making the arrangement of shapes, colors, and movements clear-cut, unambiguous, complete, and concentrated on the essentials, it organizes the form to fit the content. It is, first of all, the content to which composition refers.

I have had occasion to show through the example of Michelangelo's *Creation of Man* (see Fig. 117) that the immediacy of the work's power depends on its being reducible to two clearly defined centers, one carrying the Creator and the other carrying the creature, and being connected by the equally well-

Now that's a pregnant phrase.

defined vectorial axis, the channel of interaction. This simple schema is what hits the viewer's eye first, even before the subject matter of the painting is deciphered. The initial simplicity remains the guide to the complexity of the detail. At the same time, however, the basic theme, to which I have referred as the structural skeleton of the work,[3] is also the most concise visual statement of the work's essence. It is what it comes down to when all is said and done. The relation between the complexity of the fully realized work and the most abstract visual formula of its essence reveals the full range of its meaning. To this revelation the study of composition is dedicated.

3. See Arnheim (1974, p. 458).

25 Oct 2002

GLOSSARY

ANCHORING. A visual object's dependence on a base whose forces influence the object's dynamics. For example, visual weight can be affected by a center of attraction to which the object is anchored.

ANISOTROPISM. The asymmetry of gravitational space, by which the nature and behavior of perceptual objects change with their location and the direction of the forces they emit and receive.

ART. The ability of perceptual objects or actions, either natural or man-made, to represent, through their appearance, constellations of forces that reflect relevant aspects of the dynamics of human experience. More specifically, a "work of art" is a human artifact intended to represent such dynamic aspects by means of ordered, balanced, concentrated form.

BALANCE. The dynamic state in which the forces constituting a visual configuration compensate for one another. The mutual neutralization of directed tensions produces an effect of immobility.

BALANCING CENTER. The center around which the composition organizes itself. It is created by the configuration of vectors issuing from an enclosure such as the frame of a picture or the outer surface of a sculpture.

BIPOLAR COMPOSITION. A composition based on two separate centers held in equilibrium around the balancing center.

CARTESIAN COORDINATES. A framework of two axes on a flat surface or three axes in three-dimensional space. Centrally placed and meeting at right angles, the coordinates can serve as a frame of reference for the location of objects in visual composition. Dynamically, these axes cross at the balancing center of the composition and also serve as bases for visual forces. Locations on the axes possess a maximum of visual balance.

CENTER. Geometrically, the center is defined purely by location as the point equidistant from all homologous points of a regular figure. Physically, the center is the fulcrum upon which an object balances. Perceptually, the balancing center (q.v.) is the area where all the vectors constituting a visual pattern are in equilibrium. In a broader sense and irrespective of location, any visual object constitutes a dynamic center because it is the locus of forces issuing from it and converging toward it.

CENTRIC SYSTEM. A system organized around a center, either two-dimensionally or three-dimensionally.

COMPOSITION. An arrangement of visual elements creating a self-contained, balanced whole and structured in such a way that the configuration of forces reflects the meaning of the artistic statement. Composition of shape concerns the arrangement of elements in two- or three-dimensional space; composition of color is based on syntactic relations such as similarity, complementarity, and contrast, as well as the relations between primary and secondary hues.

CONSTANCY. The degree to which objects of the physical world are seen as possessing the same shape and size they have physically. Objective space (q.v.) has 100 percent constancy, whereas projective space (q.v.) has none. Actual visual experiences have an intermediate degree of constancy.

DEVIATION. Shapes or directions are often perceived as deviations from a norm. Certain ellipses appear as deviations from the circle. Slanted lines may be seen as striving toward, or straining away from, the base of reference. Deviation is a principal source of visual dynamics (q.v.).

DISPLACEMENT. The visual location of the center point or a central axis may deviate from its geometric location. This happens, for example, when a mass or column or a dividing line usurps the function of a neighboring central axis or when the components of a pattern balance around a point somewhere off the geometric center.

DYNAMICS. The directed tension perceived in visual objects. The carriers of dynamics are vectors (q.v.).

ECCENTRIC SYSTEM. Term used in this study to describe vectors that are responses to external centers of attraction or repulsion. In interaction with the centric system (q.v.), this second system accounts for compositional dynamics.

EXPRESSION. The ability of visual dynamics to represent the dynamics of states of being through the attributes of shape, color, and movement.

FIELD. The reach of a system of forces. With increasing distance from the generating centers, a field is reduced to empty space.

FIGURE AND GROUND. The distinction between perceptual objects and the space surrounding them. A figure is generally observed as lying in front of an uninterrupted ground—the most elementary representation of depth in drawing and painting. Dynamically, figures and the "negative spaces" of the ground are centers of forces that keep one another in balance.

FORCES. See Vectors.

FORMAT. The shape and spatial orientation of a framed picture, particularly the difference between an upright and a transverse rectangle. The ratio between height and width determines the format.

GESTALT. A field whose forces are organized in a self-contained, balanced whole. In a gestalt, components interact to the extent that changes in the whole influence the nature of the parts, and vice versa.

HEMISPHERIC SPECIALIZATION. The difference in the psychological functions performed by each of the hemispheres of the cerebrum. Broadly speaking, it seems that more of the linear functions are fulfilled by the nerve centers in the left hemisphere, whereas spatial synopsis is effected mainly by those of the right hemi-

sphere. The synthesis of these abilities makes for a properly operating mind, in the arts and elsewhere.

HIERARCHY. A scale of power, weight, or importance created visually by perceptual gradients. The height at which an object is placed, size, distance from the viewer, etc., are factors determining the position of a component on the hierarchic scale.

HORIZONTAL. The direction at right angles to the vertical (q.v.). Oriented symmetrically in relation to the pull of gravity, the horizontal provides the most balanced spatial relation between objects. It coordinates rather than subordinates objects. The central horizontal serves as one of the Cartesian coordinates (q.v.). As dividing lines, horizontals distinguish the upper from the lower areas of compositions.

IMAGINATION. A term commonly used to describe the mind's ability to create images of things not supplied by direct perceptual stimulation or to complete incompletely given percepts. In the arts, imagination is the ability to present objects, behavior, or ideas by the invention of strikingly appropriate form.

INDUCTION. A visual object may come about entirely through the dynamic effects issuing from its environment. The center of a circle or rectangle functions as a visual object even when it is not marked by any optical stimulus. An induced visual feature generates visual dynamics just as an explicitly given shape does.

INTUITIVE JUDGMENT. The evaluation of relations on the basis of the perceptual sense of balance and structural order, as distinguished from evaluation by measurement or other defined standards.

INVERTED PERSPECTIVE. The erroneous notion that the technique of making the sidefaces of objects converge, rather than diverge, toward the front is a variation of the principle of central perspective. Actually, this device of making sidefaces visible is used mostly by artists unaware of central perspective.

LATCH. A shape or other visual feature serving to bridge the division between the two centers of a bipolar theme. In Figure 101, the figure of Joseph is the latch between the Madonna and the shepherd.

MICROTHEME. A small, highly abstracted version of a painting's subject. Usually located near the center of the composition, the microtheme is often acted out by a pantomime of hands.

NODES. Places of structural density, obtained through the concentration and intertwining of vectors. Nodes are among the centers constituting the basic structure of a composition.

OBJECT. A visual object is a segregated entity perceived as part of a visual pattern.

OBJECTIVE SPACE. In representational painting, the theoretical case in which an array of objects is seen as having exactly the same distances and sizes they have in physical space. In practice, the effect of objective space is never obtained.

PERSPECTIVE. A means of projectively representing three-dimensional objects on a flat surface. Perspective creates visual depth by modifying the shape and spatial interrelation of objects through superposition, deformation, change of size, etc. *Central perspective* imitates some of the attributes of optical projection by a geometric construct that makes systems of objectively parallel edges or lines converge in vanishing points. A single vanishing point is used in one-point perspective,

whereas in two-point perspective two sheaves of parallels converge each to its own vanishing point. In principle, an unlimited number of vanishing points is available, because parallels can converge toward any location in pictorial space.

PRIMARY COLORS. The three fundamental primaries are the pure, unmixed colors red, yellow, and blue. This triad is the basis of all compositional color relations, obtained by mixture, contrast, similarity, and complementarity.

PROJECTION. An optical image brought about on a surface by the light rays reflected from an array of objects in three-dimensional space. Also a rendering of such a projection in drawing or painting. *Projective space* is the theoretical case in which a visual array would be seen as completely flat, that is, in total accord with its optical projection. The effect of projective space is never completely obtained in practice.

RETINAL PRESENCE. A term applied to visual objects that are represented in the visual field, by actual stimuli of shape, color, or movement as distinguished from those brought about merely by induction (q.v.).

RUBBER BAND EFFECT. The strengthening of dynamic pull with increasing distance of a visual object from the base of attraction to which it is anchored (q.v.). The resistance to this pull adds to the object's visual weight.

SELF. The self is perceived as holding a location in space, the center of its activity and influence. Although outside the work of art, the position of the self determines the spatial aspects of three-dimensional works and is accommodated to by two-dimensional ones. The self acts as a center of forces in the field that comprises the viewer and the work of art.

SPACE. The medium constituted by the totality of shape, color, and movement relations. Every visual experience involves all three dimensions of space. The perception of flatness is the limiting case in which depth, the third dimension, is at a minimum. *Pictorial space* has the degree of depth yielded by projection (q.v.). Laterally, pictorial space may be confined by a frame or extend somewhat behind and beyond that frame.

SPELLING OUT. The actual representation of structural features by means of stimulus material, e.g., a black spot marking a center or a wall marking a partition. See also Retinal Presence.

STATION POINT. The location of the viewer's eyes in physical space. The station point appropriate for the viewing of a painting lies in the sagittal plane that runs through the geometric center of the painting. The optically correct station point for a system of one-point perspective is located opposite the vanishing point at a prescribed distance from the picture.

STRUCTURE. A configuration of forces, as distinguished from a pattern of mere shapes, devoid of dynamics. Art or engineering is concerned with structure; geometry is not.

SYMBOLS. The visual interpretation of a more abstract subject through the translation of the subject's dynamic features into attributes of shape, color, and movement. Symbols should be distinguished from mere *signs*, which are conventional shapes, colors, actions, or objects designated to transmit standardized messages.

SYMMETRY. The "exact correspondence of form and constituent configuration on opposite sides of a dividing line or plane or about a center or axis" (*American*

Heritage Dictionary). A vertical axis produces more compelling visual symmetry than a horizontal axis.

VECTORS. Forces generated by the shapes and configurations of visual objects. A vector is characterized by its magnitude, direction, and base of attack. Visual vectors are seen as oriented in both directions unless a special base determines the origin of the vector's attack and thereby its direction. Not all vectors are explicitly supported by retinal presence (q.v.); for instance, the vector created by a figure's glance is not.

VERTICAL. Among the spatial directions the vertical is distinguished by pointing to the center of gravity. It stands for stillness and balance and provides the principal symmetry axis. Locations at different heights of the vertical create a hierarchy.

WEIGHT. Physically, weight is the effect of gravitational attraction. Kinesthetically, it is experienced either as an eccentric downward pull or as a downward press generated centrically by the object itself. Visually, weight is the dynamic power inherent in an object by virtue of its conspicuousness, size, shape, location, etc.

BIBLIOGRAPHY

Albers, Josef. 1963. The interaction of colors. New Haven: Yale University Press.
———. 1970. Bilder. Catalog of the Hamburger Kunsthalle.
Arnheim, Rudolf. 1966. Toward a psychology of art. Berkeley and Los Angeles: University of California Press.
———. 1966a. A review of proportion. *In* Arnheim 1966. pp. 102–119.
———. 1966b. Accident and the necessity of art. *In* Arnheim 1966, pp. 162–180.
———. 1966c. Concerning the dance. *In* Arnheim 1966, pp. 261–265.
———. Visual thinking. 1969. Berkeley and Los Angeles: University of California Press.
———. 1971. Entropy and art. Berkeley and Los Angeles: University of California Press.
———. 1974. Art and visual perception: a psychology of the creative eye. The new version. Berkeley and Los Angeles: University of California Press.
———. 1977a. The dynamics of architectural form. Berkeley and Los Angeles: University of California Press.
———. 1977b. Perception of perspective pictorial space from different viewing points. *Leonardo*, vol. 10, pp. 283–288.
———. 1978. Spatial aspects of graphological expression. *Visible Language*, vol. 12 (Spring), pp. 163–169.
———. 1986. New essays on the psychology of art. Berkeley and Los Angeles: University of California Press.
———. 1986a. Inverted perspective and the axiom of realism. *In* Arnheim 1986, pp. 159–185.
———. 1986. The perception of maps. *In* Arnheim 1986, pp. 194–202.
Blotkamp, Carel. 1979. Mondrian's first diamond compositions. *Art Forum*, vol. 18 (December), pp. 33–39.
Brecht, Bertolt. 1957. Kleines Organon für das Theater. *In* Schriften zum Theater. Frankfurt: Suhrkamp.
Broude, Norma. 1977. Degas's "misogyny." *Art Bulletin*, vol. 59 (March), pp. 95–107.
Brunius, Teddy. 1959. Inside and outside the frame of a work of art. *In* Nils Gösta Sandblad, ed., Idea and form: studies in the history of art. Stockholm: Almquist and Wiksell, pp. 1–23.

Burckhardt, Jacob. 1918. Format und Bild. *In* Burckhardt, Vorträge. Basel: Schwabe, pp. 312–323.

Cailleux, Jean. 1975. Eloge de l'ovale: peinture et pastels du XVIIIe siècle français. Paris: Cailleux.

Campbell, Joseph. 1949. The hero with a thousand faces. New York: Pantheon.

Carmean, E. A., Jr. 1979. Mondrian: the diamond compositions. Washington, D.C.: National Gallery.

Chamberlain, Harriet F. 1977. The influence of Galileo on Bernini's "Saint Mary Magdalen" and "Saint Jerome." *Art Bulletin*, vol. 59 (March), pp. 71–84.

Coomaraswamy, A. K. 1944. The iconography of Dürer's knots and Leonardo's concatenation. *Art Quarterly*, vol. 7, pp. 109–128.

Corballis, Michael C. 1980. Laterality and myth. *American Psychologist*, vol. 35 (March), pp. 284–295.

Cummings, L. A. 1986. A recurring geometrical pattern in the early Renaissance imagination. *In* István Hargittai, ed., Symmetry, unifying human understanding. New York: Pergamon Press, pp. 981–997.

Dodwell, Peter C. 1984. Local and global factors in figural synthesis. *In* Dodwell and Caelli, pp. 219–248.

Dodwell, Peter C., and Terry Caelli, eds. 1984. Figural synthesis. Hillsdale, N.J.: Erlbaum.

Ellis, Willis D. 1939. A source book of gestalt psychology. New York: Harcourt Brace.

Fechner, Gustav Theodor. 1871. Zur experimentalen Aesthetik. Abhandl. der Sächs. Ges. der Wiss. XIV. Leipzig: Hirzel.

―――. 1925. Vorschule der Aesthetik. Leipzig: Breitkopf und Härtel.

Ferguson, George. 1954. Signs and symbols in Christian art. London: Oxford University Press.

Fuller, R. Buckminster. 1965. Centrality of fundamental structures. *In* Gyorgy Kepes, ed., Structure in art and in science. New York: Braziller.

Füssel, Stephan. 1979. Mnemosyne. Göttingen: Gratia.

Gogh, Vincent van. 1959. Complete letters. Greenwich, Conn.: New York Graphic Society.

Gombrich, E. H. 1979. The sense of order. Ithaca, N.Y.: Cornell University Press.

Hauptmann, Moritz. 1936. Der Tondo. Frankfurt am Main: Klostermann.

Hayashi, Mikio. 1977. On the compositions of Emakimono scrolls. *Hiroshima Forum for Psychology*, vol. 4, pp. 3–7.

Henderson, Linda Dalrymple. 1983. The fourth dimension and non-Euclidean geometry in modern art. Princeton, N.J.: Princeton University Press.

Hildebrand, Adolf von. 1961. Kunsttheoretische Schriften. Baden-Baden: Heitz. 1907, trans.: The problem of form in painting and sculpture. New York: Stechert.

Hoffman, William C. 1984. Figural synthesis by vector fields: geometric neuropsychology. *In* Dodwell and Caelli, pp. 249–282.

Jenny, Hans. 1975. Cymatics. New York: Schocken.

Kauffmann, Hans. 1922. Rembrandts Bildgestaltung, ein Beitrag zur Analyse seines Stils. Stuttgart: Kohlhammer.

Kemp, Wolfgang. 1978. Foto-Essays zur Geschichte und Theorie der Fotografie. Munich: Schirmer/Mosel.

Kitao, Timothy K. 1974. Circle and oval in the square of St. Peter's. New York: New York University Press.

Klee, Paul. 1964. Das bildnerische Denken. Basel: Schwabe. 1961, trans.: The thinking eye. New York: Wittenborn.

———. 1970. Unendliche Naturgeschichte. Basel: Schwabe. 1973, trans.: The nature of nature. New York: Wittenborn.

Knott, Robert. 1978–79. Paul Klee and the mystic center. *Art Journal*, vol. 38 (Winter), pp. 114–118.

Köhler, Wolfgang. 1969. The task of gestalt psychology. Princeton, N.J.: Princeton University Press.

Krauss, Elaine. 1977. The dynamics of the tondo. Ann Arbor, Mich.: Senior thesis, University of Michigan.

Krauss, Rosalind E. 1985. The originality of the avant-garde and other modernist myths. Cambridge, Mass.: MIT Press.

La Meri. 1964. The gesture language of the Hindu dance. New York: Blom.

Lawrence, D. H. 1960. Psychoanalysis and the unconscious. New York: Viking.

Lewin, Kurt. 1935. A dynamic theory of personality. New York: McGraw-Hill.

Lynch, Kevin. 1960. The image of the city. Cambridge, Mass.: MIT Press.

Nervi, Pier Luigi. 1965. Aesthetics and technology in building. Cambridge, Mass.: Harvard University Press.

Neumeyer, Alfred. 1964. Der Blick aus dem Bilde. Berlin: Mann.

Nochlin, Linda. 1971. Realism. Harmondsworth: Pelican.

Panofsky, Erwin. 1954. Galileo as a critic of the arts. The Hague: Nijhoff.

———. 1960. Renaissance and renascences in Western art. New York: Harper & Row.

Pérouse de Montclos, Jean-Marie. 1974. Etienne-Louis Boullée. New York: Braziller.

Perrot, Maryvonne. 1980. Le symbolisme de la roue. Paris: Editions philosophiques.

Portoghesi, Paolo. 1974. Le inibizioni dell'architettura moderna. Rome: Laterza.

Reinle, Adolf. 1976. Zeichensprache der Architektur. Zurich: Artemis.

Saunders, E. Dade. 1960. Mudra, a study of symbolic gestures in Japanese Buddhist sculpture. New York: Bollingen.

Schöne, Wolfgang. 1961. Zur Bedeutung der Schrägsicht für die Deckenmalerei des Barock. Festschrift Kurt Badt. Berlin: De Gruyter.

Seitz, William C. 1965. The responsive eye. New York: Museum of Modern Art.

Sekler, Eduard F., and William Curtis. 1978. Le Corbusier at work. The genesis of the Carpenter Center for the Visual Arts. Cambridge, Mass.; Harvard University Press.

Simson, Otto von. 1956. The Gothic cathedral. Princeton, N.J.: Princeton University Press.

Sjöström, Ingrid. 1978. Quadratura: studies in Italian ceiling painting. Stockholm Studies in the History of Art, no. 30. Stockholm: Almquist and Wiksell.

Steinberg, Leo. 1973. Leonardo's "Last Supper." *Art Quarterly*, vol. 36 (Winter), pp. 297–410.

Summers, David. 1972. Maniera and movement: the figura serpentinata. *Art Quarterly*, vol. 35, pp. 269–301.

————. 1977a. Contrapposto. Style and meaning in Renaissance art. *Art Bulletin*, vol. 59 (September), pp. 336–361.

————. 1977b. Figure come fratelli: a transformation of symmetry in Renaissance painting. *Art Quarterly*, vol. 1 (Autumn), pp. 59–88.

Uspensky, Boris. 1973. A poetics of composition. Berkeley and Los Angeles: University of California Press.

Volk, Mary Crawford. 1978. On Velásquez and the liberal arts. *Art Bulletin*, vol. 60 (March), pp. 69–86.

Webster, T. B. L. 1939. Tondo composition in Archaic and Classical Greek art. *Journal of Hellenic Studies*, vol. 59, pp. 103–123.

Welsh, Robert. 1977. The place of "Composition 12 with Small Blue Square" in the art of Piet Mondrian. Ottawa: National Gallery of Canada.

White, John. 1957. The birth and rebirth of pictorial space. London: Faber & Faber.

Winter, Gundolf. 1985. Neuerung und Nachahmung. *Pantheon*, vol. 43, p. 80.

Wittkower, Rudolf. 1962. Architectural principles in the age of humanism. New York: Random House.

Zevi, Bruno. 1973. Il linguaggio moderno dell'architettura. Turin: Einaudi. 1978, trans.: The modern language of architecture. Seattle: University of Washington Press.

ACKNOWLEDGMENTS

The author is indebted to:

Mrs. Karin Einaudi of the Fototeca Unione, Rome, for her help in obtaining photographs.

Mr. John Gay, for his photograph of Troyes, Fig. 55.

Mr. Christian Heck, conservator of the Musée d'Unterlinden for photos of Grünewald's *Crucifixion*, Fig. 116.

Mme Dominique de Menil, for a photograph of Newman's *Broken Obelisk*, Fig. 21.

Mr. Ben Nicholson, for permission to reproduce his relief, Fig. 54.

Messrs. Schwabe & Co. Verlag, Basel, for permission to use a drawing by Paul Klee, Fig. 4.

Prof. Hann Trier, Cologne, for the photograph of his baldachin, Fig. 23.

De Vrienden Van Sint Pieterskerk, for slides of Dieric Bouts's paintings, Figs. 171 and 174.

Fondation Le Corbusier and SPADEM for Fig. 153.

Ufficio Pubbliche Relazioni, Autostrada S.P.A., for Fig. 155.

INDEX

237

Compositor:	Wilsted & Taylor
Text:	10/13 Plantin
Display:	Plantin
Printer:	Maple-Vail
Binder:	Maple-Vail